LEE ALEXANDER McQUEEN

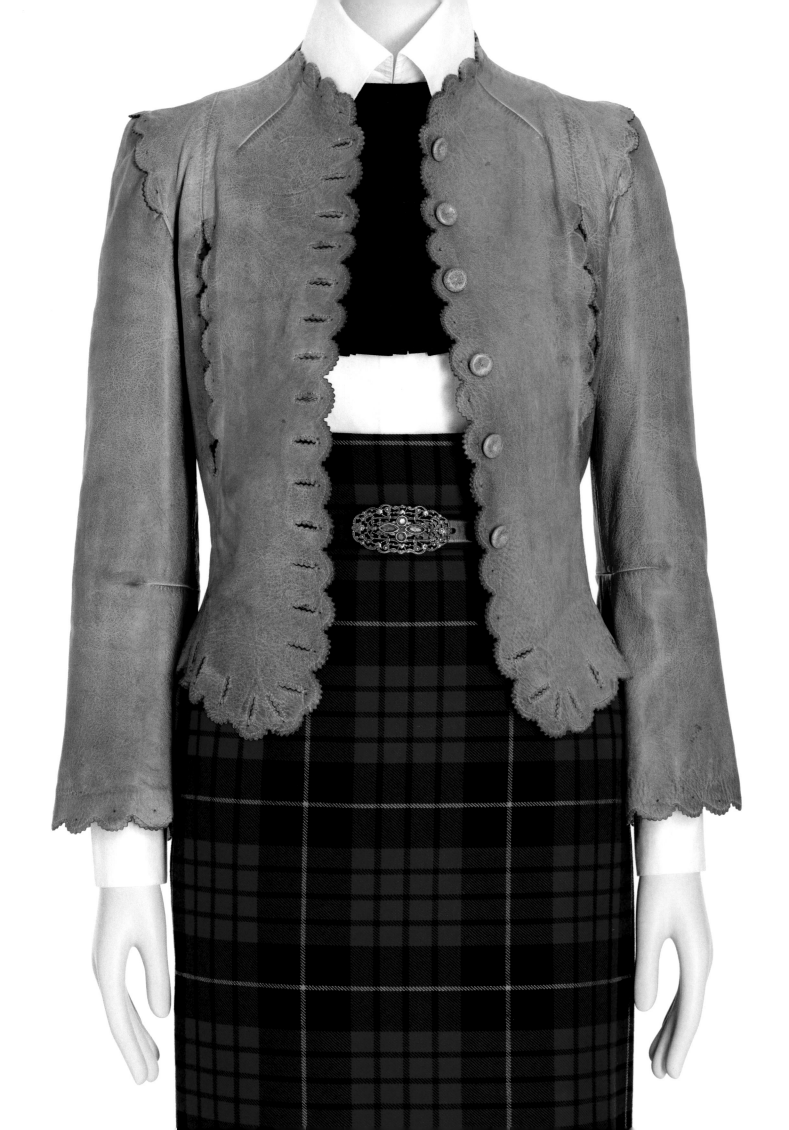

LEE

MIND

ALEXANDER

MYTHOS

McQUEEN

MUSE

CLARISSA M. ESGUERRA
MICHAELA HANSEN

With contributions by
MEGHAN DOHERTY, LINDA KOMAROFF, LEAH LEHMBECK,
ERIN SULLIVAN MAYNES, ROSIE CHAMBERS MILLS,
MEI MEI RADO, *and* BRITT SALVESEN

LOS ANGELES COUNTY MUSEUM OF ART
DELMONICO BOOKS · D.A.P. NEW YORK

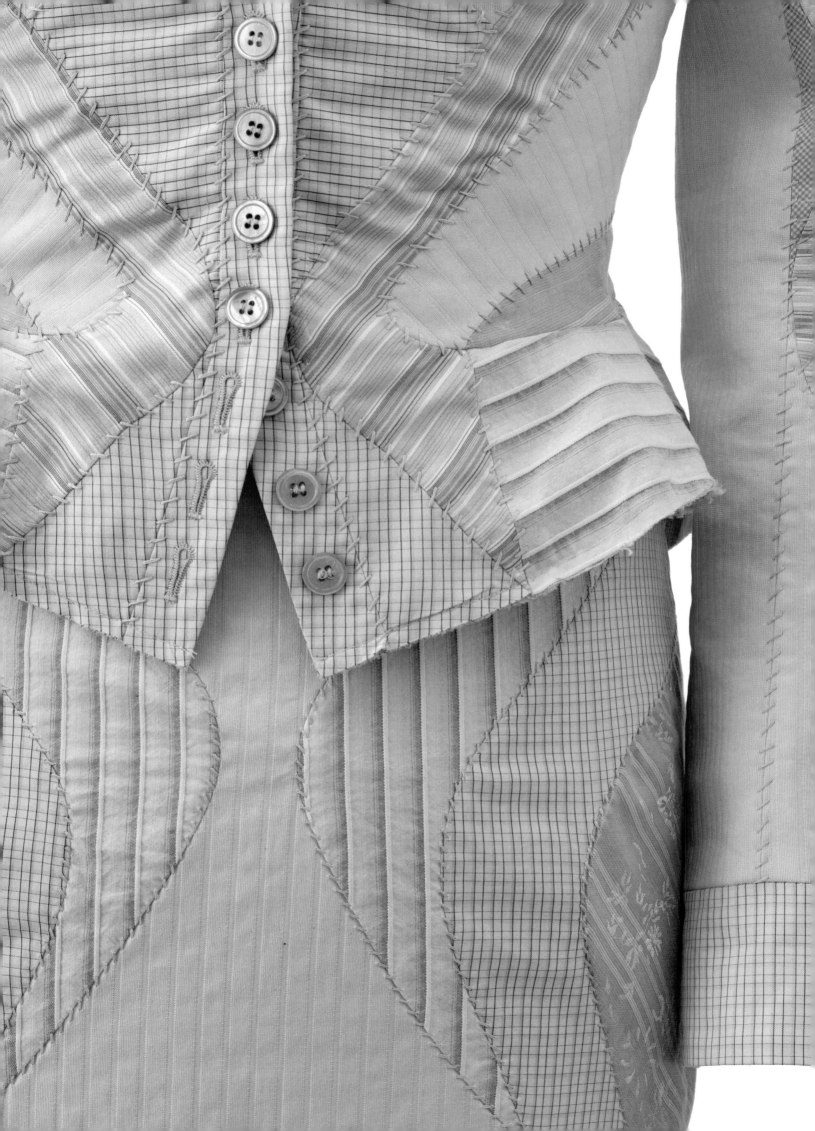

FOREWORD

Exploring imagination, artistic process, and innovation in fashion and art, *Lee Alexander McQueen: Mind, Mythos, Muse* reconsiders the designer's well-documented oeuvre by contextualizing select McQueen designs within art history. The exhibition was developed following a major gift from visionary collector Regina J. Drucker, and coincided with the transformation of our campus in advance of opening the David Geffen Galleries, which will house LACMA's permanent collection under one roof. The timing of this renovation made the museum's encyclopedic collection, typically on permanent display, available to curate in conjunction with McQueen's designs.

The resulting comparisons in *Mind, Mythos, Muse* allow us to examine the interdisciplinary impulse that defined the designer's career. Moreover, this excavation of LACMA's holdings, intended to uncover new frameworks for presenting McQueen, also yielded new insights to the museum's encyclopedic art collections. The designer once stated, "People don't want [only] to see clothes—they want to see something that fuels the imagination." Associate Curator Clarissa M. Esguerra and Curatorial Assistant Michaela Hansen have interpreted and contextualized McQueen's work to highlight the cycles of inspiration and imagination that are at the heart of all art, and I thank them both for their dedication and scholarship. Their efforts were supported by the curators of American Art, Art of the Middle East, Costume and Textiles, Contemporary Art, Decorative Arts and Design, European Painting and Sculpture, Modern Art, Photography, Prints and Drawings, South and Southeast Asian Art, and the Rifkind Center for German Expressionist Studies, and we are grateful to the contributing departments for their input.

Mind, Mythos, Muse would not be possible without the expansion of LACMA's holdings of McQueen's fashions, in large part thanks to the generosity of Regina J. Drucker. McQueen often expressed his desire to be viewed as a designer not for an elite few, but for all lovers of fashion. Honoring this spirit, Drucker—a third-generation Angeleno—has been committed to sharing her collection with our city, and in the past five years her remarkable endowment has established LACMA as the largest repository of the designer's works in a North American public institution. This catalogue and exhibition celebrate her extraordinary gift to the museum and to Los Angeles, and I wholeheartedly thank her for her munificence.

MICHAEL GOVAN
CEO and Wallis Annenberg Director, Los Angeles County Museum of Art

ACKNOWLEDGMENTS

We have been inspired not only by Lee Alexander McQueen's work, but also by the immense talents and noteworthy dedication of the individuals who made this project possible, especially Regina J. Drucker, with the support of Bruce Drucker, whose gift to the museum we honor. Thank you for your constant encouragement and light.

Melinda Kerstein oversaw costume installation with tireless creativity. We deeply appreciate Rachel Tu, Lauren Helliwell, Jennifer Iacovelli, and Tia Marone, as well as David Armendariz, Jessica Chasen, Stephany Cheng, Dale Daniel, Abigail Duckor, Miranda Dunn, Julia Latane, Catherine McLean, Holly Rittenhouse, Susan Schmalz, Janice Schopfer, Michael Windisch, and Jeff Young. Crucial to this project were Michael Schmidt and his studio, whose creations embody the perpetuation of inspiration. Our thanks to Swarovski® for their in-kind crystal contributions.

LACMA's publisher, Lisa Mark, championed this publication, along with its talented editor, Sara Cody. Peter Brenner and Jonathan Urban, assisted by Laura Cherry, created beautiful photographs of each artwork, as captured by James Gamboa's thoughtful book design. Additional thanks to David Karwan, Michael Pourmohsen, and Piper Severance. The skilled team at Michael Maltzan Architecture—Michael Maltzan, Khoa Vu, Yun Yun, and Tim Williams—designed a dynamic exhibition, with guidance from Victoria Behner. Many thanks to exhibition coordinators Carolyn Oakes and Iris Jang and registrar Elspeth Patient.

We are grateful to our curatorial colleagues, especially the Department of Costume and Textiles, led by Sharon Sadako Takeda, along with Nancy Lawson Carcione, Mei Mei Rado, and Kaye Durland Spilker. We are also indebted to contributing authors Meghan Doherty, Linda Komaroff, Leah Lehmbeck, Erin Sullivan Maynes, Rosie Chambers Mills, and Britt Salvesen, as well as to Julia Burtenshaw, Gwendolyn Collaço, Douglas Cordell, Alyce de Carteret, Claudine Dixon, Carol Eliel, Bindu Gude, Leslie Jones, Rachel Kaplan, Dhyandra Lawson, Matthew Miranda, Diana Magaloni, Rebecca Morse, Devi Noor, Melissa Pope, Eve Schillo, Aurora Van Zoelen Cortés, Sandra Williams, and Diva Zumaya.

Our appreciation extends to Deborah Ambrosino, Pantea Azizi, Caroline Bellios, Mariquita Davis, Xavier Dectot, Vanessa and Robert Fairer, Bobi Garland, Emily and Teddy Greenspan, Susan Neill, Paul Martineau, Kholood Marzook Al Fahad, Alistair McCallum, Jen Murby, Neal Rosenberg, Henry Schoebel, Sonnet Stanfill, Claire Wilcox, and Nikolaos Vryzidis. A very special thanks to John Matheson for sharing his incredible knowledge and passion.

Mind, Mythos, Muse was made possible through the Jacqueline and Hoyt B. Leisure Costume and Textiles Fund. We are grateful to CEO and Wallis Annenberg Director Michael Govan and Deputy Directors Zoe Kahr and Nancy Thomas. For their steadfast support, our heartfelt thanks to our families, especially Justin and Theodore Loy and Jeremy Grant.

CLARISSA M. ESGUERRA
Associate Curator, Department of Costume and Textiles

MICHAELA HANSEN
Curatorial Assistant, Department of Costume and Textiles

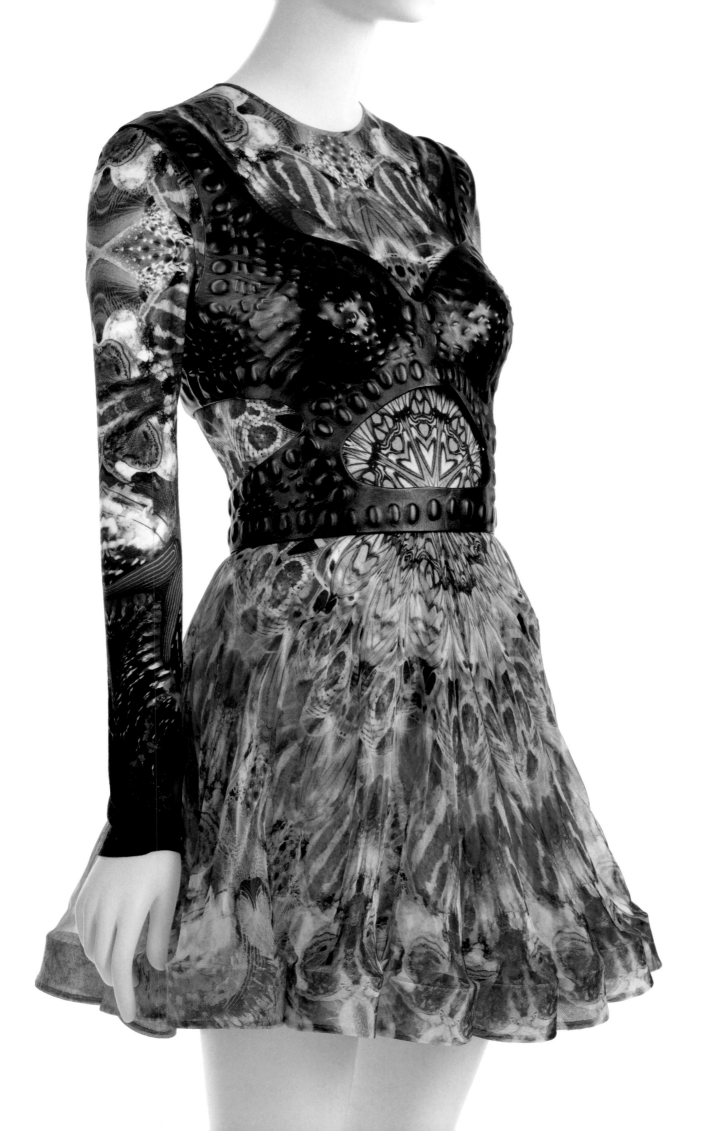

Alexander McQueen, **Woman's Dress and Harness**, from the *Plato's Atlantis* collection, Spring/Summer 2010

PREFACE: LOS ANGELES AND McQUEEN

Though Lee Alexander McQueen's home and studio were thousands of miles from Los Angeles, his work galvanized creatives and enthusiasts throughout the city, both during his lifetime and today. The reach of this influence is evident in the significant fashion collection assembled by Regina J. Drucker, which is at the heart of *Mind, Mythos, Muse*—the first exhibition devoted to the designer to be staged on the West Coast of the United States.

Drucker's family immigrated to Los Angeles from Guadalajara, Mexico, in 1927 as Catholic refugees from the Cristero Rebellion. Her deep roots in both Mexico and Southern California informed her penchant for collecting. "History runs through my veins," she has noted. "Being from the family that I was raised in, history was very important, and it was always taught to me." What first began with collecting books, art, and furniture later evolved into her passion for collecting fashion—objects that Drucker believed all people could identify with.

The works of numerous influential designers (including Cristóbal Balenciaga, Halston, Charles James, Mariano Fortuny, Issey Miyake, and Zandra Rhodes) became a part of her collection—but it was McQueen's designs that would form the largest single component, because, as Drucker has observed, with his work "fashion went from being just clothing to becoming art." Carefully compiled over the past twenty-five years and valuing rare, showstopper ensembles as well as subtle separates, the collection traces McQueen's career from 1996 through 2010.

To preserve McQueen's conceptual vision and attention to detail, Drucker assembled many complete looks as they were originally presented on the runway. In other instances, she has paired accessories with ensembles from differing looks or collections, emphasizing core themes and silhouettes the designer revisited and revised throughout his career. Such personalization emulates how the designer's clients and fans engage in self-expression through his work and reflects his own desire to break down barriers to his fashion.

Mind, Mythos, Muse proposes a model for McQueen's work to be seen anew. Cross-departmental juxtapositions highlight shared sources of inspiration and approaches to art-making that connect the designer with fellow artists working throughout history and today. One such artist is Los Angeles–based Michael Schmidt, who drew inspiration from McQueen as well as related thematic artworks to create his striking hand-crafted headpieces and footwear. Schmidt pays tribute to the designer's process through materials and sculptural designs, further centering the exhibition's uniquely Angeleno perspective and McQueen's enduring international influence.

As McQueen himself once reflected, "I'm interested in designing for posterity." This exhibition, celebrating Drucker's recent gifts, consciously aims to inspire new generations with his legacy.

INTRODUCTION

CLARISSA M. ESGUERRA AND MICHAELA HANSEN

Lee Alexander McQueen was both a conceptual and technical virtuoso. One of the most signifi-cant contributors to fashion between 1990 and 2010, the designer's critically acclaimed collections synthesized his unique training in Savile Row tailoring, theatrical design, and haute couture with a remarkable breadth of references spanning time, geography, media, technology, popular cul-ture, the natural world, and his lived experiences. The designer's singular viewpoint produced exquisitely constructed, thought-provoking fashion that could also be subversive or allegorical. His powerful—and at times controversial—collections presented deliberately personal responses to contemporary and historical sociocultural issues and events. As Nick Knight, a photographer who collaborated closely with McQueen, observed: "Any artist's work is ultimately about themselves, and their perspective on the world. And McQueen was a true artist. He worked in fashion because he believed—as I do—that it is the most relevant, the most exciting medium of our time. Which, of course, is why it has the capacity to outrage."[1]

1 Nick Knight, quoted in Jess Cartner-Morley, "Alexander McQueen: Into the Light," *The Guardian*, February 10, 2015.

2 Alexander McQueen, quoted in Susannah Frankel, "The Real McQueen," *Harper's Bazaar*, April 1, 2007.

3 McQueen, interviewed by Guise Ferré, *Muse*, no. 16, December 2008.

"WHAT YOU SEE IN THE WORK
IS THE PERSON HIMSELF.
AND MY HEART IS IN MY WORK."[2]

Both Lee McQueen the man and Alexander McQueen the designer have been the subjects of significant research and analysis, ranging from biographies and documentaries to museum exhi-bitions and scholarly texts connecting him to theoretical ideas around dress, gender, power, and performance. His impact on design is felt in aspects of fashion now taken for granted: he and his team were early innovators of technologies and practices common today, including digitally printed textiles, laser cutting and 3D printing, live-streamed runway shows, and the emergent genre of fashion film. Together, all the above have built an important foundation to understanding this artist as one of the most groundbreaking figures in fashion design of our time, whose body of work warrants continued study and engenders new possibilities for interpretation.

The first Alexander McQueen exhibition on the American West Coast, *Lee Alexander McQueen: Mind, Mythos, Muse* contextualizes the designer's imaginative work within a canon of artmakers who drew upon analogous themes and visual references. "What I do is an artistic expression which is chan-neled through me," he once stated. "Fashion is just the medium."[3] Examining select McQueen gar-ments from the Collection of Regina J. Drucker alongside antecedent and contemporary artworks, largely from LACMA's permanent collection, this project presents a case study of the designer's pro-cess and influences, and in doing so, provides the opportunity to better understand artistic legacy and cycles of inspiration.

4 McQueen, quoted in Harriet Quick, "Killer McQueen," *Vogue* (UK), October 2002.

5 Bobby Hillson, quoted in Susannah Frankel, "The Real McQueen," *The Independent Fashion Magazine*, Autumn/Winter 1999.

Understanding McQueen's history helps to illuminate the multifaceted nature of his work. "My collections have always been autobiographical," he observed, likening his collections to "exorcising my ghosts." He went on to characterize them as "about… my childhood, the way I think about life and the way I was brought up to think about life."[4]

Born Lee Alexander McQueen in London on March 17, 1969, he demonstrated an early curiosity for fashion and art. The youngest of six—his father, Robert, was a taxi driver and his mother, Joyce, was a teacher and genealogist—Lee McQueen passed his childhood birdwatching and drawing, two formative pursuits he would carry into adulthood and his design career. He also enjoyed synchronized swimming, and later scuba diving as an adult; his love of water would eventually play a key role in several of his future collections. McQueen's family, and his mother especially, encouraged Lee's creative side: in 1985, at the age of sixteen, he left school to enroll in a tailoring apprenticeship program on Savile Row, the historic center of bespoke British tailoring, after his mother watched a television documentary citing the need for new tailors. The first in a series of notable professional experiences, this opportunity enabled the exceptional technical proficiency for which McQueen became acclaimed.

McQueen spent two years at Anderson & Sheppard, concentrating on jacket construction, before moving to Gieves & Hawkes, to master trousers—two stalwart institutions of British tailoring, founded in 1906 and 1771, respectively. Few other fashion designers have studied the highly skilled craft of tailoring as rigorously as those who apprentice on Savile Row. In 1988, he applied his aptitude for cutting to a position with theatrical costumer Bermans & Nathans. Working as a pattern cutter, he was immersed in historic patternmaking techniques that would appear in future collections. From there, he joined the studio of conceptual designer Koji Tatsuno, protégé of Yohji Yamamoto, who created avant-garde silhouettes and repurposed vintage textiles, techniques and ideas McQueen would later incorporate into his work to astounding effect. In 1990, he traveled to Milan, where he was hired by renowned fashion designer Romeo Gigli. In Italy, McQueen became familiar with luxury textile mills and production houses such as the ones he would eventually use for his own label.

Upon his return to London in 1990, the burgeoning designer applied for a position as a pattern-cutting instructor at Central Saint Martins, a London college of art and design that graduated some of the era's most accomplished fashion designers. Instead of hiring McQueen, Bobby Hillson, the founder of the school's Master of Arts program in fashion, admitted him as an MA candidate: "To have left school at sixteen, studied at Savile Row, gone to Italy alone and found a job with Gigli—that was incredible. He was also technically brilliant, even though he'd never actually studied design. And still only twenty-one or twenty-two."[5] McQueen's enrollment—the cost of tuition was loaned by his aunt—reshaped the course of his career. Stylist Isabella Blow famously purchased his entire thesis collection, *Jack the Ripper Stalks His Victims,* in 1992 and championed the designer as he steadily grew his business, becoming one of his closest confidantes. When he launched his label shortly after graduating, it was Blow who suggested the appellation of the designer's middle and last names: Alexander McQueen.

Eventually, Alexander McQueen would become known for some of the most anticipated shows of each season. Provocative and immersive, they were populated with fashion unlike any that had walked the runway—complex construction rooted in men's tailoring; collections that encapsulated clear storylines; and a constant reconsideration of beauty—particularly the elongated torso, epitomized by the low waistlines of the "bumster" trouser, a new silhouette that dominated early-aughts fashions. By 1996, McQueen's reputation as a creative visionary with excellent technical foundations had been established, and he was tapped to lead the womenswear line at Givenchy, entering the world of French haute couture. Working at Givenchy helped to fund his eponymous label, which continued in London; in Paris, the designer gained the skills of refined dressmaking that would inform his future collections. After five years, he entered a partnership with Gucci Group, thereby ending his time at Givenchy. Retaining creative control, but with the security of Gucci's financial backing, McQueen's collections continued to evolve in scale, scope, and impact, growing more personal with each season, though they were not always critically acclaimed or understood. Speaking of his performative runway shows, he reflected: "I used to do it to shock people, to prove a reaction, but now I just do it for myself. The shows always reflect where I am emotionally in my own life."[6]

In early 2010, McQueen's beloved mother, Joyce, passed away; only nine days later, he took his own life. At the time of his death, McQueen exemplified many roles: simultaneously a visionary provocateur or "enfant terrible" (a persona assigned to him by the media early in his career), he was also respected as a savvy businessman, award-winning couturier, and Commander of the Order of the British Empire (CBE). As American *Vogue* editor-in-chief Anna Wintour stated in her eulogy for the designer, "There was no containing his contradictions."[7] Though he worked as Alexander McQueen for less than twenty years, his legacy as an artist continues to reverberate far beyond his relatively short time as a fashion designer.

TRANSFORMING MENTALITIES

McQueen used his work to process complex responses to the world around him and his place within it, regularly drawing from a multitude of inspirations. "I'm making points about my time, about the times we live in. My work is a social document about the world today.... In the end, if I'm brave enough to push it, to take a risk, then hopefully other people will follow."[8] With close looking, it is possible to parse the source material commingling in each McQueen collection. As the designer stated in 2003, "In any collection, there are probably over three hundred concepts I'm referencing."[9] These references range from film, photography, conceptual art, and music to science, philosophy, and religion. The Renaissance era, Flemish and Dutch Old Master paintings, and the work of individual artists such as Francisco de Goya, Alfred Hitchcock, Stanley Kubrick, and Rebecca Horn were touchstones throughout his career. Beyond fine art, he frequently referenced popular culture, as well as nature and history: "I am always on the National Geographic and History Channels. I am a sucker for history. I draw on it all the time."[10]

A single McQueen collection could unite references as seemingly disparate as the designer's personal family tree, violent persecution, and Hollywood's Golden Age, as did the Fall/Winter 2007–8 collection *In Memory of Elizabeth How, Salem, 1692*. Others, such as *Highland Rape*, *Eshu*, *Irere*, *The Widows of Culloden*, and *The Girl Who Lived in the Tree*, took on the history and legacy of

6 McQueen, quoted in Susannah Frankel, "The Real McQueen," *Harper's Bazaar*, April 1, 2007.

7 Anna Wintour, quoted in Claire Wilcox, "Directing the Eye," in *Alexander McQueen: Unseen*, ed. Robert Fairer (New Haven: Yale University Press, 2016), 16.

8 McQueen, interviewed by Susannah Frankel, *Big*, no. 3, Autumn/Winter 2007.

9 McQueen, in conversation with Björk, *Index*, September 2003.

10 McQueen, quoted in Mark Holgate, "Noble Endeavor," *Vogue* (U.S.), September 2008.

11 McQueen, interviewed by Susannah Frankel, *Big*, no. 3, Autumn/Winter 2007.

imperialism and colonialism. Moreover, his collections sought to convey the universality and ongoing relevance of these concepts. For example, while speaking about his idea to incorporate the story of a seventeenth-century colonial American witch hunt into his *Elizabeth How* collection, McQueen stated, "There's a witch hunt for every Muslim living in England, purely because of their religion. There's a witch hunt for every gay living with HIV. Everyone wants to point the finger at someone. Witch hunts have been around forever, really. It's always everyone else's fault and never our own."[11]

One way that McQueen illustrated his concepts was to borrow from cultural traditions, such as dress or music, found across the globe. A lifelong movie buff with cinematic inclinations, he understood the narrative value of set dressing, costume design, score, and sense of place. His interpretations of global dress were regularly employed as commentary on politics or identity, and in many collections, these references—along with sets and soundtracks by collaborators like Joseph Bennett, Sam Gainsbury, and John Gosling—contributed to constructing imagined worlds within a Western interpretation. For example, his clear references to textiles and silhouettes from Russia, Tibet, and Japan illustrate an eastward migration in the Fall/Winter 2003–4 collection, *Scanners*.

During McQueen's career, the practice of drawing inspiration from outside one's own culture was not only common among fashion designers, but seen as a celebration of the rapid globalization that characterized the 1990s and early 2000s. In an era where postmodernism was challenging the ideals of modernism—in particular, its assumptions about universal principles and aesthetics—artists and designers embraced strategies such as bricolage, which combined disparate ideas, tastes, and concepts into something seemingly new. Taking an optimistic but irreverent view toward an inter-connected millennium, fashion designers of the era demonstrated their curiosity, receptivity, and worldliness by sampling dress elements from diverse cultures and locales with aplomb.

This cultural cross-pollination has occurred for centuries; the transmission and sharing of ideas and traditions through travel, trade, conflict, and curiosity that defines human civilization is a cornerstone of fashion and art history. Indeed, it has been codified as a methodology for fashion design students at schools like McQueen's alma mater, where he continued to mine the research library during his professional career. In both contemporary and historic fashion, it can be challenging to immediately differentiate the superficial appropriation of culture for commercial gain from cultural exchange or inspiration as a mode of appreciation or storytelling. These distinctions are best examined on a case-by-case basis through discussion and full understanding of context.

An example of this can be seen in comparing McQueen's use of Highland dress in the Fall/Winter 2006–7 collection, *The Widows of Culloden*, and Islamic dress in Spring/Summer 2000's *Eye*. With *Widows*, McQueen sourced his own Scottish ancestry in telling the story of British conquest; his intimate knowledge of and personal attachment to what tartan meant to him prevailed throughout the soaring storyline of the collection. With *Eye*, McQueen aimed to highlight the dress traditions of the Middle East and neighboring regions, in what could be considered an ethnocentric commentary on revealing and concealing the female body, against the backdrop of tensions between the region and the West. Though his intentions were to celebrate dress and culture outside his own, he lacked personal intimacy with the subject matter; when combined with the demands of

rapidly developing new work for each fashion season, the result was a collection that conflates a diverse region of people into a single aesthetic approach.

Today, a necessary reckoning with the effects of colonization and globalization is underway, and the practice of borrowing dress elements solely for aesthetic purposes is increasingly scrutinized and criticized. People—often those of the cultural backgrounds Western fashion has historically excluded—are increasingly speaking out when they feel fashion has misappropriated or profited from their culture by using important dress elements with meaningful histories or even sacred functions. Although preparation for this catalogue and exhibition took place only a decade after Alexander McQueen's death, ongoing conversations and debates around issues of appropriation in fashion illuminate how different our present already is from the world in which McQueen worked—making his intentions and the context in which he designed perhaps more crucial than ever to consider when interpreting his body of work.[12]

Growing up gay in a traditional, working-class milieu, McQueen often identified with the feeling of being an outsider (which may be another reason why he was fascinated with cultures outside his own). After witnessing the domestic abuse of his older sister as a child, he vowed to protect and empower women, and consistently strove to design clothing that confronted the male gaze in an industry dominated by men at the helms of the most successful houses.[13] To achieve this, McQueen purposefully surrounded himself with the perspectives of female creators who not only supported his collections, but helped him to define both his creative and business frameworks. Among these women were Sarah Burton, his invaluable right-hand collaborator and natural successor; Katy England, another long-time collaborator; Tabitha Simmons, Camilla Nickerson, Anna Whiting, and Sam Gainsbury, who all played critical roles in the production of the designer's collections; and Trino Verkade, the label's first studio employee as well as cofounder (and now CEO) of McQueen's Sarabande Foundation. In his work itself, he implemented experimental shapes and styling that were often criticized for failing to conform to ideals of pleasant, easily digestible female beauty. Though the press affected shock when reviewing collections that, directly or metaphorically, addressed violence against women, McQueen countered that his collections only held a mirror to a society that tolerated misogyny, maintaining "I design clothes because I don't want women to look all innocent and naive, because I know what can happen to them. I want women to look stronger."[14]

A number of McQueen's collections critique overconsumption and the fashion industry itself (*The Horn of Plenty, Deliverance, What a Merry Go Round, It's a Jungle Out There*), while still others comment on climate change and the destructive effects human actions have on the planet (*Plato's Atlantis, Natural Dis-tinction, Un-Natural Selection*). Relative to other leading catwalks of the 1990s and early 2000s, the designer's projects and runways were populated with more diverse models and performers.[15] He poked fun at fashion's mainstream ideals of beauty and, as did some of his favorite artists and muses, such as Joel-Peter Witkin or Leigh Bowery, confronted people with the imperfections of the real world—then celebrated the beauty in that reality. In many ways, McQueen's approach was a predecessor to the cultural zeitgeist of the 2020s. His willingness to tackle social and political issues directly during his lifetime may be why his work continues to resonate so powerfully today. "With me, metamorphosis is a bit like plastic surgery, but less drastic. I try to have the same effect

12 For more on cultural appropriation in fashion, see The Fashion and Race Database (fashionandrace.org).

13 McQueen himself suffered abuse as a child, which perhaps informed his drive to question authority and traditional power dynamics, challenge the status quo, and address issues of mental health in collections such as *Voss*.

14 McQueen, quoted in Caroline Edwards, *Fashion at the Edge: Spectacle, Modernity, and Deathliness* (New Haven: Yale University Press, 2003), 149.

15 For instance, when McQueen was the guest editor for the September 1998 issue of *Dazed and Confused*, titled "Fashion-able," he promoted the beauty of different physical abilities. The project stemmed from the runway show for his Spring/Summer 1999 collection, *No. 13*, which featured Paralympic athlete Aimee Mullins.

16 McQueen, quoted in Pascale Renaux, "Homage," *Numéro*, December 2007.

17 sarabandefoundation .org/pages/support.

with my clothes. But ultimately I do this to transform mentalities more than the body. I try and modify fashion like a scientist by offering what is relevant to today and what will continue to be so tomorrow."[16]

McQUEEN'S LEGACY

Admired by dress enthusiasts, artists, and art aficionados alike, McQueen's talents left behind a legacy of uniting fashion with art. At the same time, his working-class beginnings, tenacious work ethic, and authenticity endeared him to members of the general public, who found a bridge to the exclusive world of fashion in the designer's sense of humor and self-deprecating public persona. Before today's direct-to-consumer marketing strategies and "buy-now, wear-now" runway presentations, McQueen fostered a sense of an immediate and personal connection with fans beyond his clientele. This relatability, combined with his aspirational fusion of fashion and fine art, catapulted McQueen to a celebrity status so pronounced that even casual consumers of popular culture know his name.

Examining McQueen's clear intent to support new generations of artists and designers inspires another lens of interpretation for his work. Nowhere is this artist's lasting legacy more evident than in the continuation of the Alexander McQueen fashion house, under the creative direction of Sarah Burton, who collaborated closely with the designer for thirteen years before his death. Through her work, the McQueen DNA of experimentation, innovation, and varied inspiration continues. Further infusing the art and design world with his creative approach is the Sarabande Foundation, a charitable trust established by McQueen as a space that supports "emerging talent who are creatively fearless [and]... who have the potential to push boundaries and overturn prevailing orthodoxies."[17]

Today, McQueen's fashions continue to inform silhouettes, approaches to construction, performative runway shows, and the general embrace of new technologies. For this exhibition, Los Angeles artist Michael Schmidt synthesizes McQueen's designs and the variety of artworks displayed alongside them in headpieces specially made for select looks. For instance, in responding to *Plato's Atlantis*, Schmidt honored McQueen's runway show for the collection, which presented distinctive, unprecedented silhouettes (see p. 161). In some pieces, Schmidt incorporated 3D printing (which McQueen introduced in the collection's "Alien" shoes) to create custom mannequin heads inspired by the magnificence of nature; for others, he reinterpreted the collection's sculptural hair styles and iconic "Armadillo" boots using materials relevant to the collection's themes of pollution and global warming, recycling discarded cellophane candy wrappers, plastic six-pack rings, and CDs into headpieces and footwear in shapes that pay tribute to McQueen's vision. These and other derivations act as visual cues for the thematic tone of each exhibition section, as well as further illustrate the continuing cycle of inspiration that joins McQueen with artists of the past, present, and future.

Reflecting on his artful design process, *Lee Alexander McQueen: Mind, Mythos, Muse* explores the designer's diverse sources of inspiration by displaying McQueen's imaginative fashions alongside thematically related or relevant historical and contemporary artworks. While it is unknown whether Alexander McQueen directly referenced any of the specific LACMA works illustrated here, contextualizing his work within a broader canon of art history demonstrates the universality

of imagery and themes explored in his fashion collections. These juxtapositions, spanning a multitude of mediums, eras, and cultures, highlight McQueen's approach to storytelling, as well as the cyclical nature of inspiration. *Mind, Mythos, Muse* draws from LACMA's permanent collection and is organized into four thematic sections: **Mythos** looks at McQueen's use of religion and mythology as a framework for contemplating human nature. **Fashioned Narratives** explores his penchant for telling stories of imagined worlds with collections and runway shows rooted in his own personal history and romanticized historical references. **Technique and Innovation** demonstrates his masterful abilities in tailoring, dressmaking, and deconstruction, which he combined with his vast knowledge of fashion history and interest in innovative technologies. Lastly, **Evolution and Existence** examines his fascination with and appreciation of nature and life cycles.

The designer once remarked, "When I'm dead and gone, people will know that the twenty-first century was started by Alexander McQueen."[18] Indeed, he continues to be regarded as a visionary, his influence enduring in contemporary fashion more than a decade after his untimely death, as it will undoubtedly persist in the future.

18 McQueen, quoted in Judith Thurman, "Dressed to Thrill," *The New Yorker*, May 16, 2011.

MYTHOS

Previous page: Alexander McQueen, **Woman's Dress**, from the Untitled (*Angels and Demons*) collection, Fall/Winter 2010–11 (detail)
This page: Alexander McQueen, **Woman's Dress**, from the *Neptune* collection, Spring/Summer 2006 (detail)

MYTHOS

MYTHOS explores a selection of McQueen's collections inspired by mythological and religious belief systems. Incorporating visual references to diverse cultures as well as art historical movements, these collections put the impressive breadth of the designer's artistic source material on display. At the same time, his use of disparate aesthetic references highlights a practice of external inspiration-seeking that was characteristic of fashion design during his career.

The untitled Fall/Winter 2010 collection, posthumously called *Angels and Demons*, references Christian iconography from the Byzantine period as well as the Northern and Italian Renaissance, particularly in dichotomous representations of redemption vs. sin and heaven vs. hell. A feat of technical innovation, concept, and beauty, the collection was completed after McQueen's death by his womenswear studio under the direction of Sarah Burton, and was as much a tribute to the designer, and his mastery of the medium, as it was a manifestation of the designer's introspection.

1 McQueen, interviewed by Nick Knight for SHOWStudio's *In Fashion* series, June 1, 2009 (showstudio.com/projects/in_fashion/alexander_mcqueen).

> "AS FAR AS I THINK
> THE WORLD NEEDS FANTASY, NOT REALITY.
> WE HAVE ENOUGH REALITY TODAY…
> IT'S BASED ON FANTASY, THIS COLLECTION,
> AND MYTH AND LEGEND."[1]

With *Neptune*, his Spring/Summer 2006 collection, McQueen looked to ancient Greece and Rome. Borrowing from representations of soldiers and wrestlers, marble sculpture and architecture, and attributes of the titular god himself, the collection recast contemporary women as powerful—and empowered—warriors or goddesses. Mining classicism and neoclassicism alike, *Neptune* underscored the designer's desire to impart strength to the women wearing his creations.

McQueen cited Turkish music as the inspiration for his exploration of relationships, both real and perceived, between Christianity and Islam for his Spring/Summer 2000 collection, *Eye*. The collection harkened back to the European *turquerie* vogue in the sixteenth through eighteenth centuries by conflating distinct designs and costume traditions found across the former Ottoman Empire and present-day Turkey as a single vision. McQueen's irreverent fusion of religious symbols and silhouettes, historical secular dress, and contemporary fashion—while very much of the moment in which he created *Eye*—raises questions today around issues of cultural sensitivity and appropriation.

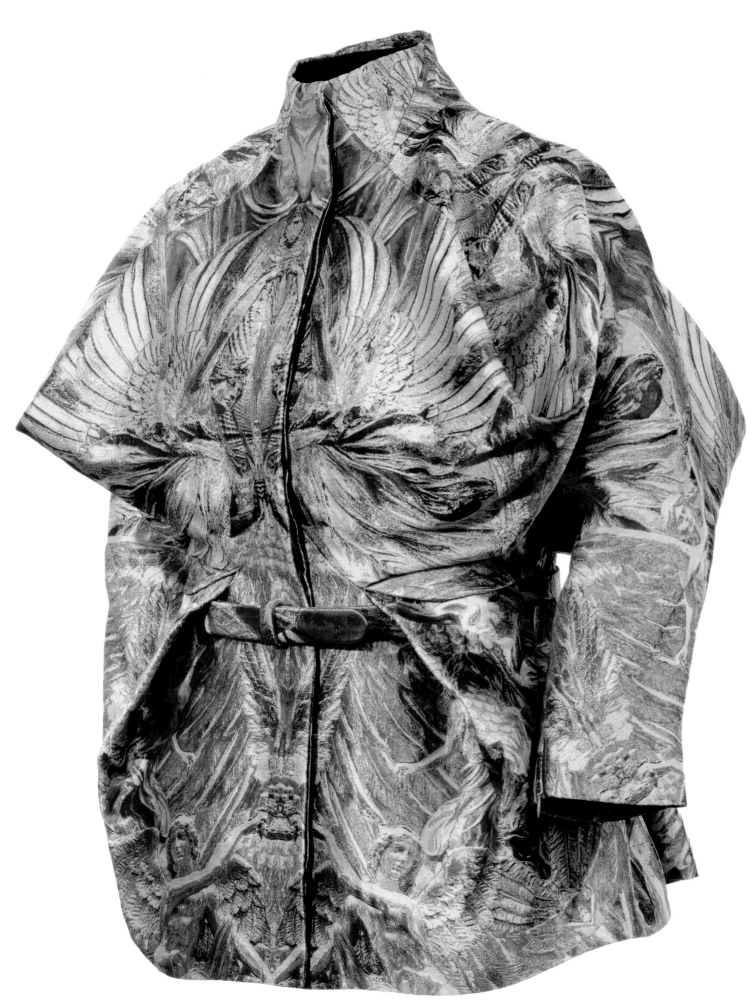

Alexander McQueen, **Woman's Jacket**, from the Untitled (*Angels and Demons*) collection, Fall/Winter 2010–11

UNTITLED (ANGELS AND DEMONS)

FALL/WINTER 2010–11

The title *Angels and Demons* was taken from tweets posted by McQueen preceding his death, less than a month before the collection's premiere. His exploration of heavenly and fallen angels has often been interpreted as a reflection of the artist's inner emotional conflict prior to his death. But conflict and religion were themes throughout the designer's career, and he never shied from presenting life in all its contradictions, finding meaning in ambiguity. With *Angels and Demons*, McQueen "was looking at the art of the Dark Ages, but finding light and beauty in it."[1]

Marking a shift from the digitally engineered designs presented in the Spring/Summer 2010 collection *Plato's Atlantis* (see p. 161), *Angels and Demons* celebrated craftsmanship and traditional tailoring and dressmaking skills. Hand-cartridge-pleated satin or gilded featherwork, articulated as if growing from the body, exemplify McQueen's mastery of haute couture techniques.[2] Feathers and wings are printed on or sculpturally draped to align with the wearer's shoulder blades. A jacket (opposite and p. 25), evoking an abstracted angel, is cut from a jacquard textile rendered from golden wings and angelic figures, suggestive of Italian Renaissance marble (p. 24).

Masterfully uniting the high-tech with history, the collection's luxurious fabrics borrowed from Byzantine regalia or drew on art of the Northern Renaissance, including painter Hans Memling, who McQueen spoke of as his favorite artist. More than a decade earlier, in *It's a Jungle Out There* (Fall/Winter 1997–98), McQueen translated Dutch and Flemish Old Master works to print designs; here, photographs of the artworks that the designer was referencing were manipulated digitally, then engineered to fit pattern pieces or to become jacquard weaves. One dress (p. 27) composites Hieronymus Bosch's paintings *The Temptations of Saint Anthony*, *The Last Judgment*, and *The Garden of Earthly Delights*. Bosch's extraordinary (and often imitated) imagery can be traced to the work of Jan Mandijn (p. 26) and Pieter Bruegel the Elder (pp. 28–29). A successor to this tradition of fantastic, allegorical, and demonic subject matter, McQueen once noted: "I find beauty in the grotesque, like most artists. I have to force people to look at things."[3]

1 Sarah Burton, quoted in Sarah Mower, "Alexander McQueen Fall 2010 Ready-to-Wear," March 8, 2010 (www.vogue.com/fashion-shows/fall-2010-ready-to-wear/alexander-mcqueen).

2 The collection's gilded-feather jacket is thought to reference McQueen's premiere haute couture collection for Givenchy, *Search for the Golden Fleece* (Spring/Summer 1997).

3 McQueen, quoted in Susannah Frankel, "The Real McQueen," *Harper's Bazaar*, April 1, 2007.

24

Circle of Desiderio da Settignano, **Two Fragments with Two Seraphim**, c. 1460

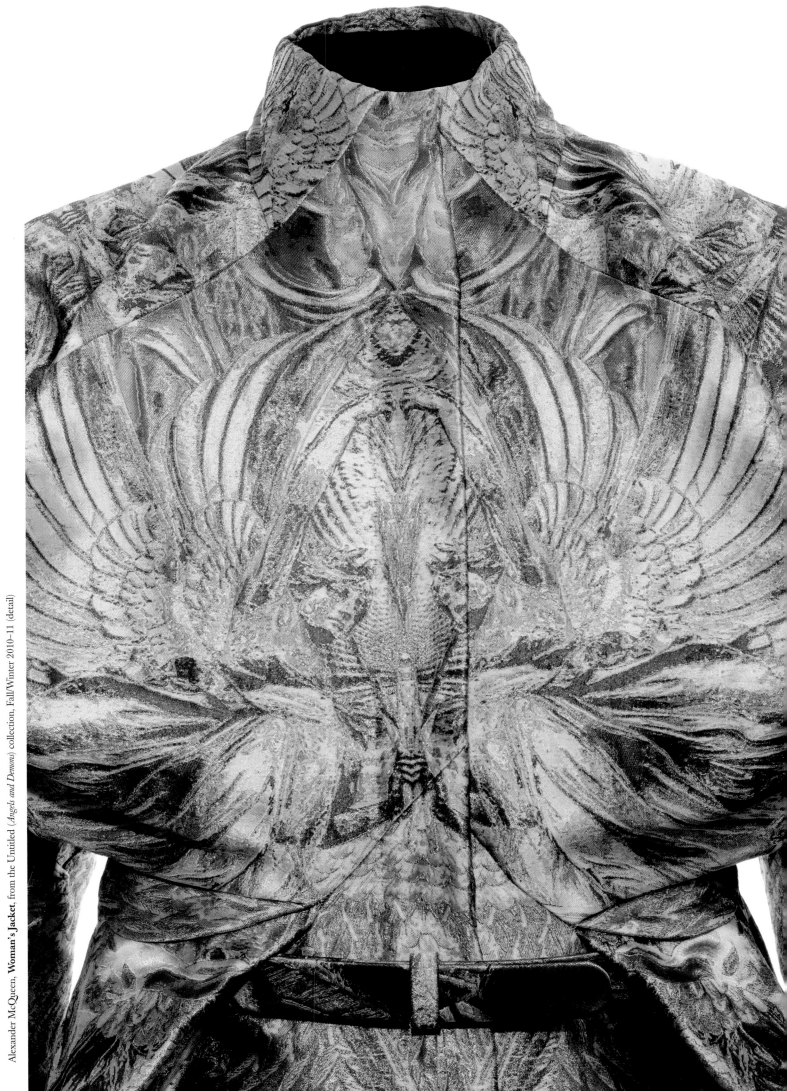

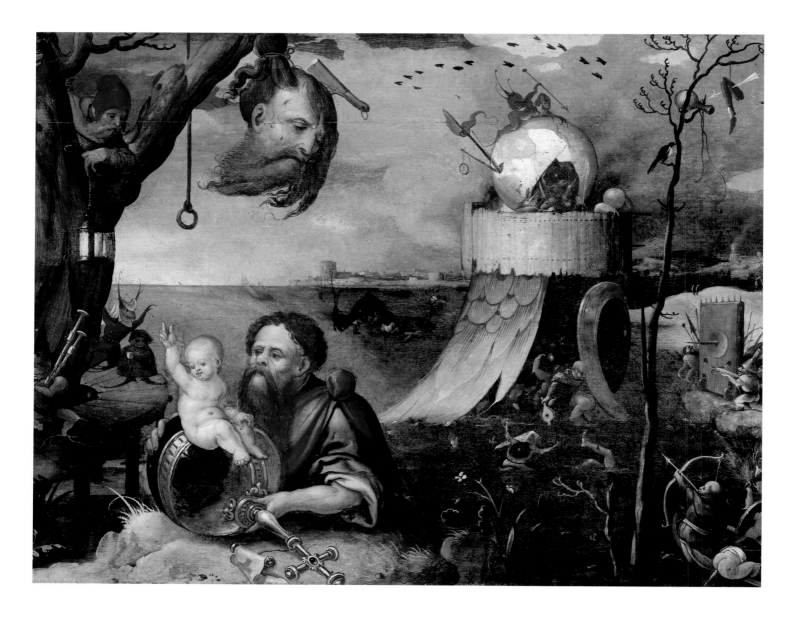

Jan Mandijn, *Saint Christopher and the Christ Child*, c. 1550

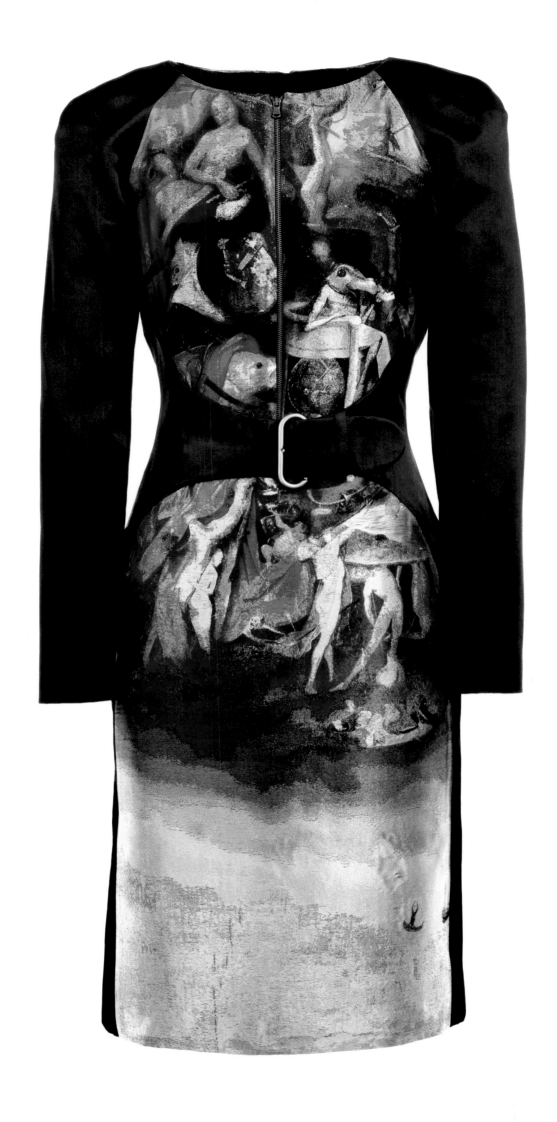

Alexander McQueen, **Woman's Dress**, from the Untitled (*Angels and Demons*) collection, Fall/Winter 2010–11

ENVY (INVIDIA)

Pieter Bruegel the Elder

1 Though Bosch and Bruegel are treated as the conceptual inventors of this print, like much sixteenth-century European printmaking, this was a collaborative affair. The artist Pieter van der Heyden was responsible for translating Bruegel's drawing and engraving it in the copperplate. Hieronymus Cock through his Antwerp-based firm Aux Quatre Vents (At the Sign of the Four Winds) published and distributed the print. Bruegel and Cock's names both appear in the inscription; van der Heyden's PAME monogram is also present at bottom center.

Dutch artist Hieronymus Bosch (1450–1516) was closely identified with his signature depictions of devils and demonic hybrids; his influence was undiminished decades after his death, and his style inspired a wave of imitators. Pieter Bruegel the Elder (c. 1525–1569) identified as this print's "inventor," or designer, regularly employed Boschian motifs and earned the moniker "the second Hieronymus Bosch" for his successful approximation of the master's fantastic and terrifying form of world building.[1]

Envy, with its companions *Anger, Gluttony, Sloth, Greed, Pride,* and *Lust,* is from a series illustrating the Seven Deadly Sins, which Bruegel designed between 1556 and 1558, followed by the Seven Virtues from 1559 to 1560. Unsurprisingly, Bruegel's fiendish Boschian vocabulary was better suited to depicting vices. Envy, called the "abominable monster" (*horrendum monstrum*) in the print's inscription, is treated with some hints of the sin's traditional iconography. The Latin word *Invidia* identifies the vice and the female allegorical figure at center (envy was typically associated with women). Dogs, envy's allegorical animal, fight over a bone in the center foreground. A peacock feather with its telltale eyespot, a possible reference to envy's "evil eye," sprouts from a bestial tree at center.

Nevertheless, Bruegel imparts his own distinct sensibility to this image. While Bosch's style functions symbolically, indicting the wickedness of mankind and striking fear in sinners by visualizing the fantastic tortures that might await, Bruegel alleviates some of these Boschian horrors by injecting playful visual details throughout the composition. For example, an anthropomorphic face appears on the building fronting the bridge, with windows for eyes and a door for a mouth. To the right, a pair of legs (one of them shoeless) kick helplessly while their owner is stuck head-first in a gourd-shaped structure, giving his limbs the appearance of stems.

ERIN SULLIVAN MAYNES
Assistant Curator, Robert Gore Rifkind Center for German Expressionist Studies

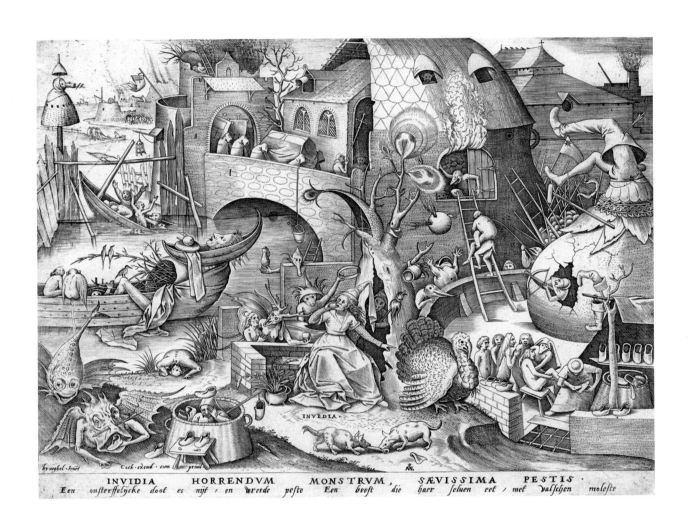

INVIDIA HORRENDVM MONSTRVM, SÆVISSIMA PESTIS·
Een onsterffelijcke doot es nijt / en wreede peste Een beest die haer seluen eet / met valschen moleste

Pieter van der Heyden, after Pieter Bruegel the Elder, *Envy (Invidia)*, 1558

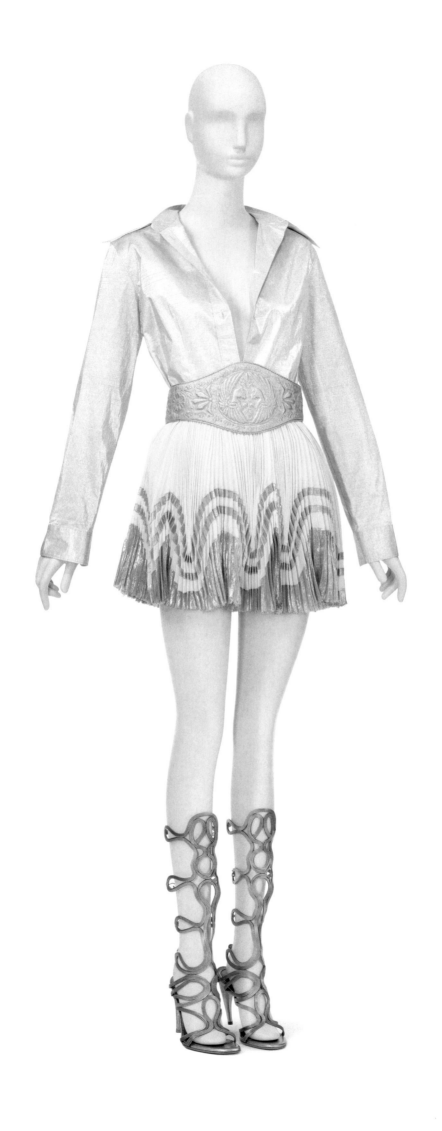

Alexander McQueen, **Woman's Ensemble (Blouse, Skirt, and Belt) and Shoes,** from the *Neptune* collection, Spring/Summer 2006

NEPTUNE SPRING/SUMMER 2006

Named after the Roman god of water, *Neptune* draws on imagery from classical antiquity to signify the strength of women. Neptune (and his Greek counterpart, Poseidon) was known to be both turbulent and seductive, like the sea; in the collection's runway presentation, McQueen married these concepts with models who were all 5′11″ or taller, walking to a soundtrack dominated by self-assured female musicians such as Siouxsie and the Banshees, Missy Elliot, Aretha Franklin, and Suzi Quatro. The resulting collection highlighted body-conscious looks derivative of ancient Greco-Roman men's and women's garments and iconography.

A diaphanously draped green dress (p. 33) recalls the sleeves and torso of a belted Ionian chiton, but made with a short, gathered skirt to expose the legs, rather than the traditional full length. Further revealing the body, a shaped sheer band of net along the waist and hips, encrusted with beads and crystals, resembles the lower portion of the molded cuirasse (lorica) worn by the Roman military to protect their torsos. A similar bodice is depicted in Jacques-Antoine Beaufort's *The Oath of Brutus* (p. 32), where it is worn under a red cloak (or chlamys).

Gladiators, who fought in arenas for entertainment, inspired a silver look (opposite) with a short, pleated skirt, accessorized with what runway show notes refer to as a "boxing belt" (p. 35). Quilted on the belt are confronting hippocamps (p. 34 bottom), Hellenistic seahorses who pulled Neptune's chariot and were symbols of both the sea and the netherworld. Artists revived this mythological creature during the Renaissance, as in an expertly constructed example (p. 34 top) depicting a golden Neptune riding a hippocamp made of a curling turban shell for the lower portion of the body, with the upper half finished in gilt.

Like the hippocamp, the phoenix—the mythical bird that cyclically regenerates, symbolizing ever-lasting life, renewal, and the sun—was often used in revival styles in combination with other neo-classical motifs. An early nineteenth-century blue-and-white textile (p. 38) draws upon this Greco-Roman imagery, as does McQueen's long white dress (p. 37) with confronting phoenixes beaded on a sheer back panel (p. 39).[1] The dress's columnar shape—a favorite silhouette for classical revival fashions—is also present in a fitted white dress (p. 36) with a crystal-encrusted center-front plastron (p. 20). The concept of women as columns, or pillars of strength, is evoked in Aimé-Jules Dalou's *Caryatids of the Four Continents* (pp. 40–41), which personify the Americas, Africa, Europe, and Asia.

Neptune was largely considered a letdown by fashion journalists; it was a wearable, commercial collection and it was presented on a traditional thirty-foot runway, both of which contrasted with McQueen's characteristically provocative designs and theatrical performances.[2] Although these sentiments continue to some degree today, the collection is nevertheless part of a long history of artists who were similarly drawn to and inspired by the imagery and aesthetics of Greek and Roman mythology.

1 Although show notes for the collection describe it as a phoenix, this motif has also been interpreted as a swan, a bird that likewise features prominently in classical mythology.

2 Sarah Mower, for example, wrote of this runway presentation that McQueen had "joined the regular ranks of ready-to-wear designers who line up their models like soldiers and march 'em on out with the collection." Sarah Mower, "Alexander McQueen Spring 2006 Ready-to-Wear," *Vogue*, October 6, 2005 (www.vogue.com/fashion-shows/spring-2006-ready-to-wear/alexander-mcqueen).

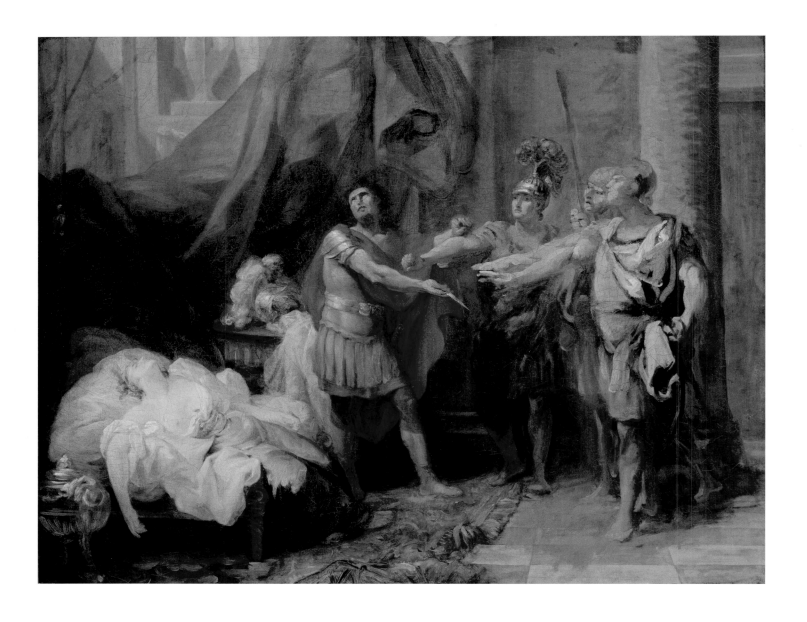

Jacques-Antoine Beaufort, *The Oath of Brutus*, c. 1771

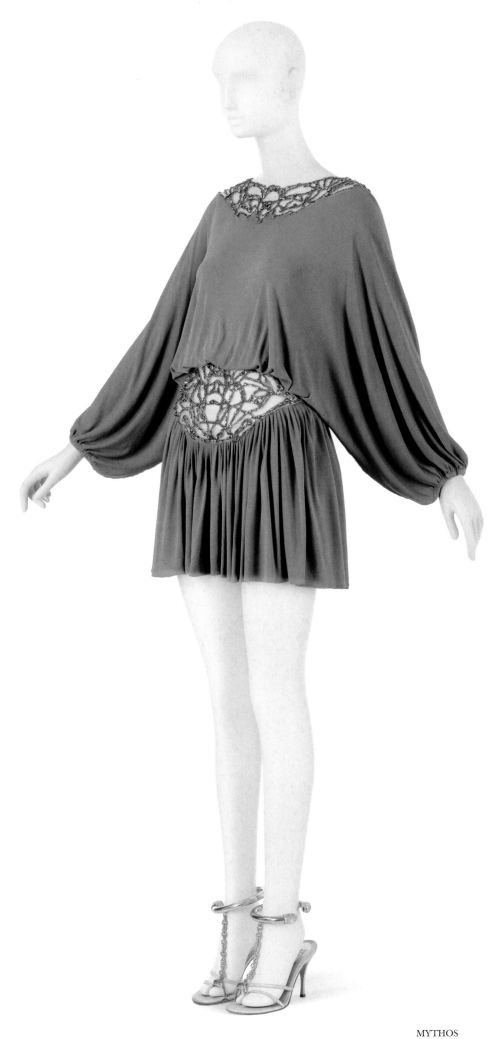

Alexander McQueen, **Woman's Dress and Shoes,** from the *Neptune* collection, Spring/Summer 2006

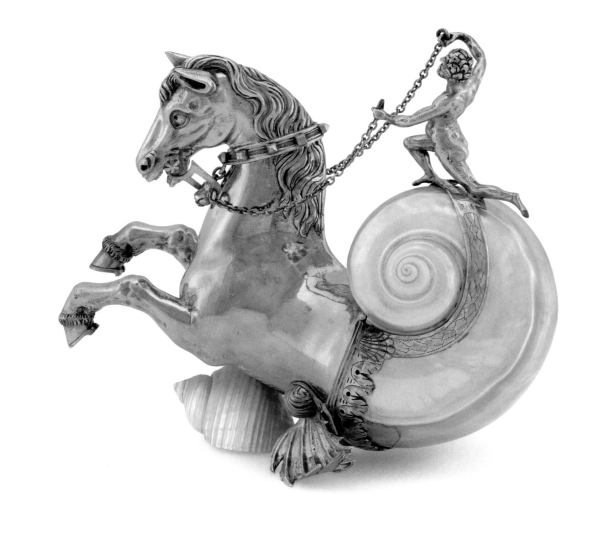

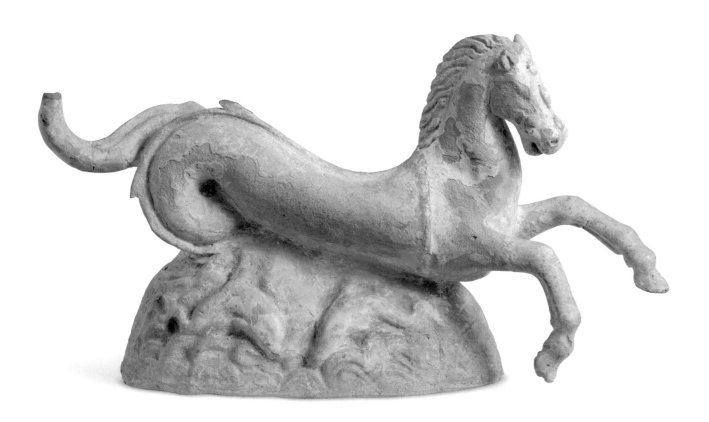

Top: **Seahorse**, Germany, c. 1590–1600; Bottom: **Hippocamp**, Italy, Sicily, 3rd century BC

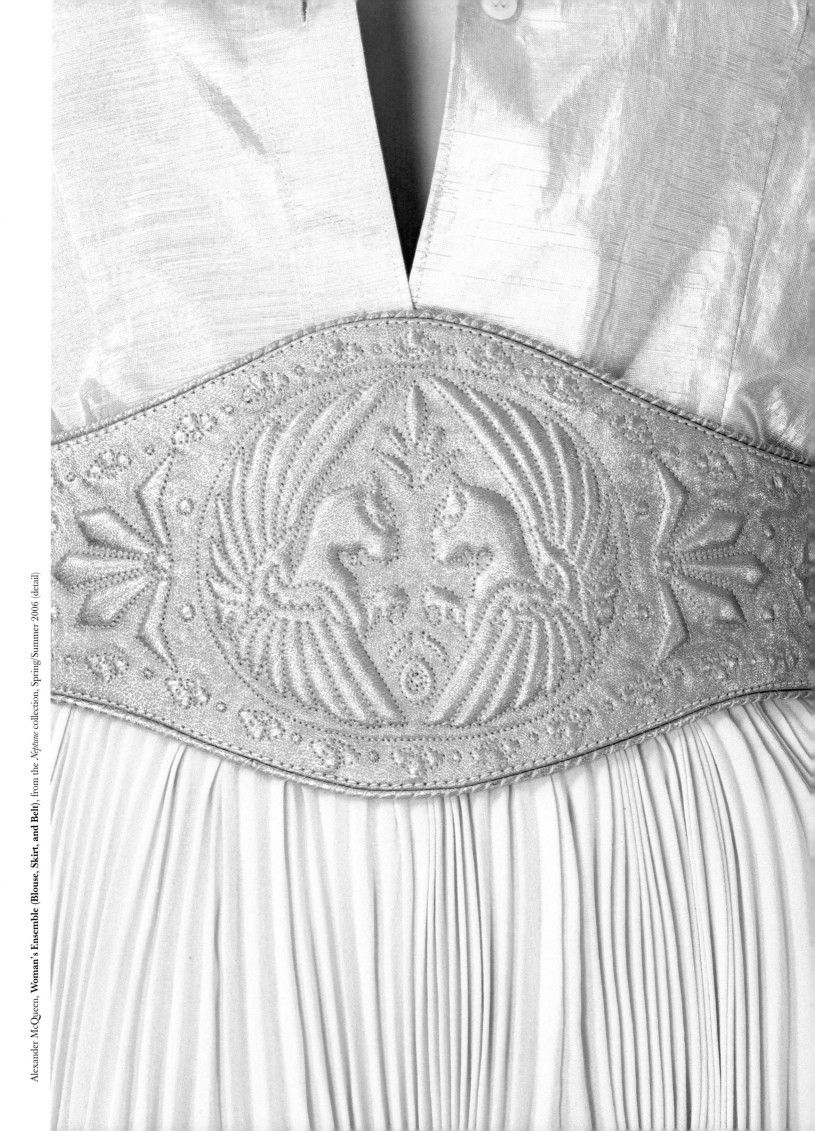

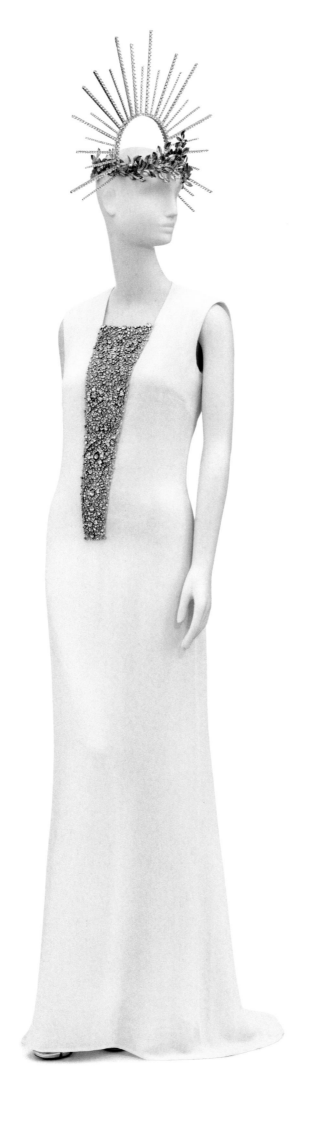

36

Alexander McQueen, **Woman's Dress**, from the *Neptune* collection, Spring/Summer 2006;
Michael Schmidt, **Headpiece** (Swarovski crystals and metal), 2021

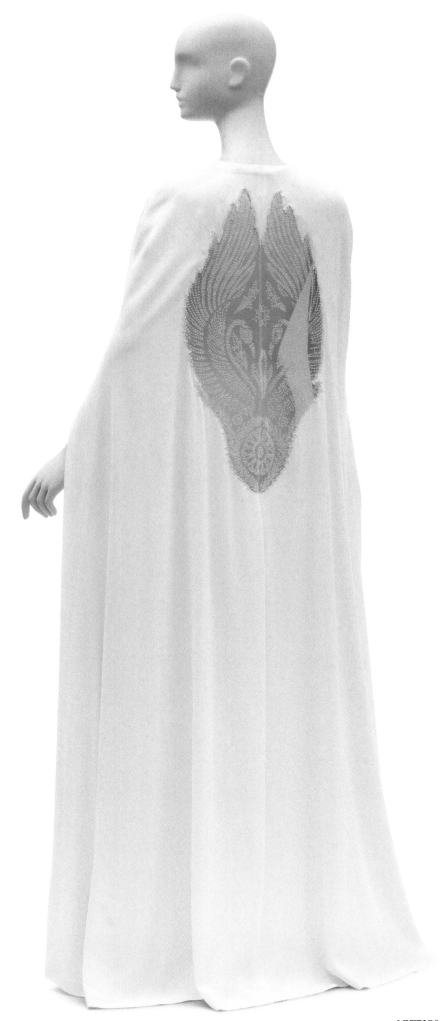

Alexander McQueen, **Woman's Dress**, from the *Neptune* collection, Spring/Summer 2006

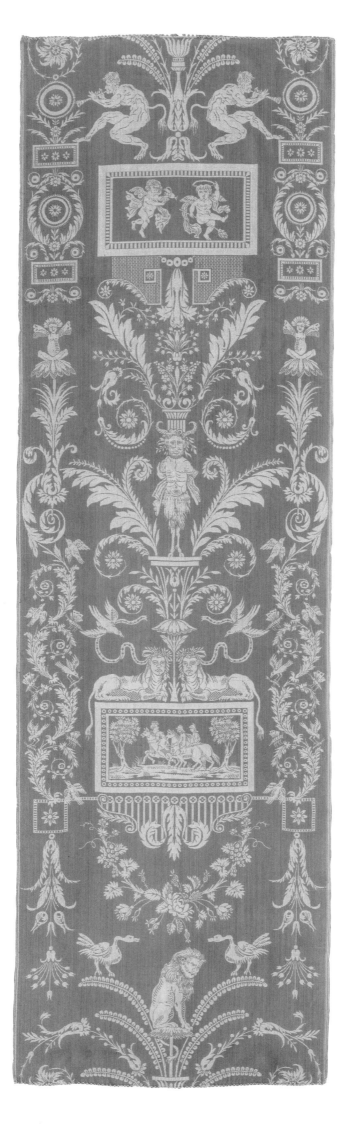

Textile Length, France, 1820–40

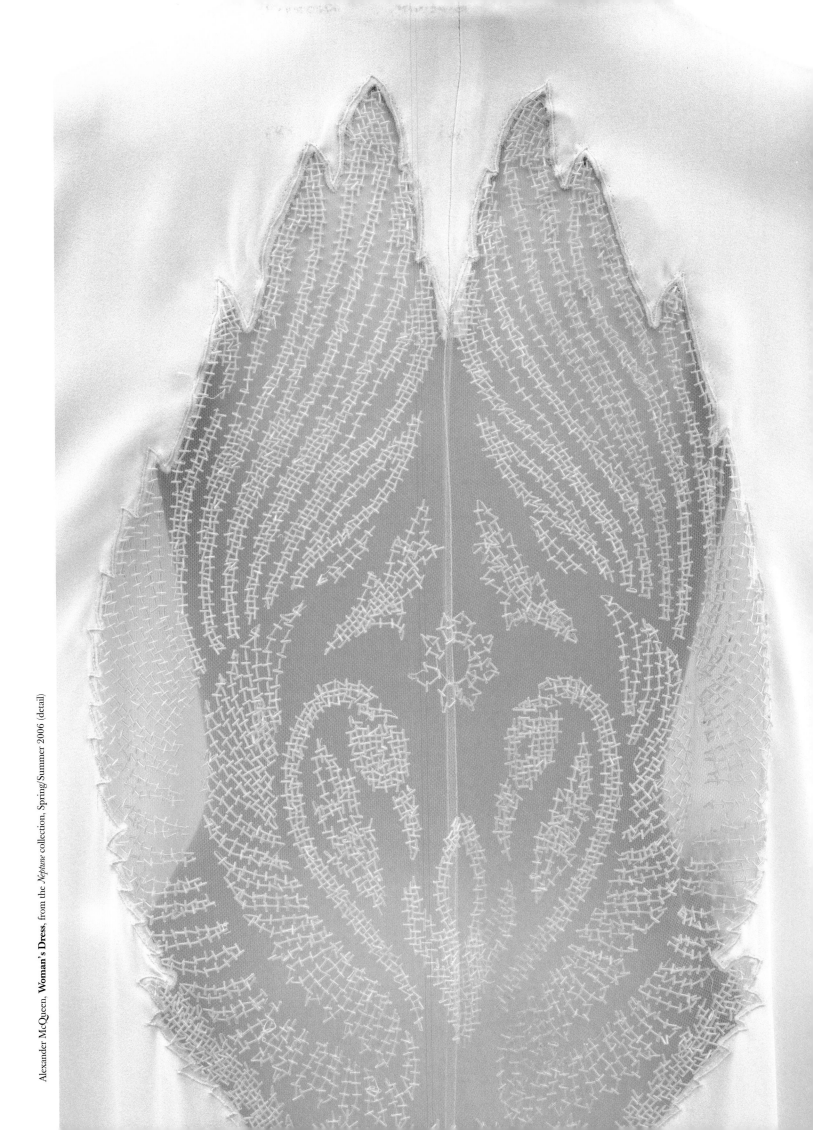

Alexander McQueen, **Woman's Dress**, from the *Neptune* collection, Spring/Summer 2006 (detail)

CARYATIDS OF THE FOUR CONTINENTS

Aimé-Jules Dalou

1 The sculptures were commissioned for the new mansion of chocolatier Émile-Justin Menier.

2 Based on Ripa's engravings, personifications of *Asia* held incense burners. Here, she appears to be holding a feather fly-whisk. Thanks to Bindu Gude, associate curator of South and Southeast Asian art at LACMA, for the information.

3 Nasheli Jimenez del Val, "Seeing Cannibals: European Colonial Discourses on the Latin American Other," PhD dissertation (Cardiff University, 2009).

4 Sculptural conventions in the nineteenth century wavered little in an effort to perpetuate a framework that served the French aristocratic elite.

Aimé-Jules Dalou's graceful female caryatids representing Europe, Asia, Africa, and America exemplify French art's roots in classical models, reiterate the influence of French colonial expansion, and reflect the supposed cultural superiority of the state. The caryatids, which served as architectural ornamentation on the facade of a luxurious Parisian *hôtel*,[1] were part of the *ville sculptée* (sculpted city), a reference to the Parisian explosion of public sculpture in the second half of the nineteenth century, during which Neoclassical models prevailed. Dalou's columnar figures, elements long associated with the height of ancient architecture, dutifully followed these traditions.

The regions of the globe were cemented for artists by the distribution of Cesare Ripa's illustrated *Iconologia* in 1603, an emblem book that established the allegorical female representations of the continents and served as a reference for the following 250 years. Ripa's personifications were based on classical models depicting the three known parts of the classical world, and drew on contemporary northern European *tableaux vivants* and imperial parades. In Dalou's representation of Europe, as in Ripa's engraving, *Europe* is crowned and holds a scepter and a book—attributes used in the West to signal progress, civilization, and superiority. *Asia* dons a lavish turban, and her luxurious textiles and jewelry signal both economic and political successes of her past, as well as what was regarded as her present-day excess and indolence.[2] With downcast eyes and exposed décolletage, *Africa* is depicted with an overflowing cornucopia, suggestive of fertility and abundance. *America*'s personification is historically located at the greatest physical distance from *Europe*, and is therefore understood to be furthest from its notions of success and civility. *America* is posed bare-breasted with a feather headdress, though without the references to cannibalism and savagery that so often accompanied such depictions at the time.[3]

Here, Europe's presumed supremacy remains at the forefront, even if it is manifested more subtly than in the tradition of such representations. Attributes of her personification belong to the world of the man-made rather than to that of nature, and in particular, her noble, distant gaze is a direct reference to the idealized portraits of great men of the past.[4] Dalou's amateur anthropological descriptions of the faces of each continent reinforce stereotypes perpetuated through French colonial expansion begun in the seventeenth century, and notably exemplify nineteenth-century representations of the exotic, natural female constructed for the European male gaze.

LEAH LEHMBECK
Curator and Department Head, Departments of European Painting & Sculpture and American Art

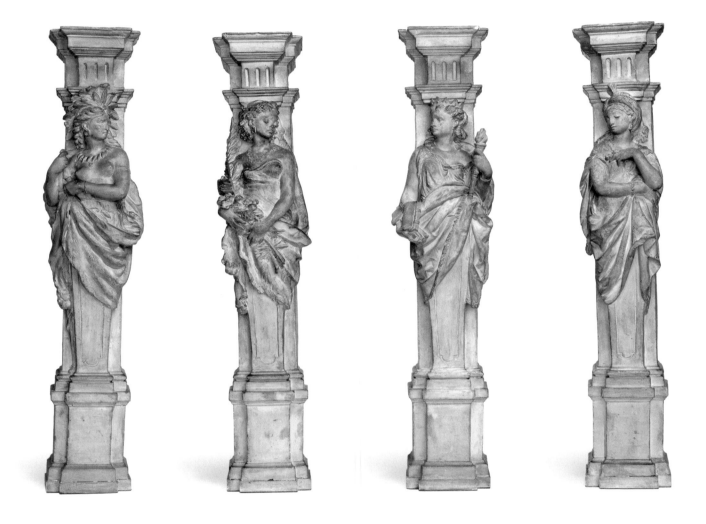

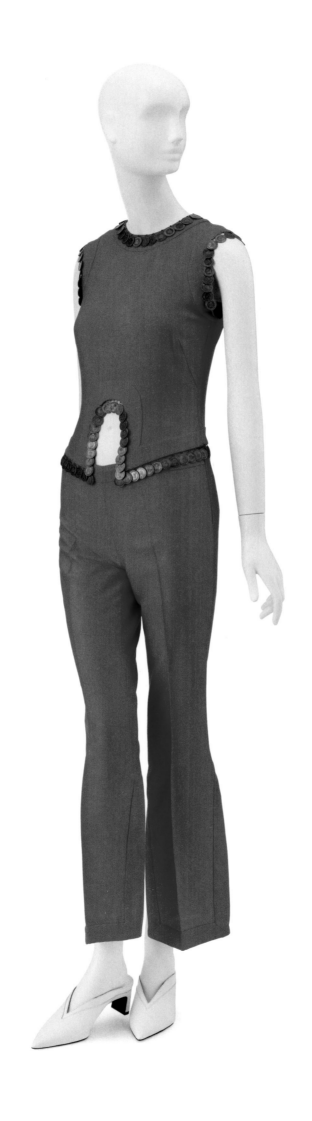

Alexander McQueen, **Woman's Ensemble (Top and Pants)**, from the *Eye* collection, Spring/Summer 2000

EYE SPRING/SUMMER 2000

McQueen's *Eye* collection was inspired by Turkish music overheard in a cab, as well as the Arab community in London, particularly its center in Edgware Road. As he explained, "I was on the way to the cinema one night and saw a bunch of women in *yashmaks*—those long black veils—and I was really interested in the face masks and eyes."[1] The collection combines body-conscious and bondage-style Western fashion with interpretations of cultural and religious dress traditionally associated with diverse regions including the former Ottoman Empire, contemporary Turkey, and the Persian Gulf. Controversial then and now, *Eye* nevertheless provides valuable insight to the paradox of commercialism and creativity that defined fashion at the turn of the millennium.

In interviews preceding the collection's debut, McQueen frequently discussed the commercial realities required to keep his imaginative label, of which he was at the time sole owner, a successful business. One proven tactic for McQueen was the draw of his over-the-top runway shows, and *Eye*—which was presented at New York Fashion Week, rather than London, where his shows were typically staged—delivered a provocative spectacle. Walking on a black water-covered runway representing the Middle Eastern oil industry, models wore various interpretations of Islamic head coverings, or body jewelry by Shaun Leane referencing Crusades-style armor. Looks inspired by wrestling and soccer gear (p. 49) and adorned with red crescent moons reminiscent of the Turkish national flag and national men's football uniform reinforce the idea that *Eye* depicts a competition or clash between East and West.

Certain details demonstrate the designer's appreciation of the cultures that inspired the collection. One look features a red-and-white striped skirt reminiscent of French-influenced silks fashionable in Turkey during the eighteenth century,[2] with a top constructed with partially detached sleeves that emulates a common feature of Turkish dress (p. 51). Another ensemble featuring coins with a faux-Arabic inscription of McQueen's name (p. 45) references calligraphy traditions (p. 48). These coin embellishments elicit comparison with so-called "money hats" traditionally worn by brides on their wedding day (p. 44); coins adorning the bare midriff (opposite and p. 45) evoke belly-dancing costumes worn in modern cabarets as captured by Youssef Nabil (pp. 46–47). Yet by conflating such disparate references into a single, sensational vision, *Eye* connects McQueen to the legacy of *turquerie*, the eighteenth-century Western European fashion for imitating the beauty of Turkish culture, but in such a way that idealized reality or conveyed fantasy (pp. 52–53).

Since its premiere, *Eye* has often been interpreted as making a statement regarding practices around concealing or revealing women's bodies. In this reading, McQueen's work is generally understood as liberating women from religious dress practices perceived in the West to be oppressive.[3] However, the collection's provocation was confined to the runway; outside the showpieces and heavy styling, many separates were commercially attractive and wearable. Rather, the September 1999 presentation was intended to drive greater global brand recognition—in October of the same year, the label's first store would open in London. Despite seeming to engage contemporary debates around the politics of veiling, *Eye* offers no clear commentary on women's agency.

1 McQueen, quoted in Rachel Marlowe, "Arabian Knight," *W* magazine, "W Beauty Flash" section, March 2000.

2 Thanks to Gwendolyn Collaço, assistant curator, Art of the Middle East, for this information. A similar red-and-white striped textile can be seen in Jean-Étienne Liotard's *Lady Montagu in Turkish Dress* (National Museum of Warsaw, Poland, 1756).

3 Preceding the events of September 11, 2001, McQueen was not alone in addressing such topics on the runway. Before the premiere of *Eye*, Hussein Chalayan contemplated the dress and social roles of Islamic women in his Spring/Summer 1998 collection, *Between*. Though subversive, the conceptual collection benefited from a cultural sensitivity—grounded in Chalayan's Turkish Cypriot roots—that is not reflected in *Eye*.

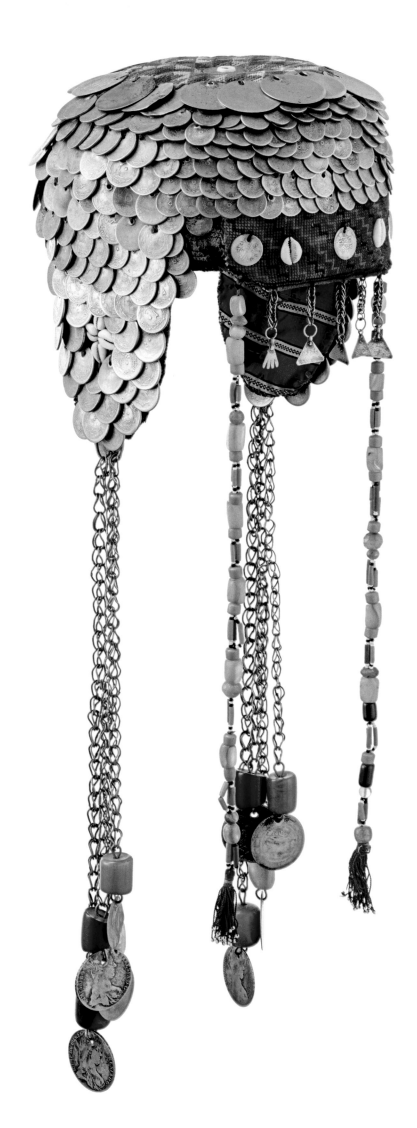

Woman's Wedding Headdress (*Wuqayat al-darahim*), or **"Money Hat,"** Palestine, Hebron, 20th century

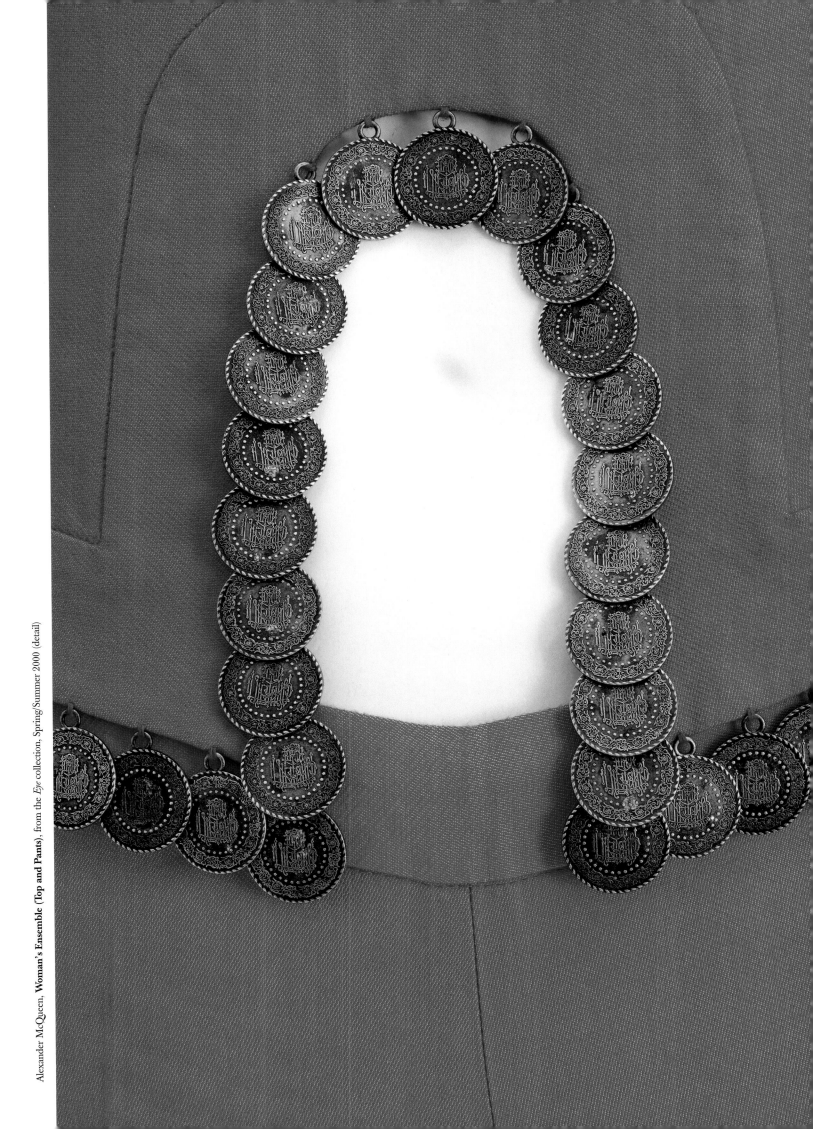

NATACHA ATLAS, CAIRO, 2000

Youssef Nabil

1 Nabil already admired Atlas's music, and particularly loved her rendition of one his favorite songs, "Mon amie la rose," which she transformed into something as much Eastern as Western. Youssef Nabil, conversation with the author, February 23, 2021.

2 See *Youssef Nabil: Once Upon A Dream* (Venice: Palazzo Grassi and Marsilio Editori, 2020), 66–67 and 102–3.

Known for her fusion of Arabic, North African, and Western electronic music, Natacha Atlas is shown here in one of several portraits by Youssef Nabil in which he creates an anachronistic effect by hand-painting the black-and-white print, harkening back to the glamorous photography of mid-twentieth-century Cairo. When Nabil met the singer, he knew instantly he wanted to photograph her in a kind of "Oriental tableau" as a traditional belly dancer, inspired by the classic Egyptian movies he watched obsessively on television while growing up in Cairo.[1] Although the pair's friendship developed following the photo shoot, Atlas already trusted his instincts and he quickly arranged for the costume and props.

Here, the figure is cropped just below the shoulders, like a film closeup, with the camera reverentially focusing on Atlas's tautly muscled torso and legs, her body perfectly suited to the subject, as the pop singer had performed as a belly dancer in London clubs earlier in her career. Supine, sensuous, and headless, she is ostensibly unaware of the viewer's eyes upon her. But Atlas is not the woman trapped by the "male gaze" implicit in the Western fantasy of the Middle East, which presupposes a state of feminine vulnerability and passivity. Rather, she is formidable, with the tense energy and toned physique required of a dancer, both aware and in control of her sexuality.

The belly dancer went on to become an important theme in Nabil's work in both still photography and video. His dancers are powerful, confident, and in charge, as in actress Salma Hayek's potent performance in the video *I Saved My Belly Dancer* (2015). They are also exquisite in their sinuous movements, as in *The Last Dance #I* and *#II* (2012), two series of still images that capture the swirl of the dancer's flowing gold costume.[2] In contrast to the Orientalist trope of the belly dancer, for Nabil she activates both a remembered and an imagined memory of Egypt, of home.

LINDA KOMAROFF
Curator and Department Head, Art of the Middle East

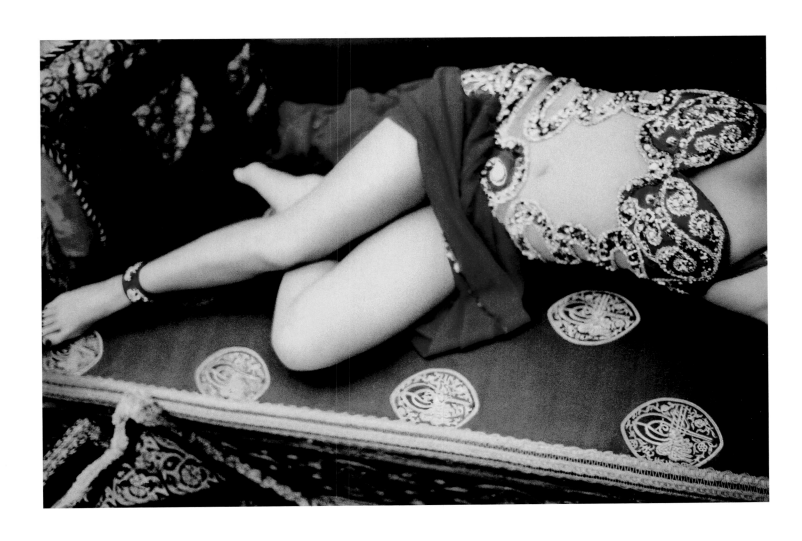

Youssef Nabil, *Natacha Atlas, Cairo*, 2000

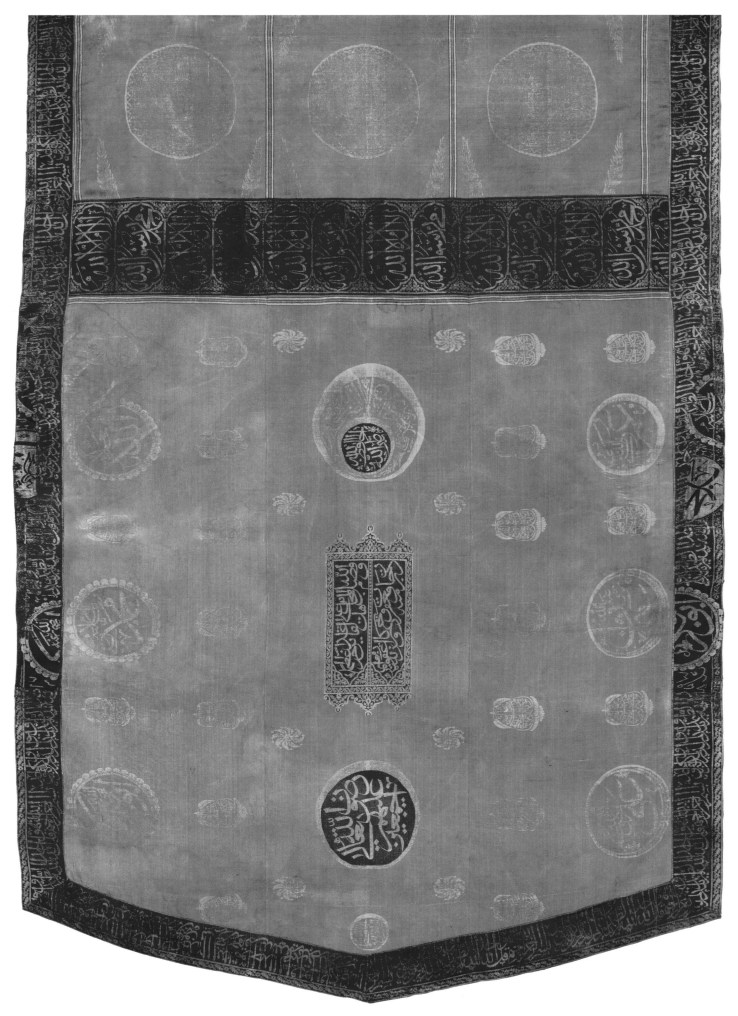

Banner (*Sanjak*), Turkey, probably Istanbul, early 19th century

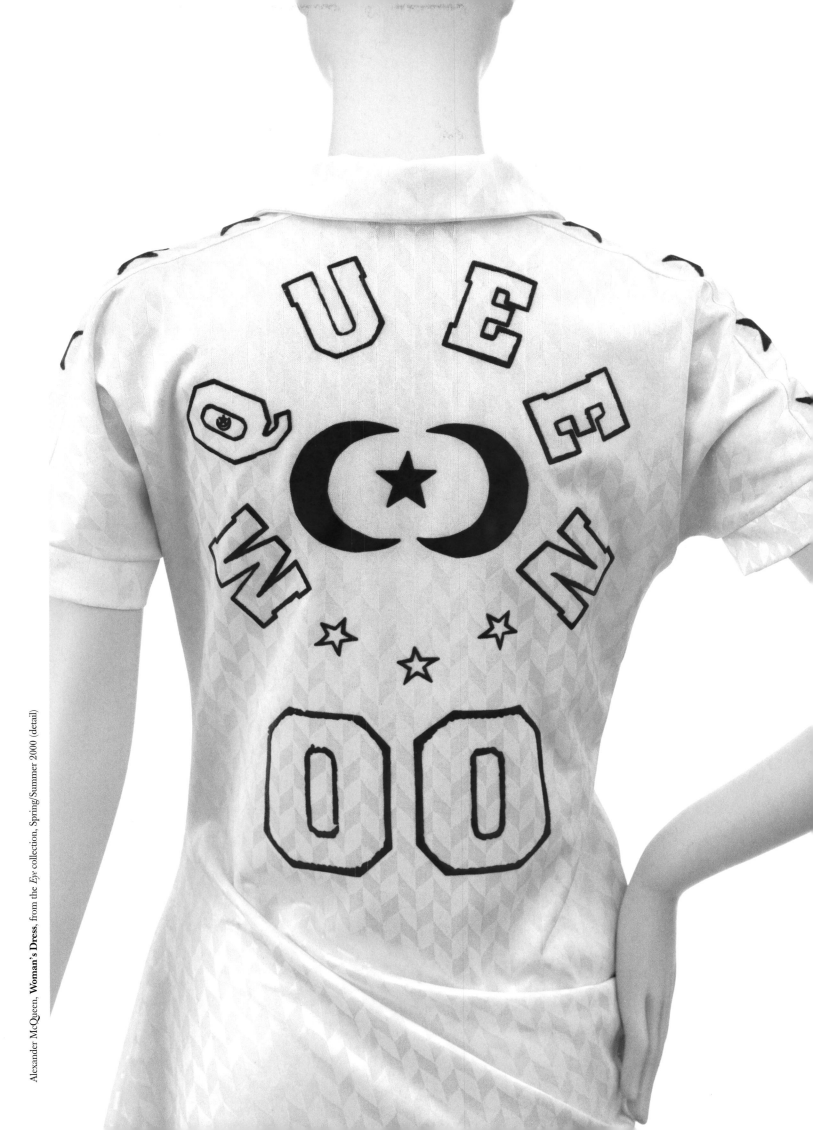

Alexander McQueen, **Woman's Dress**, from the *Eye* collection, Spring/Summer 2000 (detail)

50

Liturgical Veil (Cover for Chalice and Paten set), Turkey, 1550–1600; remade: Eastern or Southeastern Europe, after 1600

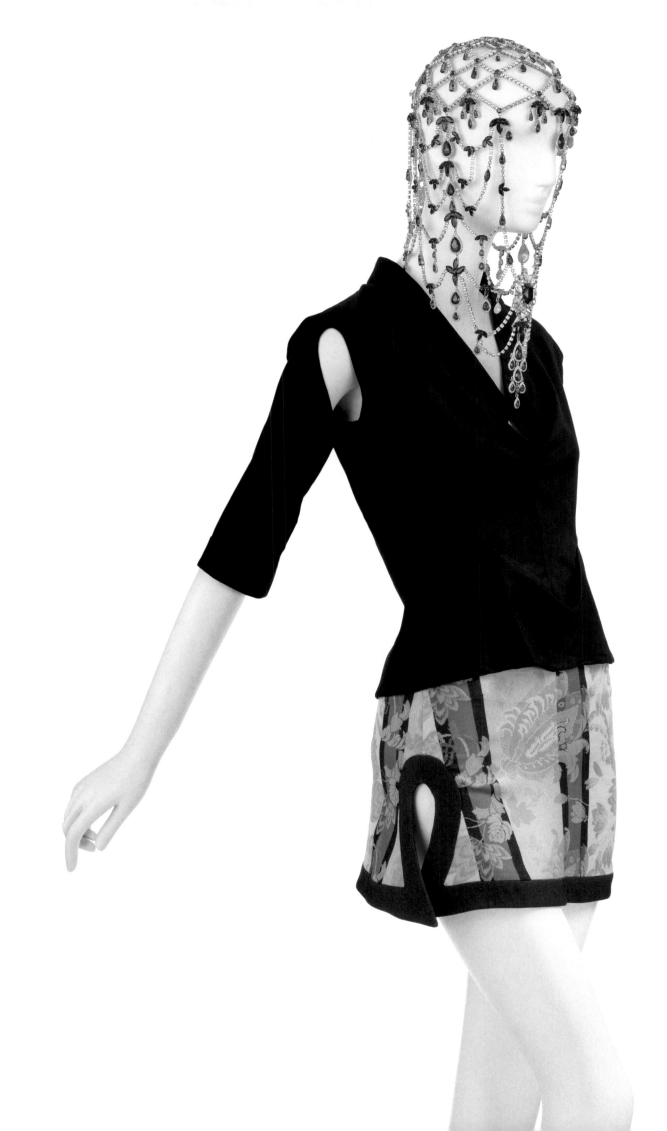

Alexander McQueen, **Woman's Ensemble (Top and Skirt)**, from the *Eye* collection, Spring/Summer 2000;
Michael Schmidt, **Headpiece** (Swarovski crystals and metal), 2021

PORTRAIT OF A LADY IN TURKISH FANCY DRESS

Jean-Baptiste Greuze

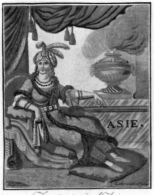

Frontispice de l'Asie.

French painter Jean-Baptiste Greuze (1725–1805) is best known for his genre scenes of moral tales and images of adolescent girls. An unusual work in his oeuvre, *Portrait of a Lady in Turkish Fancy Dress* depicts an unidentified sitter posed in an opulent ensemble, which its contemporaneous audience would recognize as *à la sultane* ("the sultana's style"), referring to imperial consorts in the harem of an Ottoman sultan. Turkish-inspired sartorial elements include a fur-trimmed half-sleeved robe resembling the *kurdee*, asymmetrically arranged skirt, waist sash, bejeweled belt, and feather-adorned turban. This costume portrait typifies the *turquerie* taste that penetrated many aspects of European culture during the eighteenth century, including art, architecture, interior decoration, literature, theater, and fashion.

Diplomatic and trade relationships between Europe and the Ottoman Empire dated back to the fourteenth century. From the late seventeenth century, increasing exchanges between the two regions, as well as frequent travel by ambassadors, merchants, and artists, all led to a development of first-hand knowledge in Europe of Ottoman life and costume. Two widely circulated materials provided the key sources for Turkish costumes in eighteenth-century Europe: the memoir of Lady Mary Wortley Montagu, an English noblewoman who accompanied her ambassador husband to Constantinople from 1716 to 1718; and Flemish-French artist Jean Baptiste Vanmour's 1714 collection of costume engravings, *Recueil de cent estampes représentant différentes nations du Levant* (Collection of One Hundred Prints Representing Different Countries of Levant). Additionally, in 1721 and 1742, the two Ottoman embassies to France significantly contributed to the *turquerie* craze. Details of the foreign ambassadors' visits to the French court—including their gifts, activities, and costumes—were much reported, providing the public with imagery that coupled exotic imagination with serious knowledge of the Ottoman culture.

Sultana's image abounded in masquerade balls, fancy dress portraits, theatre and opera, and illustrations of people from four continents (pp. 40–41). For instance, the 1797 album *Costumes de différents pays* (Costumes of Different Countries) composed by French diplomat and illustrator Jacques Grasset de Saint-Sauveur, features a sultana in a fur-trimmed gown and headgear (above) similar to those in *Portrait of a Lady in Turkish Fancy Dress*. Like many stage costumes for the role of sultana, the ensemble in Greuze's painting is a free interpretation of Ottoman dress filtered through French fashion tastes and ideal body type: the structured silhouette clearly suggests a stay beneath the bodice and likely a small hoop under the skirt, while the lace *engageantes* (detachable sleeve-ruffles) and neckline trim, as well as the embroidered garlands on the skirt, all conform to European style.

MEI MEI RADO
Associate Curator, Department of Costume and Textiles

Jacques Grasset de Saint-Sauveur, **Fashion Plate, "Frontispice de l'Asie,"** from *Costumes de différents pays,* c. 1797. Hand-tinted engraving on paper. Los Angeles County Museum of Art, Costume Council Fund (M.83.190.171)

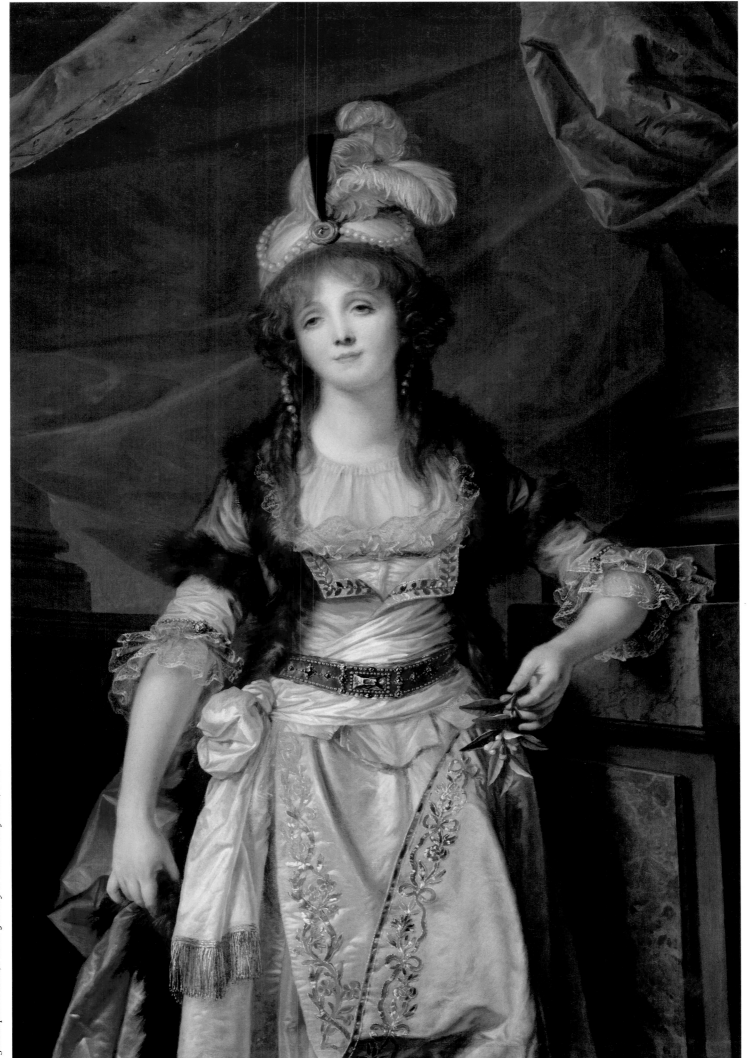

Jean-Baptiste Greuze, *Portrait of a Lady in Turkish Fancy Dress*, c. 1790

FASHIONED NARRATIVES

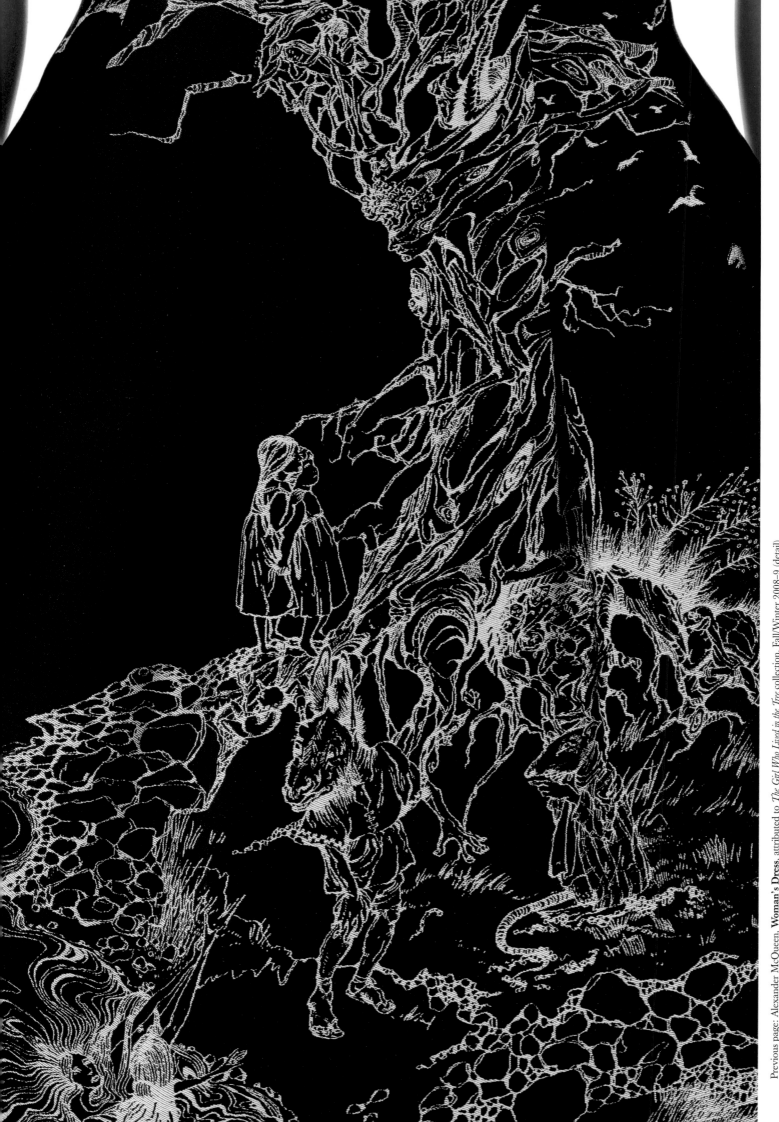

FASHIONED NARRATIVES

FASHIONED NARRATIVES considers McQueen's penchant for worldbuilding, highlighting collections that tell original stories or reimagine past events. Rooted in the designer's personal history and romanticized historical references, these narrative collections explore themes of tradition, discovery, exchange, power, violence, and metamorphosis.

Inspired by an ancient elm on McQueen's East Sussex property and the designer's travels to India, *The Girl Who Lived in the Tree* envisions a fairytale about a princess who descends from the tree's branches to earth. Drawing on nineteenth- and mid-twentieth-century English fashion and India's plentiful textile traditions, the Fall/Winter 2008–9 collection traces rhythms of power in the rise and fall of the British Empire. The story of the girl's explorations and coronation, spanning the lives of Queen Victoria and Queen Elizabeth II, parallels histories of imperialism and global trade.

1 McQueen, interviewed by Nick Knight for SHOWStudio's *In Fashion* series, June 1, 2009 (showstudio.com/projects/in_fashion/alexander_mcqueen).

"I THINK

STORYTELLING IS WHAT

WE LOVED AS KIDS,

AND THIS IS WHAT

[A SHOW] IS ABOUT."[1]

Scanners portrays a migration across the Siberian tundra, south through Tibet, and finally eastward to Japan. McQueen's designs, borrowed from the textile and dress traditions of these locations, guide viewers through his narrative's geographic settings. In doing so, the Fall/Winter 2003–4 collection's fictional journey mirrors this vast region's rich history of cultural exchange, and today provides an opportunity to consider how McQueen's personal beliefs may have influenced themes and aesthetics of his collections.

With *The Widows of Culloden*, McQueen mined his Scottish ancestry and condemned the history of British colonialism and violence in Scotland. Centered on the 1746 Battle of Culloden, the Fall/Winter 2006–7 collection draws on the natural splendor and traditional costume of Scotland while evoking the human tragedy of political conflict. A year later, the Fall/Winter 2007–8 collection, *In Memory of Elizabeth How, Salem, 1692*, further traced McQueen's familial background, and British imperialism, to colonial Massachusetts. The collection pays tribute to distant ancestors executed in the Salem witch trials and, more broadly, addresses cycles of persecution.

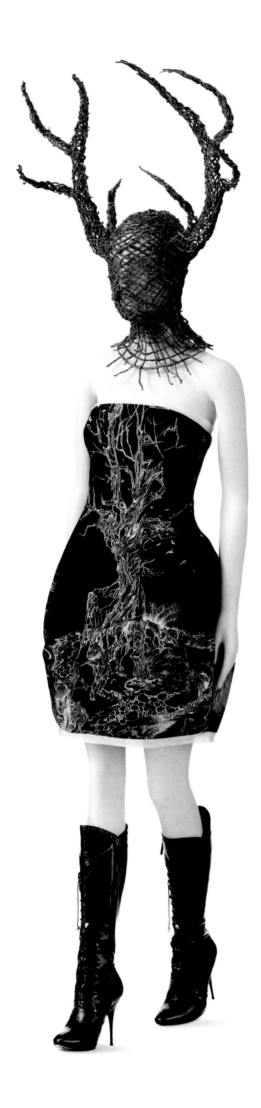

Alexander McQueen, **Woman's Dress and Boots**, from *The Girl Who Lived in the Tree* collection, Fall/Winter 2008–9; Michael Schmidt, **Headpiece** (bast-fiber twine and metal wire, woven), 2020

THE GIRL WHO LIVED IN THE TREE

FALL/WINTER 2008–9

A fantastical white line drawing of a twisting tree with creatures emerging from and around it decorates a black strapless dress (opposite and p. 56). The digitally woven scene derives from a series of illustrations by Arthur Rackham for a 1908 publication of Shakespeare's *A Midsummer Night's Dream*,[1] and served as the transportive central image to the aptly titled *The Girl Who Lived in the Tree*. An expansive elm on the property of McQueen's seventeenth-century East Sussex home served as a source of inspiration for the collection blending British and Indian history with punk and romanticism.[2] References to British royalty include historical silhouettes and ornamentation associated with Queen Victoria, the Duke of Wellington, and Queen Elizabeth II. Also referenced are the opulent textiles, jewelry, and motifs of Indian court dress, details that were incorporated on the runway as the "feral creature" of the girl, as McQueen described her, transformed into a queen.

Black is used in *The Girl Who Lived in the Tree* to represent the principal character in darkness. A dress with a high empire waist (p. 61) alludes to the prevailing silhouette of the Regency period, when Victoria was a child; acorns, a symbol of stability common in British decorative arts, dangle from the torso. A silk gauze dress (p. 60) dating to the 1820s demonstrates black as a fashionable hue, and features a woven pattern of anchors and crowns celebrating the might of Britain's navy—the largest in the world in the eighteenth and nineteenth centuries.

Through sea trade, fine cottons were exported from India to European markets, as seen in a white, silver-embroidered dress, also from the 1820s (pp. 64–65). Such luxury fabrics were equally prized domestically, such as in the man's cotton waist sash (*patka*) (p. 62), which would have been tied to display its resplendent gold embroidery and iridescent beetle-wing (elytra) sequins. This tradition of metallic embroidery is echoed in a white McQueen dress (pp. 54–55, 63), where appliqués of gold-embroidered birds and branches cascade from a fitted bodice onto a tulle skirt, a look that symbolizes the girl emerging from the tree. The silhouette recalls mid-twentieth century fashions, around the time when Elizabeth II began her reign—five years after India achieved its independence.

This reference to a queen whose colonial reach no longer included the Indian subcontinent was purposefully optimistic. After the death of his long-time supporter and muse, Isabella Blow, in May 2007, McQueen spent time in India to reflect and to heal; the result was a collection where references to India symbolized hope and a girl who had finally emerged from the darkness into the light. He reflected that "Out of the negativity had to come positivity."[3]

1 John Matheson, conversation with the curators, March 3, 2021. Notably, *A Midsummer Night's Dream* is the source for the quote "Love looks not with the eyes, but with the mind," which was tattooed on McQueen's arm and similarly etched into the artist's memorial headstone on the Scottish Isle of Skye.

2 Sarah Mower, "Alexander McQueen Fall 2008 Ready-to-Wear." *Vogue Runway*, February 2008 (www. vogue.com/fashion-shows/fall-2008-ready-to-wear/alexander-mcqueen).

3 McQueen, quoted in Mark Holgate, "Noble Endeavor," *Vogue*, September 2008.

Woman's Dress and Shoes, England, 1820s

Alexander McQueen, **Woman's Dress and Boots,** from *The Girl Who Lived in the Tree* collection, Fall/Winter 2008–9

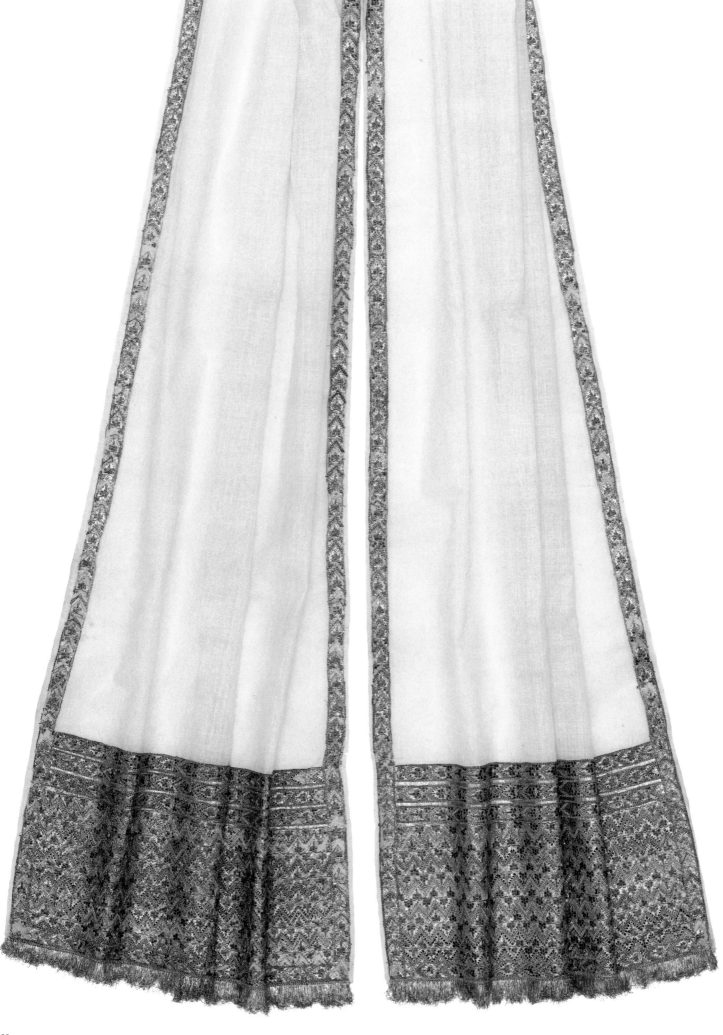

Man's Waist Sash (*Patka*), India, probably Lucknow, early 19th century (detail)

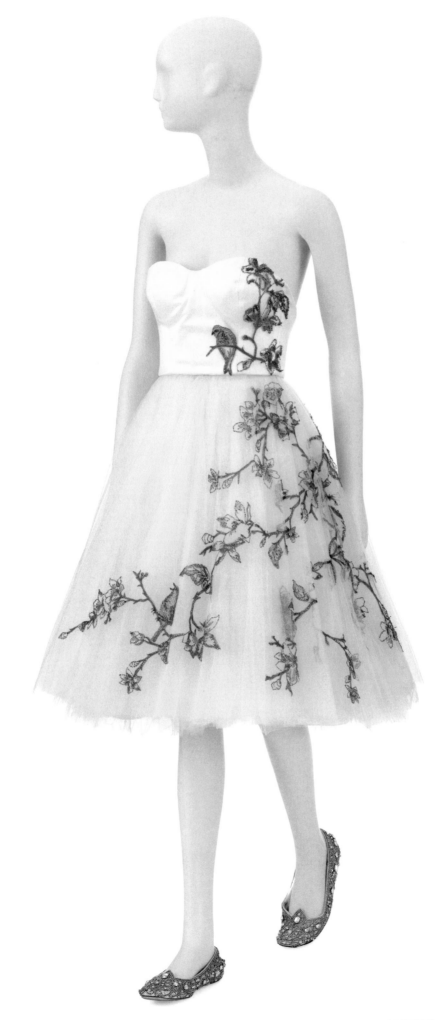

Alexander McQueen, **Woman's Dress**, attributed to *The Girl Who Lived in the Tree* collection, Fall/Winter 2008–9; **Woman's Shoes**, from *The Girl Who Lived in the Tree* collection, Fall/Winter 2008–9

WOMAN'S DRESS

1 After the Company Raj era was ended by the Indian Rebellion of 1857, the British government forcibly took control of the region in 1858, thereby expanding the British Empire. This period, known as the British Raj, lasted until 1947.

2 Pinecones are found both in the mountainous regions of Northern India as well as in the British Isles. The gold-gilt pinecone tassel is similar to another extant ornament that adorns an early nineteenth-century reticule (drawstring purse) from The National Trust, Great Britain. See Althea Mackenzie, *Buttons and Trimmings* (London: National Trust, 2004), 90–91.

3 Hussars were cavalry men that originated in Central Europe in the fifteenth and sixteenth centuries; the dress of these horsemen spread throughout European armies through the nineteenth century.

A LADY of HINDOOSTAN.

By the 1820s, when this English woman's evening gown was at the height of fashion, the strength of the British East Indian Company had also reached its peak. During this period of Company rule in India, also known as Company Raj (1757–1858),[1] the aesthetics and commodities exported from the subcontinent that so fascinated England (left) had profound effects on the luxury dress of women throughout the Western world.

The finely woven white cotton plain weave of the dress was a major Indian export to Europe beginning in the late eighteenth century as neoclassical ideals and aesthetics took hold. Here, a scrolling vine-and-leaf motif embroidered in flattened silver thread covers the semi-transparent muslin, a delicate technique perfected in India. The curvilinear forms recall similar foliate motifs prevalent in Mughal Indian architecture, decorative arts, and block-printed fabrics.

While the textile is Indian in make, the dress was constructed in England in the prevailing mode, characterized by a fitted torso with low décolletage, high waistline, and puff sleeves equal in width from side-to-side to widening skirt hems. To further accentuate the heightened fashionability of this new silhouette that defined the Romantic era, which evolved from the columnar silhouettes of the Empire period, trimmings were incorporated at the sleeves and lower skirts to highlight their shape. Pleated pink bands festoon these areas, with the sleeves additionally trimmed with golden tassels and pinecones.[2] Horizontal rows of gold passementerie adorn the breast, referencing military dress. Braided trim or frogging closures in this configuration were a distinctive feature of Hussar jackets,[3] which were adopted into both fashionable men's and women's dress, though were less often found in such resplendent formal wear. The high style of this gown, commissioned and worn by a wealthy English woman, was an early nineteenth-century bellwether of the growing exchange, trade, and imperial pursuits of the British Empire in India throughout the century.

CLARISSA M. ESGUERRA
Associate Curator, Department of Costume and Textiles

Fashion Plate, "A Lady of Hindoostan," England, early 19th century

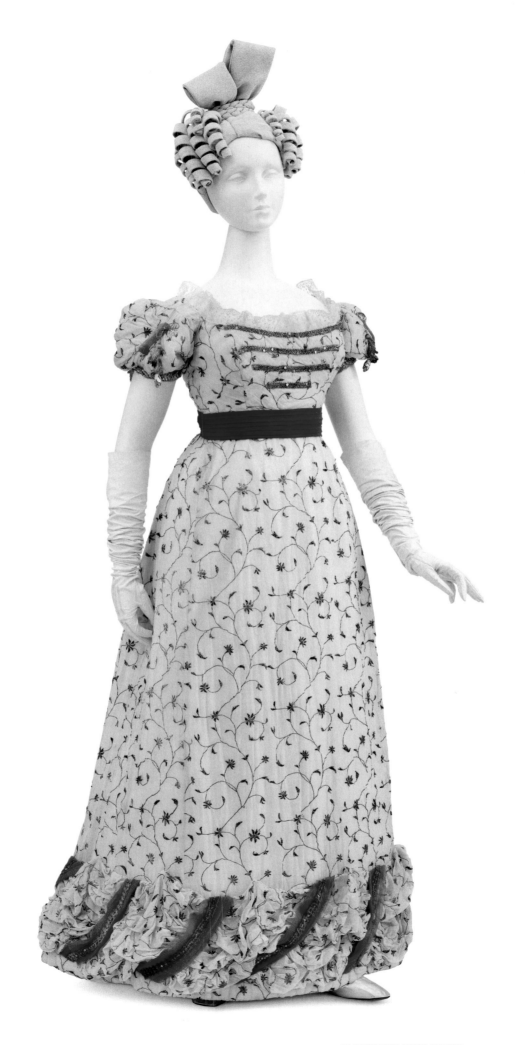

Alexander McQueen, **Woman's Tops and Skirt**, from the *Scanners* collection, Fall/Winter 2003–4; **Woman's Boots**, from the *In Memory of Elizabeth Hau, Salem, 1692* collection, Fall/Winter 2007–8; Michael Schmidt, **Headpiece** (gold leaf and papier-mâché), 2021

SCANNERS FALL/WINTER 2003–4

Scanners conveys a journey across Siberia and Tibet, destined for Japan, as illustrated by garment materials, construction, and decorative motifs the designer borrowed from these regions. Consequently, certain fabrications reflect Eurasian textile trade that occurred via routes such as the Silk Road. Although McQueen was not a textile scholar, *Scanners* affords a unique lens through which to consider notable cultural exchanges, such as the proliferation of Buddhism, ingrained into textile history.

As *Scanners* embarks from Siberia—its frigid tundra recreated in the runway show by snow and a wind tunnel—ensembles display a Russian influence. Russia's colonization of Siberia to expand its global export trade in fur, known as "soft gold," is indicated in such pieces as a metallic-trimmed fox-and-rabbit fur coat (p. 69), which combines soft and hard luxury in a manner similar to silk textiles embellished with gold (p. 68) to suit Russian tastes.

Transitioning south to Tibet sees the introduction of checkerboard textiles (opposite and p. 121), as well as a woven silk pattern of interlocking octagons and floral medallions imported to Tibet from China. In Tibet, the pattern is identified by the term for brocade design, *kati rimo*; the design is also seen (like other motifs derived from Chinese textiles) in Tibetan material culture such as knotted rugs or painted wooden trunks (p. 70).

Acquired through trade or tribute, Chinese silks were frequently repurposed in Tibet as decorations for Buddhist temples. In this way, *kati rimo*—though inherently secular—came to be incorporated into Tibetan Buddhist art. McQueen's "croquet" style dress (p. 71) updates the typically polychrome pattern in black and silver metallic threads, yet closely approximates a pair of temple hangings (p. 72) remade of Chinese silk for Tibetan Buddhist use.

Completing its west-to-east pilgrimage, *Scanners* emerges from its initial icy setting into Japan, a country long associated with the rising sun. A kimono-inspired jacket (p. 73) displays another of McQueen's interpretations of *kati rimo*, here woven as one of multiple discrete patterns within a single textile. In Japan, the design of interlocking octagons and floral medallions introduced via imported Chinese silks is called *shokkō*. As Buddhism was embraced, *shokkō* and its variations were also incorporated into Japanese Buddhist practice. The jacket's trompe l'oeil piecing suggests Buddhist patchworking methods observed in Japanese priest's mantles, or *kesa* (pp. 74–75).

Notably, the *Scanners* journey seemingly bypasses China, and its integral role in this distinctive textile design. As McQueen selected sartorial symbols to tie his narrative together, the aesthetic connection he made between Tibet and Japan may have been informed by both his career-spanning affinity for Japanese dress and his personal adoption of Buddhism.[1] In this way, the pastiche of textile traditions in *Scanners* demonstrates how cultural appropriation in fashion can be at once specific and meaningful, and incomplete or decorative, while also providing a novel opportunity to consider the international dissemination of a documented textile pattern.

1 In 2008, McQueen stated that he had been Buddhist for seven years. He spoke of Buddhism in multiple interviews, including the significance of a trip to India (where the religion originated), which inspired *The Girl Who Lived in the Tree*. The London Buddhist Centre was among the beneficiaries of McQueen's estate upon the designer's death.

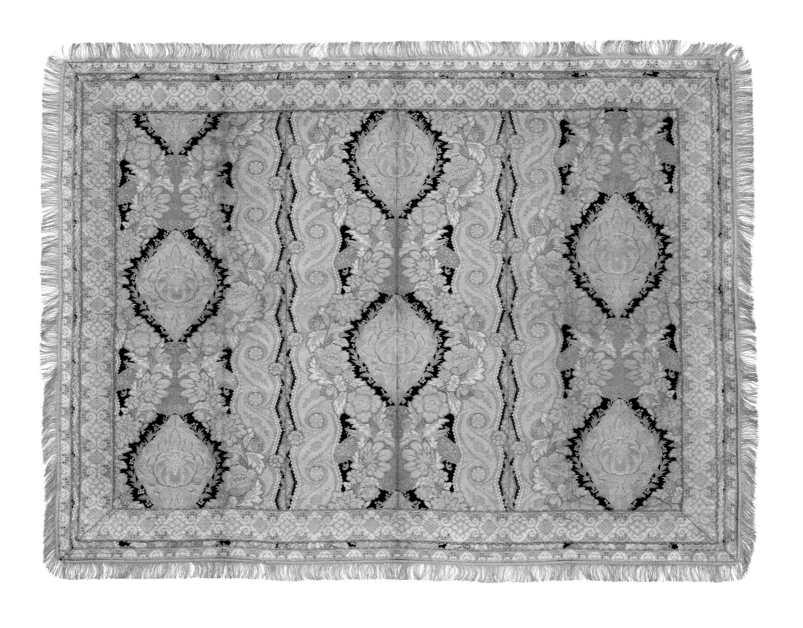

Textile Cover, probably Russia, early 18th century

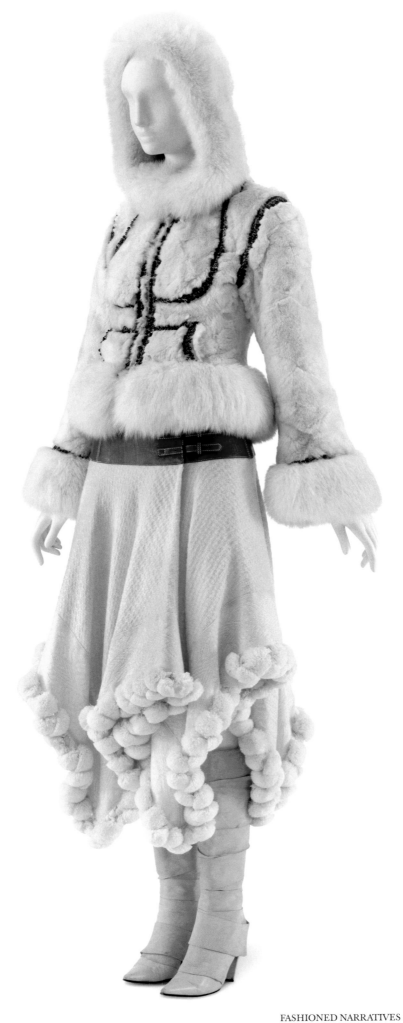

Alexander McQueen, **Woman's Ensemble (Coat and Skirt) and Boots**, from the *Scanners* collection, Fall/Winter 2003–4

Trunk with Brocade Design (*Kati Rimo*), Tibet, 17th–18th century

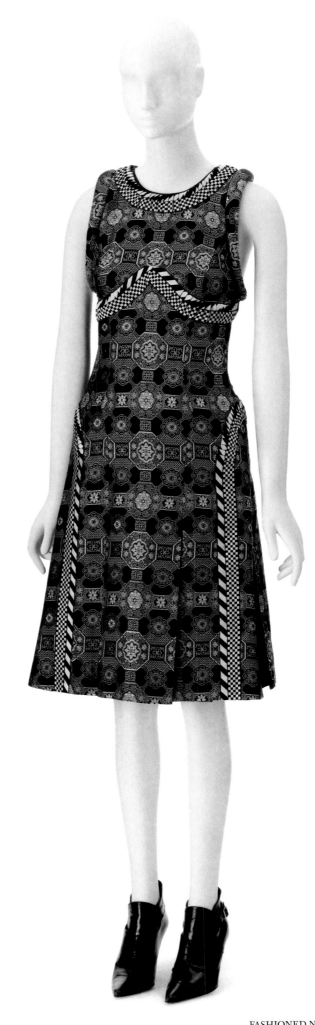

Alexander McQueen, **Woman's Dress**, from the *Scanners* collection, Fall/Winter 2003–4; **Woman's Boots**, attributed to the *Supercalifragilisticexpialidocious* collection, Fall/Winter 2002–3

Pair of Brocade Design (*Kati Rimo*) Temple Hangings, Tibet, 17th century

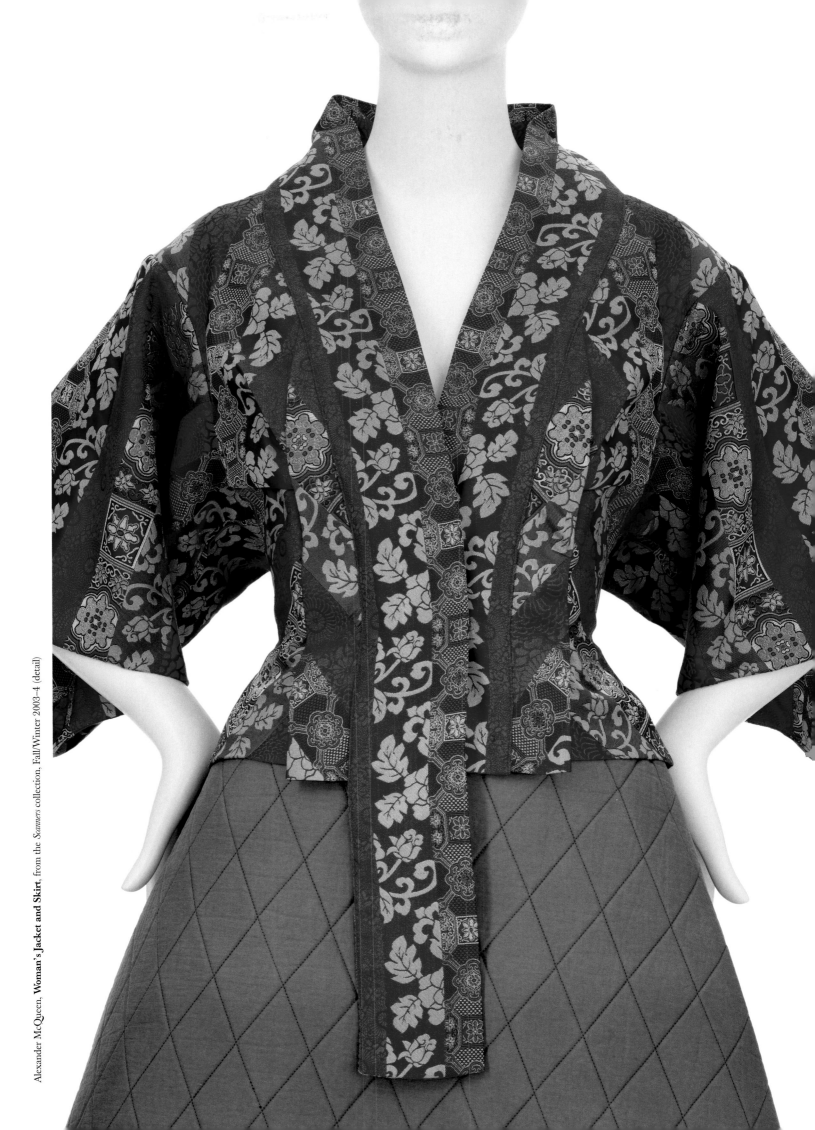

BUDDHIST PRIEST'S MANTLE (KESA)

1 Helen Loveday, *Japanese Buddhist Textiles: The Baur Collection* (Geneva: 5 Continents Editions, 2014), 300–1. See also a nineteenth-century Buddhist altar cloth (*uchishiki*) in the collection of the Museum of Fine Arts, Boston (William Sturgis Bigelow Collection, 11.3913; collections. mfa.org/objects/9551/ buddhist-altar-cloth).

2 Sharon Sadako Takeda in collaboration with Monica Bethe, *Miracles & Mischief: Noh and Kyōgen Theater in Japan* (Los Angeles: Los Angeles County Museum of Art, 2002), 182 and 187.

Buddhism originated in India near the Himalayas around the fifth century BCE, when, according to tradition, the Indian prince who would become the Buddha renounced his royal status. As he embarked on the pursuit of enlightenment, the Buddha dressed in a garment that was *kāṣāya*-colored—indicating something impure or earth-colored. Subsequently, the principal draped Buddhist vestment came to be called *kāṣāya*; the Sanskrit word later lent itself to *kesa*, the Japanese term for a Buddhist priest's mantle.

Buddhism arrived in Japan by way of Korea and China beginning in the sixth century CE. Through patchworking techniques, *kesa* construction emulates Buddha's ascetic garment made from discarded cloth, while the columnar organization comes from Buddha's directive to model vestments on the image of rice fields. As Buddhism became codified, so too did the design of *kesa*, which are made through a devotional stitching process with columns traditionally ranging in odd numbers from five to twenty-five. Symbolizing the wearer's knowledge of Buddha's teachings, or dharma, *kesa* may be passed from teacher to disciple. They may also function as personal mandalas, or Buddhist representations of the cosmos.

Over time, mendicant robes modeled on Buddha's own gave way to *kesa* made from sophisticated woven textiles. Early examples were commonly imported from China, while later examples were made with textiles domestically woven in Japan. Often, *kesa* were constructed from fabric donated to temples by Buddhist devotees seeking to accrue merit or memorialize loved ones. Through the characteristic Buddhist process of remaking, secular textiles are transformed into something sacred.

This nineteenth-century, seven-column *kesa* made of fine silk and gold-gilt paper threads displays a composition of interlocking lobed and floral medallion motifs, a variation[1] of the woven pattern of linked octagons and floral medallions known in Japan as *shokkō*. Originating in China, the pattern is seen in Ming dynasty textiles beginning from the sixteenth century, but is itself derived from painted decorative patterns on architectural elements dating to the Song dynasty. In Japan, *shokkō*-patterned silks, and variants of the composition, are seen in secular garments, such as the robe worn by Okina in the opening ritual performance for Noh and Kyōgen theater;[2] in Japanese Buddhism, they are often seen repurposed as liturgical textiles such as altar cloths (*uchishiki*) or *kesa*.

The reimagination of this pattern within China, and its international resonance abroad, demonstrates the natural inclination to borrow across cultures and time periods so often revealed by textile history. This *kesa*'s *shokkō* pattern variation exemplifies the inherent reinvention of globally transmitted motifs over time—a legacy that fashion designers such as Alexander McQueen tap into when they reimagine historical textiles in contemporary ways.

MICHAELA HANSEN
Curatorial Assistant, Department of Costume and Textiles

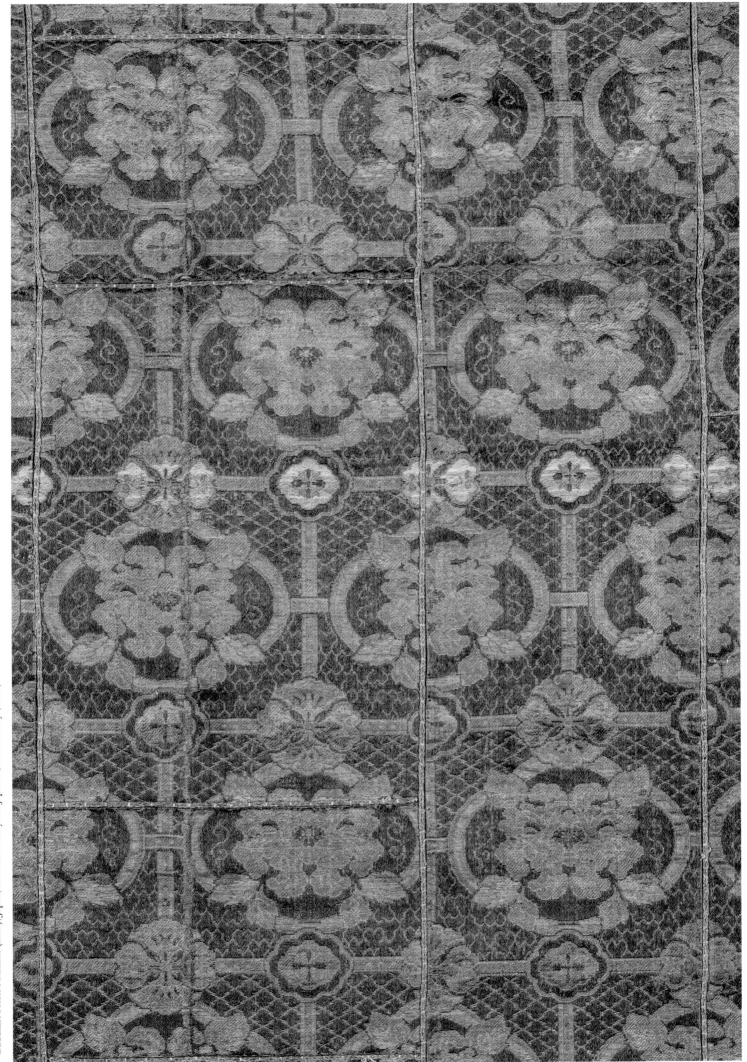

Buddhist Priest's Mantle (*Kesa*), Japan, late Edo to early Meiji period, 19th century (detail)

Alexander McQueen, **Woman's Dress**, from *The Widows of Culloden* collection, Fall/Winter 2006–7; **Woman's Shoes**, attributed to *The Widows of Culloden* collection, Fall/Winter 2006–7; Michael Schmidt, **Headpiece** (wool knit and metal), 2020

THE WIDOWS OF CULLODEN FALL/WINTER 2006–7

After *Neptune*, his Spring/Summer 2006 collection, was deemed by critics as too commercial for "a designer whose capabilities have won such respect,"[1] McQueen responded by turning inward for inspiration. "I needed to do something that was close to my heart," he stated in regards to *The Widows of Culloden*. "I wanted to start from the crux, and the crux is my heritage."[2] The designer first explored his Scottish heritage a decade earlier in *Highland Rape*; while the controversial Fall/Winter 1995–96 collection was interpreted by some critics as misogynistic, he argued that it "was about England's rape of Scotland."[3] The Fall/Winter 2006–7 collection treads similar ground, in this case the brutal Battle of Culloden in 1746, where 9,000 British government troops defeated the Jacobite army of 5,000, which fought in support of Charles Edward Stuart. Some 1,500 Jacobites were killed, compared to 50 British soldiers; beyond the battle, the British stormed villages and burned buildings housing the wounded. Later, in an attempt to strip away clan identity, the government passed the Act of Proscription, which included the outlawing of Highland dress—such as tartans.

Though history tends to remember the Highlander men who died, McQueen memorialized the widows they left behind. Romantic in silhouette and refined in construction, the collection uses the MacQueen clan tartan throughout, alongside details recalling the natural world of Scotland. An expertly draped green jersey dress (opposite) suggests the color of the moors, while another ensemble pairs a leather jacket tooled in an eighteenth-century style with a plaid skirt (pp. 2, 81). The latter look, like others throughout the collection, was aged to appear worn.

Though tartans have been part of fashionable dress since the Highland romantic revival of the nineteenth century, here their use references a place that McQueen felt was "harsh and cold and bitter…. There's nothing romantic about [Scotland's] history. What the British did there was nothing short of genocide."[4] This complicated history extends into North America with John Singleton Copley's *Portrait of Hugh Montgomerie* (pp. 78–80). Posing before a 1760 battle between the British and the Cherokee, Montgomerie, a Scotsman, is dressed in traditional attire at a time when tartans were less about clan allegiance and more about representation of Scottish nationalism and "the acknowledgement of Scotland's centrality to the financial and military expansion of the British Empire."[5] Indeed, despite any similarities between the Scots and the Cherokee, who both fought to keep their native lands, Montgomerie aligns himself with the British colonizer. By contrast, McQueen's use of plaid remembers it as a tool to amplify the Jacobite cause prior to Culloden, reclaiming the tartan not as a trophy of British conquest but a symbol of Scottish identity.

Though an intimate examination of melancholy, *The Widows of Culloden* also found the beauty therein. The collection's runway show, which was set to the haunting score of Jane Campion's film *The Piano* (1993), grew lighter in color palette and texture as the looks progressed, transforming from the aged and earthy tartans, furs, and leathers and into pale neutral tones (p. 107), as if to signify an otherworldly sense of hope for the spirits who haunt the Highlands. Their legacy continues as long as history is not forgotten.

1 Sarah Mower, "Alexander McQueen Spring 2006 Ready-to-Wear," *Vogue*, October 6, 2005 (www.vogue.com/fashion-shows/spring-2006-ready-to-wear/alexander-mcqueen).

2 McQueen, quoted in Susannah Frankel, Introduction to *Alexander McQueen: Savage Beauty*, ed. Andrew Bolton (New York: Metropolitan Museum of Art, 2011), 25.

3 McQueen, quoted in Ghislaine Wood, "Clan MacQueen," in *Alexander McQueen*, ed. Claire Wilcox (London: V&A Publishing, 2015), 51.

4 McQueen, quoted in Susannah Frankel, *Visionaries: Interviews with Fashion Designers* (London: V&A Publications, 2001), 19.

5 Jonathan Faiers, *Tartan* (Oxford: Berg, 2008), 44.

PORTRAIT OF HUGH MONTGOMERIE, LATER TWELFTH EARL OF EGLINTON

John Singleton Copley

John Singleton Copley's ambitious life-size portrait of Hugh Montgomerie epitomizes eighteenth-century Grand Manner portraiture in nearly every regard: sweeping brushwork coupled with an attention-grabbing palette coalesce in support of a dramatic composition intended to heroicize the subject. While these conventions contributed to the contemporary success and future memorialization of both the artist and his subject, Copley's layered image attests to the complexities surrounding related historical events.

Montgomerie was a military man and politician. In 1780, the year this painting was executed, he became a member of the Parliament of Great Britain, representing his district in southwest Scotland. Portrayed commanding a British battalion in the victorious pose of the Apollo Belvedere—a pose that well-educated viewers would have recognized at the time—Montgomerie stands above a group of fallen Tsalagi (Cherokee) warriors.[1] Montgomerie did not actually take part in the battle shown here, which occurred in 1760 in the British settler colony of South Carolina (in fact, he was serving elsewhere in the tragically misplaced and mismanaged war between the Cherokee and the English settlers in Virginia and the Carolinas).[2] Nevertheless, he is depicted at the moment in which British troops turned against the Cherokee in the former's war against the French in order to force a peace treaty with the Indigenous tribe. The British burned the Lower Cherokee villages just east of the Blue Ridge Mountains,[3] with the fires suggested by Copley's strokes of orange pigment underlining billowing gray clouds that cover nearly two-thirds of the canvas. This portentous atmosphere leads to a scene of mortal combat closer to the foreground, in which bare-chested Cherokee wielding clubs and axes fall to the guns and bayonets of the British troops. While the portrait purports to relay the absolute triumph of Montgomerie's command, it does not tell the truth: the Cherokee did not capitulate as Copley's painting suggests.[4] A few weeks later, after a deadly ambush, the Cherokee prevailed and these British troops retreated entirely.[5]

In this constructed layering of time and place, the Anglo-American Copley offers another opportunity beyond this battle scene to introduce the intricacies inherent to political allegiances, power dynamics, and the relationship with British colonialism in particular. He does this through dress. Montgomerie is depicted wearing traditional Scottish attire, his kilt painted to resemble the tartan of the Montogomery clan. In 1780, at the time the portrait was painted, however, it was forbidden to wear tartan unless one was serving in the British military.[6] The dress can thus be viewed as one marker of the relationship between England and Scotland, or more precisely, between British military might and Scottish cultural heritage. Through Montgomerie's position as a military man himself, he is able to safely declare his simultaneous alignment with England, Scotland, and his clan.

1 The Cherokee originally self-identified as the Aniyunwiya; Tsalagi is also the name of their language.

2 The scene was long thought to have been a general reference to the Anglo-Cherokee wars led by Archibald Montgomerie, Hugh's cousin, but new research allows for a more precise identification of the battle. See Richard C. Cole, "Montgomerie's Cherokee Campaign, 1760: Two Contemporary Views," *The North Carolina Historical Review* 74, no. 1 (January 1997), 19–36.

3 Keowee, the largest of the Lower Cherokee towns and the first to be burned in the British campaign, sat in what is now northeastern South Carolina. Along with its burial grounds, it was entirely submerged in 1970 when a dam was built to provide power to the area.

4 Moreover, the Cherokee were armed in an equivalent manner to the British; the imbalance shown here was Copley's invention. Alyce de Carteret (Mellon Postdoctoral Fellow, Art of the Ancient Americas) notes that such fictions may have contributed to the widespread fallacy that European weaponry was more powerful and allowed colonizers to subdue Indigenous populations easily.

5 Jeff W. Dennis, chap. 2, *Patriots and Indians: Shaping Identity in Eighteenth-Century South Carolina* (Columbia: University of South Carolina Press, 2017); see also Cole, "Montgomerie's Cherokee Campaign."

6 For an in-depth history of Scottish tartan in dress and fashion, see Jonathan Faiers, *Tartan* (Oxford: Berg, 2008).

John Singleton Copley, *Portrait of Hugh Montgomerie, Later Twelfth Earl of Eglinton*, 1780

This complex set of identities and loyalties was not the same for other clans of Scotland, particularly those from the Scottish Highlands. Unlike Montgomerie, whose family was from the Lowlands, and who traditionally supported England interests, Highlanders often opposed the British, as their affiliation with Catholicism aligned them with James Stuart, the exiled English claimant to the British throne. This struggle between (Catholic) Jacobites and (Protestant) British forces was tested in a final attempt to recapture the throne in 1745–46, just fifteen years before the battle between the British and the Cherokee depicted in Copley's picture. The pivotal fight on April 16, 1746, known as the Battle of Culloden, attempted to return the deposed Stuart dynasty to the English throne. Although certainly not the final act of resistance, the attempt failed decisively, resulting in a redistribution of the population that enabled the British to access resources and deliberately disrupt the Scottish clan system.

The centuries-long centralization of the British monarchy into what would become the Kingdom of Great Britain in 1707 fueled colonial expansion across the globe, both economically and militarily—including the battle depicted at Montgomerie's feet. Here Copley uses visual conventions of his day to suggest victor and vanquished. The precision of the fair-skinned British troops' forward march, their regimented display, and overpowering numbers are all plainly contrasted with the disorganization of the dark-skinned Cherokee—the same features ascribed to the Jacobite army in their defeat at Culloden (above).

Such images of conquest inevitably contribute to the erasure of the defeated, generating an assumption that once the depicted battle was lost, these groups or peoples disappeared. But a single flattering portrait-cum-history painting does not constitute abiding truth; indeed, the British went on to lose the American Revolutionary War (which was being fought at the very moment this image of supposed military superiority was painted), the Cherokee Nation went on to become the largest tribe in the territory known as the United States, and as of this writing, a significant political movement for independence from the United Kingdom persists in Scotland.

LEAH LEHMBECK
Curator and Department Head, Departments of European Painting & Sculpture and American Art

Attributed to David Morier, *An Incident in the Rebellion of 1745*, c. 1745–85. Oil on canvas, 23 7/8 × 39 1/8 in. (60.5 × 99.5 cm). Royal Collection Trust, RCIN 401243

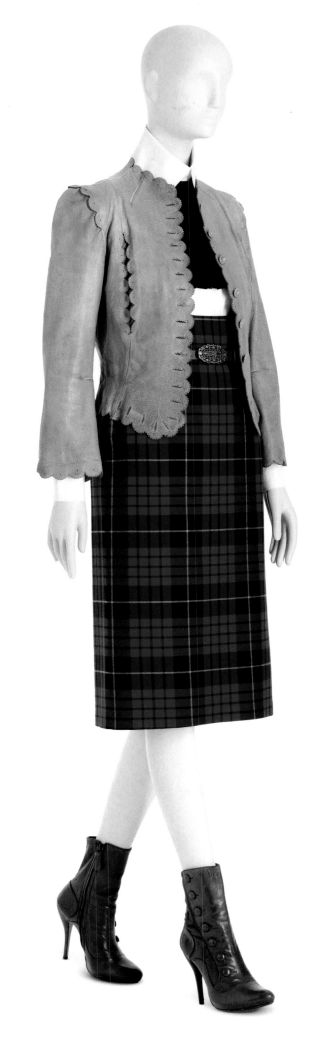

Alexander McQueen, **Woman's Ensemble (Jacket, Blouse, Jabot, Skirt, Boots, and Belt)**, from *The Widows of Culloden* collection, Fall/Winter 2006–7

Alexander McQueen, **Woman's Dress**, from the *In Memory of Elizabeth How, Salem, 1692* collection, Fall/Winter 2007–8 (detail)

IN MEMORY OF ELIZABETH HOW, SALEM, 1692

FALL/WINTER 2007–8

A year after *The Widows of Culloden* was inspired by McQueen's Scottish heritage, *In Memory of Elizabeth How, Salem, 1692* continued the designer's fascination with his ancestry. This time, galvinized by a discovery his mother made through her genealogical research, the designer focused on Elizabeth How,[1] one of three distant relatives executed in Salem in the deadliest witch hunt in colonial New England. When asked about the title of the collection, and its naming after Elizabeth How, McQueen remarked, "Surely everyone deserves to live their life without being subjected to that kind of violence."[2] Granting recognition both to Arthur Miller's retelling of the event in *The Crucible,* centered around three female protagonists, as well as to McQueen's own ancestors, the fashion show began with a large projected image of the stoic faces of three women.

Embracing witchcraft rather than shying away from it, the runway show for *In Memory of Elizabeth How* acknowledged the long history of paganism that the Salem Puritans decried. Models walked along a black sandy stage, following the lines of a large red pentagram, a common symbol of Wiccan identity. Two dresses (opposite and p. 85) encrusted with beading celebrate the wavy strands of hair that were typically shorn from accused women so no marks of Satan could be hidden underneath. This brutal ritual was subverted and beautified in McQueen's shimmering looks. Hair has long symbolized female strength; unconfined, it connotes virility and freedom, as well as temptation and sin. The beading may also be interpreted as fire, in reference to the European practice of burning witches at the stake.[3]

These associations are present in Ernst Barlach's series of woodblock prints inspired by Goethe's *Faust* (p. 173). In *Will-o'-the-wisp*, Mephistopheles conjures a fairy-like flame that resembles hair; *Witch's Ride* depicts a scene of witches flying above the ominous forest with Mephistopheles and Faust below, as one witch on a broomstick is held back by her long hair. *Lilith, Adam's First Wife* (p. 84), another print by Barlach from the same period, illustrates Lilith with brazenly long locks. Though Lilith has been interpreted in some religious and mythological traditions as a demonic figure, in recent decades she has become a symbol of feminine strength, a reconsideration that McQueen similarly posed with this collection.

1 There is some discrepancy in the spelling of her surname; McQueen's collection spells it *How*, while a Salem memorial stone spells it *Howe*. Historical records use both spellings.

2 McQueen, quoted by Susannah Frankel, *Big*, no. 3, Autumn/Winter 2007. McQueen also mentioned being influenced by Arthur Miller's *The Crucible* (both the 1953 play and the 1966 film). The three women in *The Crucible* are Elizabeth Procter, Abigail Williams, and Ann Putnam; it is possible that McQueen conflated his ancestor, Elizabeth How, with Elizabeth Procter as portrayed in Miller's retelling of the Salem trials.

3 By contrast, those convicted of witchcraft in colonial America were sentenced to death by hanging.

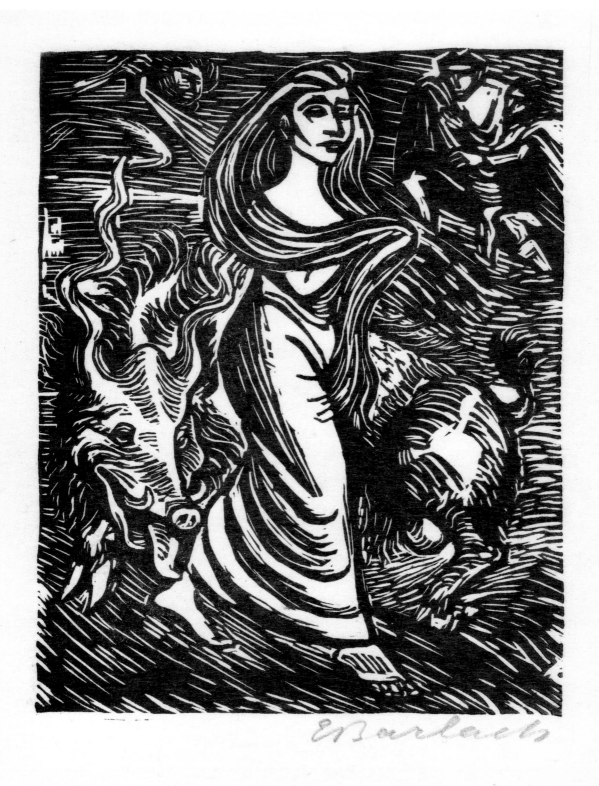

84

Ernst Barlach, *Lilith, Adam's First Wife*, 1922, published 1923

Alexander McQueen, **Woman's Dresses, Boots** (left) and **Shoes** (right), from the *In Memory of Elizabeth Hoar, Salem, 1692* collection, Fall/Winter 2007–8

TECHNIQUE
AND INNOVATION

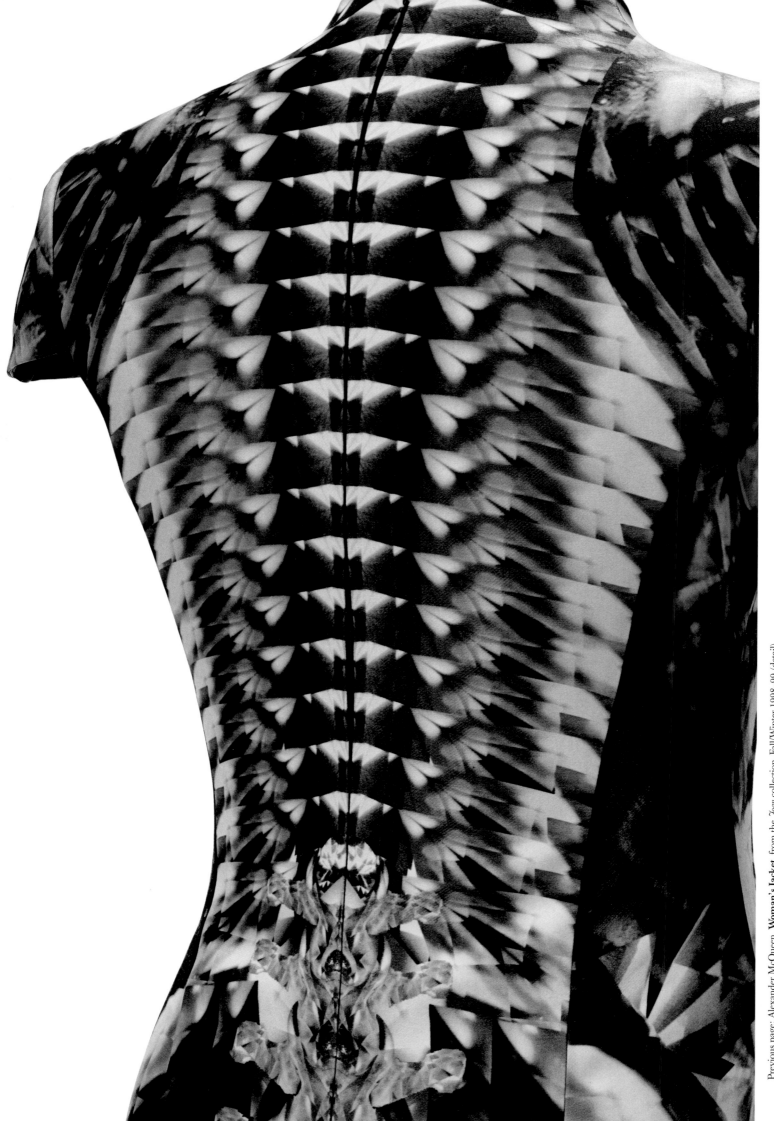

TECHNIQUE AND INNOVATION

TECHNIQUE AND INNOVATION demonstrates McQueen's masterful abilities in garment construction, where various experiences in tailoring and dressmaking culminated in collections strongly informed by his hands-on approach. McQueen—who once stated that "the basis for anything I do is craftsmanship"[1]—consistently drew upon his formative years apprenticing on Savile Row in tailoring each of his collections. In his dressmaking, complex garment patterns emerge, informed both by his skill as a cutter as well as his tactile sensitivity in draping. It was through this deep knowledge of technique that he could masterfully deconstruct clothing by mixing form with function and history with innovation.

1 McQueen, in "Fashion in Motion: Alexander McQueen," short film showcasing his *No. 13* collection (Spring/Summer 1999), produced by 55° and V&A (www.vam.ac.uk/ articles/fashion-in-motion-alexander-mcqueen).

2 McQueen, interviewed by Sophia Kokosalaki, *Self Service*, issue 16, Spring/ Summer 2002.

3. McQueen, quoted in Susannah Frankel, "The Real McQueen," *Harper's Bazaar*, April 1, 2007.

"I SPENT A LONG
TIME LEARNING HOW
TO CONSTRUCT CLOTHES,
WHICH IS IMPORTANT TO
DO BEFORE YOU
CAN DECONSTRUCT THEM."[2]

McQueen also drew upon Western costume history and its various silhouettes, textiles, and trims, referencing and refashioning the dress of both men and women of various eras, ranging from the Renaissance and the Enlightenment to the Belle Epoch and the Jazz Age. Greatly informing his use of historic silhouettes and era-specific embellishments were the period films that often influenced his own collection storylines.

This attention to detail was not limited to construction, but also applied to the inventive fabrics and surface treatments he incorporated in his designs. McQueen promoted innovation by incorporating emerging technologies, such as printing photorealistic imagery onto sequins or using laser-cutting on leather, and he is credited with popularizing the use of digitally edited and printed textile designs, now common in the fashion industry. Rather than producing bolts of printed textiles, he worked with his team to engineer prints that were purposefully placed on the fabric according to the shape of garment patterns, creating multilayered, multidimensional effects previously unseen in dress. "As a designer," McQueen said, "you've always got to push yourself forward; you've always got to keep up with the trends or make your own trends. That's what I do."[3]

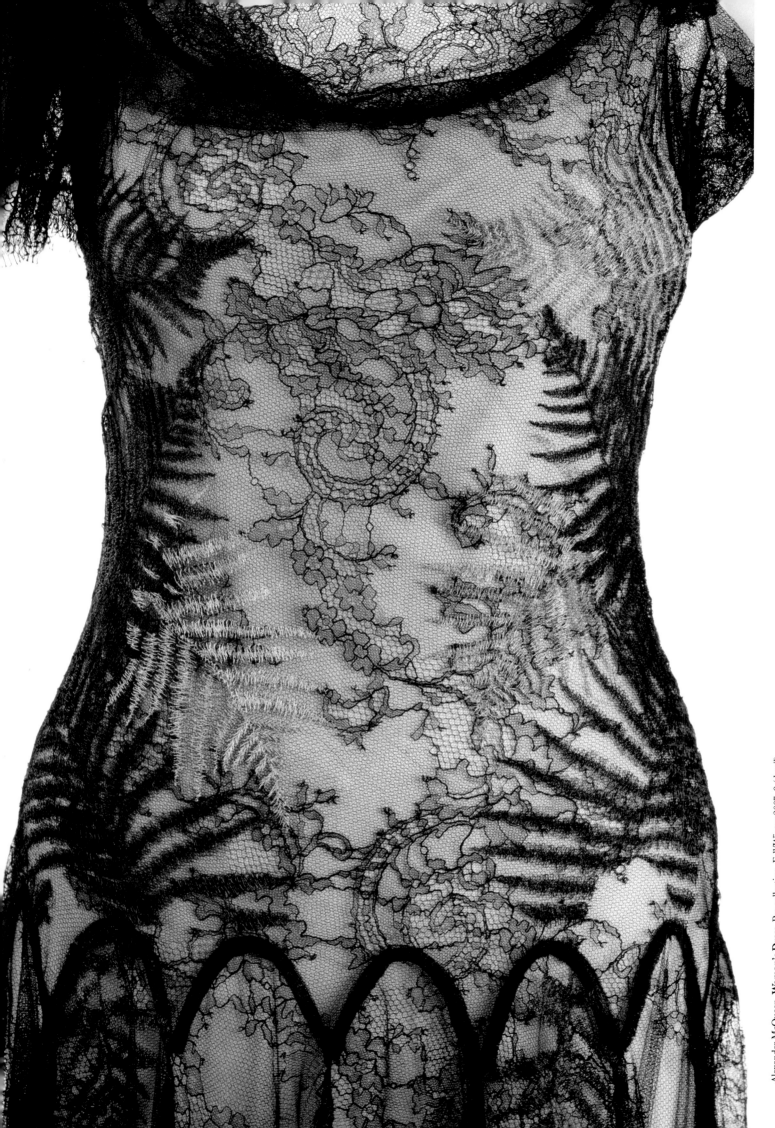

Alexander McQueen, **Woman's Dress**, Pre-collection, Fall/Winter 2007–8 (detail)

TAILORING, DRESSMAKING, DECONSTRUCTION

Essential to every piece bearing the Alexander McQueen label is the designer's foundation in garment construction. His roots in Savile Row and subsequent work with experimental designers Koji Tatsuno in London and Romeo Gigli in Milan are well documented. This meant that by the time he joined the prestigious master's program at Central Saint Martins, he had several more years of experience than his cohort, despite being just twenty-one.[1] Later at Givenchy, McQueen continued to hone his craft, particularly in dressmaking: "Because I was a tailor," he noted, "I didn't totally understand softness, or lightness. I learned lightness at Givenchy."[2]

An amalgamation of McQueen's varied technical abilities and experiences is evident in a suit (pp. 4, 92 left) from his *Deliverance* collection. Made to appear patched in reference to the American Great Depression, the suit is tailored from various patterned fabrics, each piece draped and molded around the body with both technical and visual finesse. A dress from the same collection (p. 92 right) similarly recalls patchwork, but in bias-cut squares of chiffon. A top from the *Voss* collection (p. 93) is less complicated in patterning but no less brilliant in deconstruction of form and function. Created from silk fabric typically used to make men's ties, the halter is secured on the wearer's body by knotting a tie around the neck, a detail that may have gone unnoticed among an ensemble on the runway, but which can be appreciated in its solitary display.

Two dresses from the Untitled (*Golden Showers*) collection and one dress from *Dante* (pp. 94–95) utilize traditional wool suiting, adapted with net cutouts and piecing to reveal, conceal, and highlight parts of the body. Another grouping of dresses made after McQueen's appointment to Givenchy attest to his skills. Draping forms the basis of a dress from *Irere* (p. 96 right), while dresses with insets and godets from the *Pantheon ad Lucem* (p. 96 left) and the pre-Fall/Winter 2007–8 collections (opposite and p. 97) demonstrate how the designer's proficiency in piecing translates into garments that generate sinuous movement around the body.

By understanding the trades of tailoring and dressmaking, McQueen was able to break rules in order to expand on his deconstruction of clothing. An ensemble from *Supercalifragilisticexpialidocious* (pp. 98 right, 99), subverts outerwear, underwear, and accessories in a tweed jacket tailored with a leather belted bra and harness. Leather lacing decorates the back of the jacket and along the sides of an accompanying pair of jeans. A body-conscious dress from *Scanners* (p. 98 left) made of wrapped bands of silk with zippers at the side seams, reimagines the bandage and zipper dresses made famous by Azzedine Alaïa, who McQueen greatly admired.[3]

1 Susannah Frankel, "The Real McQueen," *The Independent Fashion Magazine*, Autumn/Winter 1999.

2 McQueen, quoted in Edwina Ehrman, "Givenchy," in *Alexander McQueen*, ed. Claire Wilcox (London: V&A Publishing, 2015), 105.

3 McQueen stated that Alaïa inspired some of his own designs: "I have so much respect for him, and I don't even think he will mind." Quoted in Cathy Horyn, "Galliano, Still the Master Showman," *New York Times*, October 10, 2005.

Left: Alexander McQueen, **Woman's Suit (Jacket and Skirt)**, from the *Deliverance* collection, Spring/Summer 2004
Right: Alexander McQueen, **Woman's Dress**, from the *Deliverance* collection, Spring/Summer 2004

Alexander McQueen, **Woman's Dress**, from the Untitled (*Golden Showers*) collection, Spring/Summer 1998

Left: Alexander McQueen, **Woman's Dress**, from the Untitled (*Golden Showers*) collection, Spring/Summer 1998
Right: Alexander McQueen, **Woman's Dress**, from the *Dante* collection, Fall/Winter 1996–97

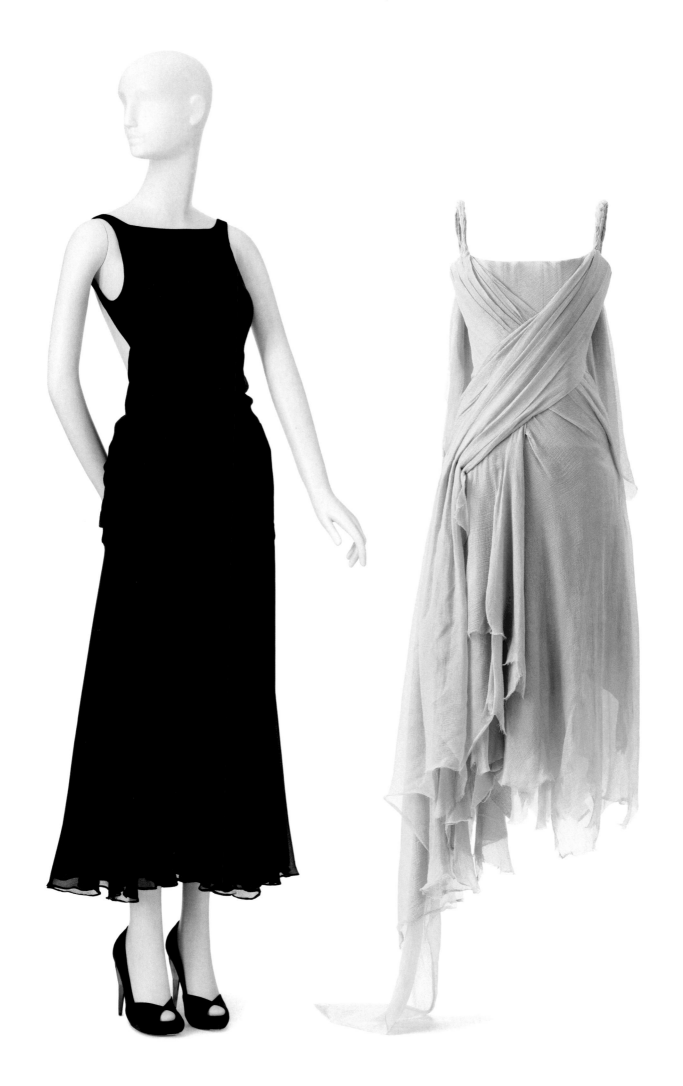

Left: Alexander McQueen, **Woman's Dress**, from the *Pantheon ad Lucem* collection, Fall/Winter 2004–5; **Woman's Shoes**, from the *Natural Dis-tinction, Un-natural Selection* collection, Spring/Summer 2009
Right: Alexander McQueen, **Woman's Dress**, from the *Irere* collection, Spring/Summer 2003

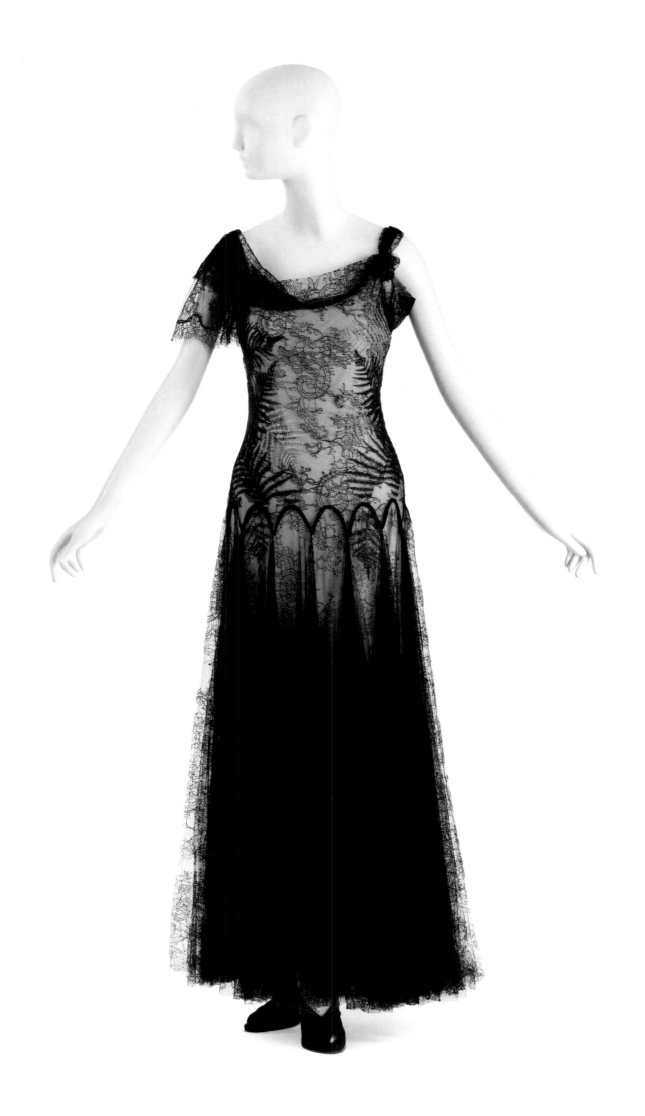

Alexander McQueen, **Woman's Dress**, Pre-collection, Fall/Winter 2007–8; **Woman's Shoes**, attributed to *The Man Who Knew Too Much* collection, Fall/Winter 2005–6

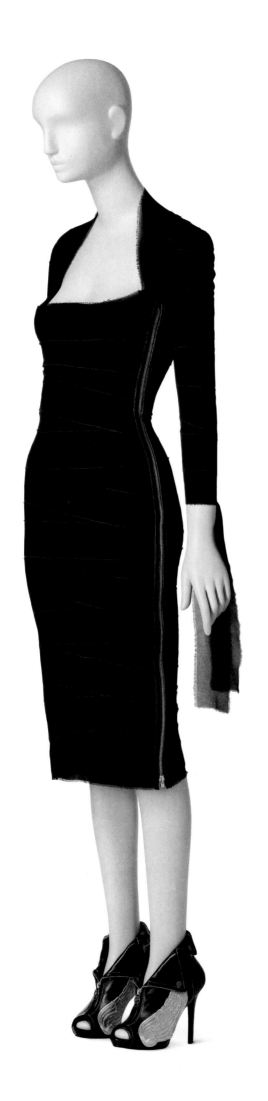
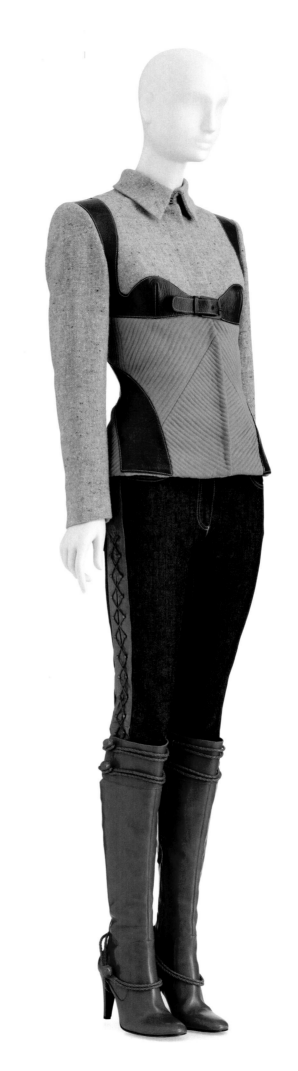

Left: Alexander McQueen, **Woman's Dress**, from the *Scanners* collection, Fall/Winter 2003–4; **Woman's Shoes**, from the Untitled (*Angels and Demons*) collection, Fall/Winter 2010–11
Right: Alexander McQueen, **Woman's Jacket and Jeans**, from the *Supercalifragilisticexpialidocious* collection, Fall/Winter 2002–3; **Woman's Boots**, attributed to *The Widows of Culloden* collection, Fall/Winter 2006–7

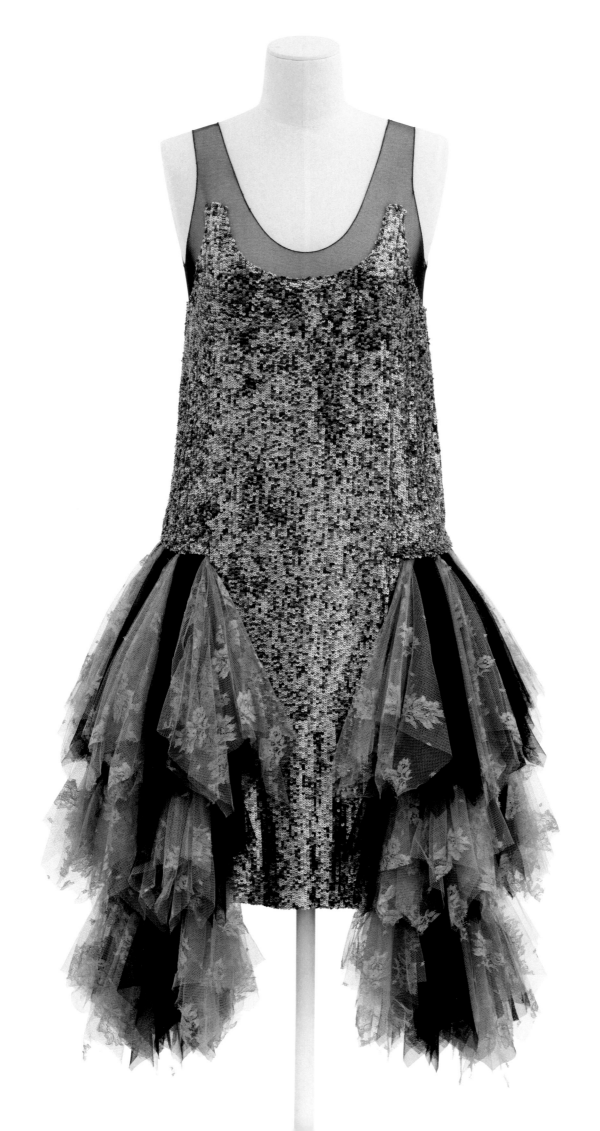

Alexander McQueen, **Woman's Dress**, from the *What a Merry Go Round* collection, Fall/Winter 2001–2

COSTUME HISTORY

McQueen often reimagined the silhouettes and details of Western costume history as a tool for storytelling. At times, he married his historical knowledge with his love of period films, such as *The Mission* (1986), which informed the *Irere* collection's sweeping storyline of European colonialism and Christian missionaries in North and South America in the late sixteenth century.[1] An ensemble with a quilted leather doublet strung with rosaries (pp. 10, 103 right) is similar to a 1580 print of a lady by Hendrik Goltzius (p. 102). A perforated and embossed leather jacket (p. 105) also recalls the fashion for slashing in menswear, illustrated in Goltzius's print of a Polish nobleman (p. 104). References to the period continue in a denim look (p. 103 left) with lacing throughout, the long ends trailing far below the edge of the doublet-inspired jacket.

The designer also reinterpreted seventeenth-century fashion, such as that depicted in Flemish court painter Frans Pourbus II's portrait of a young King Louis XIII of France (p. 106). Pourbus renders the monarch with exquisite attention to detail, especially in his starched lace collar, slashed satin doublet and sleeves, and gold scrolling-vine embroidery. A similar attention to detail is found in a dress from *Sarabande* (p. 107), which includes a small ruff at the neck and elaborate gold beading throughout the chest in a similar pattern around a mirrored "cQ" in reference to the McQueen logo.

Two looks inspired by the eighteenth century include a dress with long, draped box pleats at the front of the body (p. 109), inspired by the back of a *robe à la française* (p. 108). A reference to the stomacher, which typically accessorizes the center-front of period gowns, appears at the V-shaped back of McQueen's dress, completing the designer's vision for backwards construction. His treatment of an eighteenth-century-style man's coat (p. 110) echoes the embroidery found along the center-front opening, neckline, and pocket flaps, but is constructed from glen-plaid wool suiting, rather than silk (p. 111).

The early nineteenth century is referenced in the empire waistline of a form-fitting dress from *Supercalifragilisticexpialidocious* (p. 115), as well as two women's coats modeled after men's tail coats for *No. 13* (pp. 112–13). One look, with deconstructed lapels that button to the front collar, has a skirt that may be buttoned in back into a tail or buttoned in front to create the skirt of a frock coat—two styles that prevailed throughout the 1800s.

References to the early twentieth century and the Edwardian fashions in the film *Picnic at Hanging Rock* (1975) are evident in two looks from *It's Only a Game* (p. 117). The high, fitted collars and vertical pintucks of silk net and lace of dresses from 1900 (p. 116) inspired McQueen's jackets, with the grosgrain ribbon typically found inside historic boned bodices acting here as an exposed waist closure. In a dress from *What a Merry Go Round* (opposite), McQueen reinterprets the 1920s *robe de style*, with its straight cut and volume at the hips, into a sequin-covered dress with rows of tulle and lace in colors that recall the nightlife of Germany's Weimar Republic, the setting of the film *Cabaret* (1972), one of the designer's inspirations for the collection.

1 McQueen may have also been inspired by Juan de Alcega's *Tailor's Pattern Book* from 1589. An original copy of the book is in the collection of the Victoria and Albert Museum, and a facsimile was translated and published 1979 (Bedford, UK: Ruth Bean). For more, see www.vam.ac.uk/articles/mcqueensresearch-library.

DAMOISELLE FRANCHOYSE DEGMONT

Golzius fecit

Hendrik Golzius, *Portrait of Lady Françoise van Egmond*, 1580

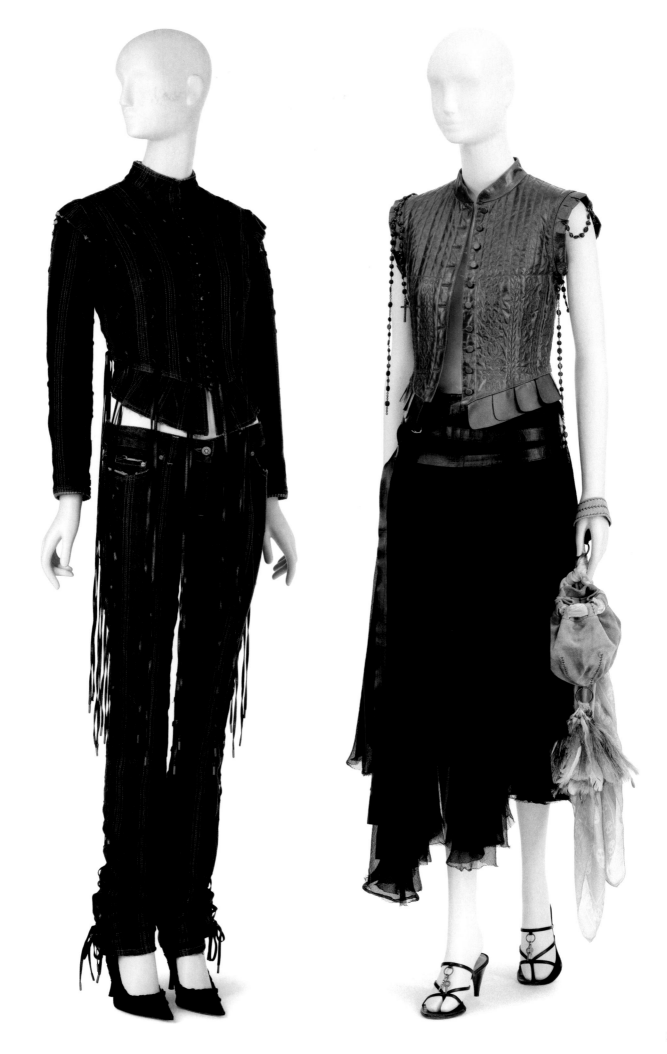

Left: Alexander McQueen, **Woman's Ensemble (Jacket and Jeans)**, from the *Irere* collection, Spring/Summer 2003; **Woman's Shoes**, attributed to *The Man Who Knew Too Much* collection, Fall/Winter 2005–6
Right: Alexander McQueen, **Woman's Vest, Skirt, Purse, and Shoes**, from the *Irere* collection, Spring/Summer 2003

Hendrik Golzius, *A Polish Nobleman Standing: Balthasar Bathory De Somlyo*, 1583

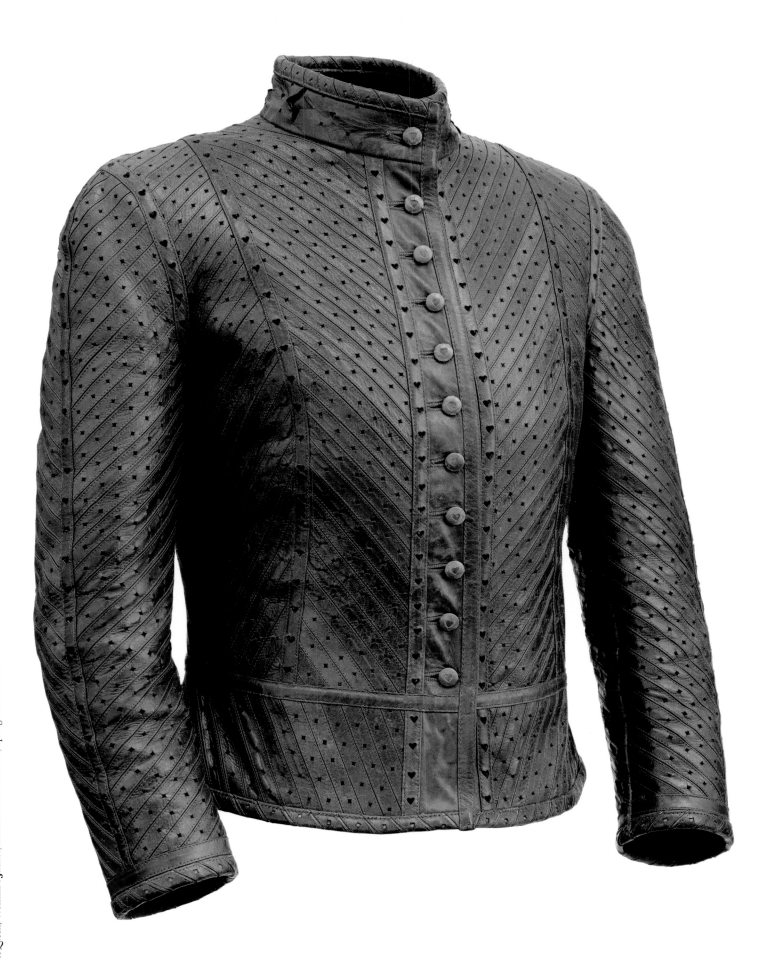

Alexander McQueen, **Woman's Jacket**, from the *Irere* collection, Spring/Summer 2003

Frans Pourbus II, *Portrait of Louis XIII, King of France, as a Boy*, c. 1616

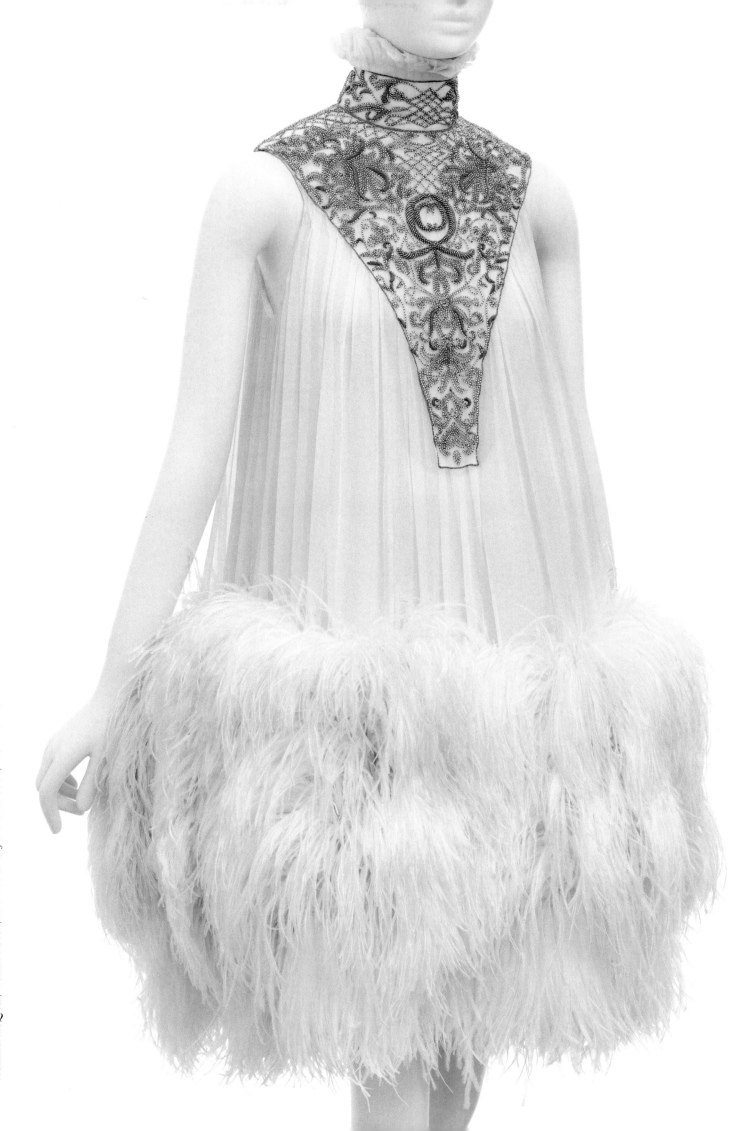

Alexander McQueen, **Woman's Dress**, from *The Widows of Culloden* collection, Fall/Winter 2006–7

Woman's Dress (*Robe à la française*), probably Italy, 1760s;
Woman's Stomacher, England, mid-18th century; **Woman's Petticoat**, England, c. 1760

Alexander McQueen, **Woman's Dress**, Pre-collection, Fall/Winter 2007–8

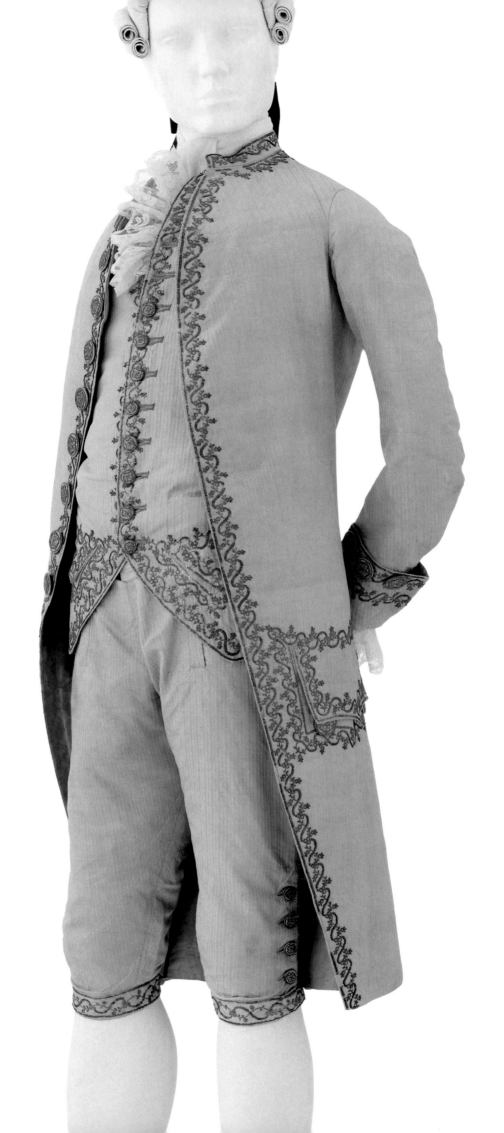

Man's Suit (Coat, Waistcoat, and Breeches), England, c. 1770

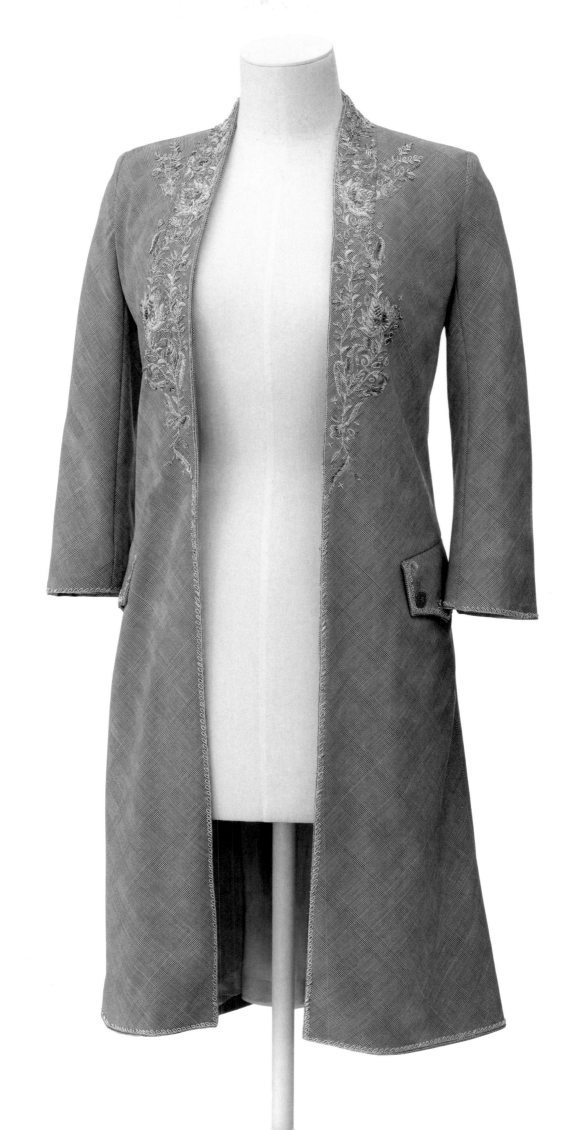

Alexander McQueen, **Woman's Coat**, from the *Irere* collection, Spring/Summer 2003

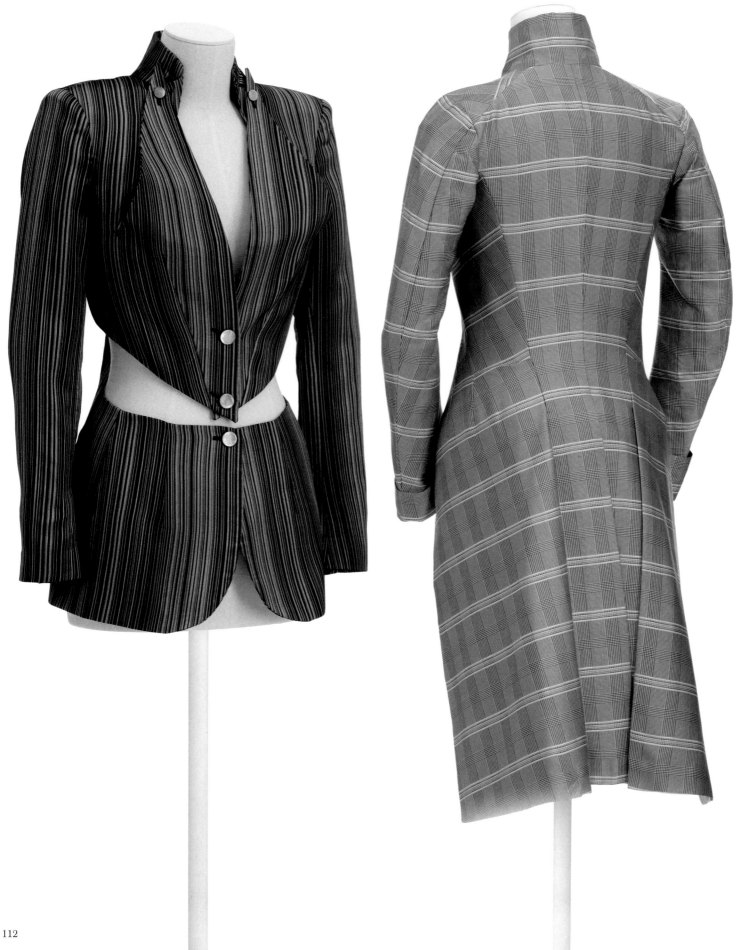

Alexander McQueen, **Woman's Coats,** from the *No. 13* collection, Spring/Summer 1999

EVENING OR FULL DRESS.

N.º78, of ACKERMANNS REPOSITORY of ARTS &c. Pub. June 1,1810, at 101, Strand, LONDON.

Fashion Plate, "Evening or Full Dress," England, 1810

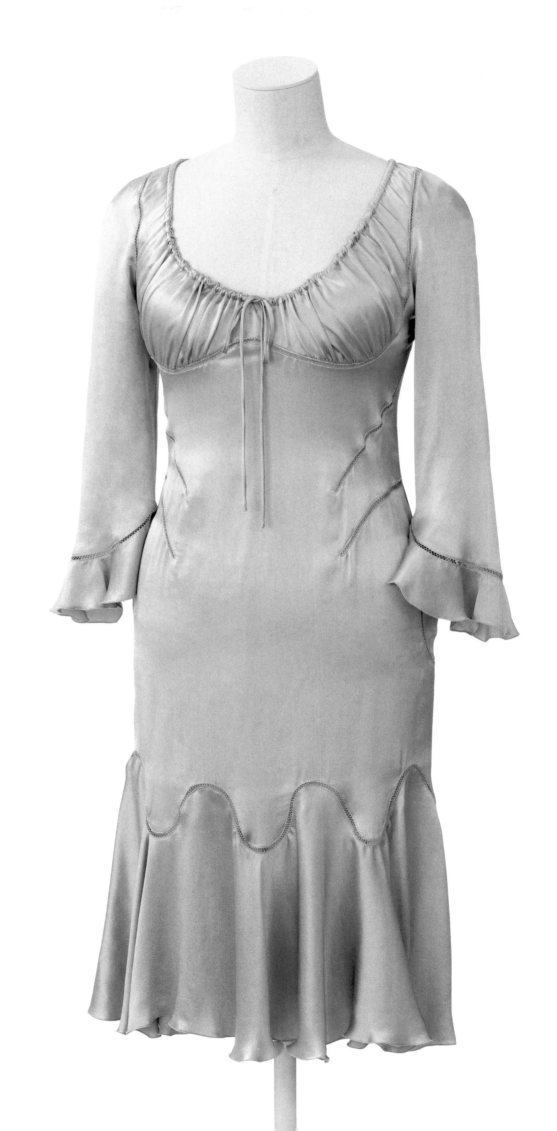

Alexander McQueen, **Woman's Dress**, from the *Supercalifragilisticexpialidocious* collection, Fall/Winter 2002–3

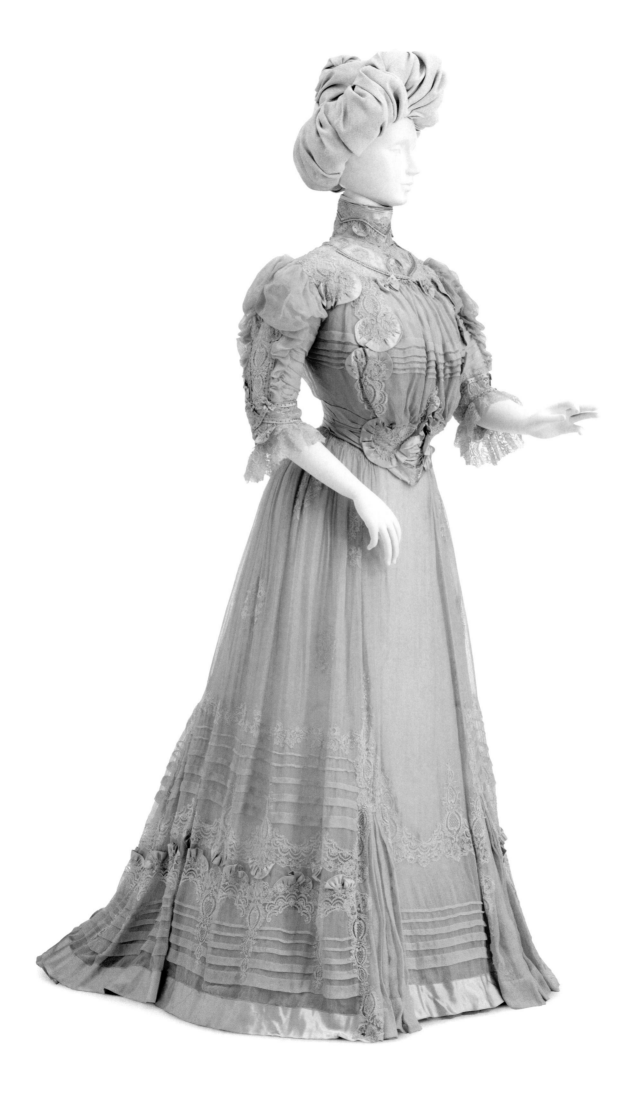

Emma and Marie Weille, **Woman's Dress (Bodice and Skirt)**, c. 1905

Left: Alexander McQueen, **Woman's Suit (Jacket and Skirt) and Shoes**, from the *It's Only a Game* collection, Spring/Summer 2005
Right: Alexander McQueen, **Woman's Jacket and Skirt**, from the *It's Only a Game* collection, Spring/Summer 2005; **Woman's Boots**, from the *Pantheon ad Lucem* collection, Fall/Winter 2004–5

117

Alexander McQueen, **Woman's Jacket**, from the *Joan* collection, Fall/Winter 1998–99

SURFACE DECORATION

Beyond crafting his fashionable silhouettes, McQueen's technical mastery extended to patterned, shaped, and embellished textile surfaces created through traditional techniques or innovative materials and visual effects, often inspired by his predecessors and muses. Several black-and-white printed looks underscore his strong graphic sense and appreciation for photographic techniques and history, which he incorporated into surface treatments to reinforce artistic concepts.

A jacket from the *Joan* collection (opposite and pp. 86–87) reproduced an 1845 daguerreotype by Carl Gustav Oehme, an early adopter of the medium who trained with its inventor, Louis Daguerre.[1] Superimposing Oehme's image atop a sequined ground textile disrupts the print registration, producing a shadowy effect that further emphasizes the spectral quality of McQueen's collection, named for martyred saint Joan of Arc.

The designer may have become familiar with Wanda Wulz's 1932 photograph *Io + Gatto* (I + Cat) through Michel Frizot's *New History of Photography* (1998), which was held in his personal library.[2] Printed on a white leather dress (p. 125 right), McQueen gave the experimental image of two layered negatives further dimension and drape through laser-cut vertical slashes. A printed ensemble from *The Widows of Culloden* (p. 125 left), worn here with an intricately tiered fur coat, collages photorealist architectural imagery with birds, moths, and skulls, signifying the collection's themes of nature, metamorphosis, and memento mori.

A checkerboard suit from *Scanners* (p. 121) similarly flaunts McQueen's advanced cutting abilities: curved or squared, on the grain or bias, the pattern pieces are meticulously arranged to create a vibrant optical illusion, visually sculpting the body. His technique can be compared to renowned American designer Gilbert Adrian, who excelled in the graphic pattern placement of tailored suits (p. 120). Referencing another master of twentieth-century pattern cutting, McQueen used curved seams and quilting to create a down-filled jacket (p. 123) that recalls Charles James's influential 1937 eiderdown jacket (p. 122), a notable precursor to high fashion "puffer" styles.

McQueen himself advanced innovative digital technologies that have left a lasting mark on fashion. Digitally manipulated images of crystals—exemplifying his fascination with the interplay between the natural and the artificial—form the basis of dresses from *Natural Dis-tinction, Un-Natural Selection* (pp. 88, 124), a pioneering collection of digital print design. The engineered yet artful compositions achieve idealized silhouettes through print, rather than tailoring or undergarments.

From a collection memorializing Isabella Blow—McQueen's friend, patron, and muse—a deceptively simple black dress displays the designer's gift for imbuing the technical with the personal (pp. 126–27). On the wearer's left side of the fully embellished surface, opaque and translucent gold-colored beads are precisely embedded between vertical rows of black sequins to produce a faithful portrait of Blow. Mimicking a lenticular print, this representation of her face is visible only at certain angles, an effect not unlike the experience of memory.

1 John Matheson, conversation with the curators, March 5, 2021. The children's clothing supports the 1840s date of the Oehme photograph.

2 The National Art Library at the Victoria and Albert Museum has compiled a resource documenting McQueen's research library (www.vam.ac.uk/articles/mcqueens-research-library).

Gilbert Adrian, **Woman's Suit (Jacket and Skirt)**, 1943–45

Alexander McQueen, **Woman's Suit (Jacket and Skirt)**, from the *Scanners* collection, Fall/Winter 2003–4

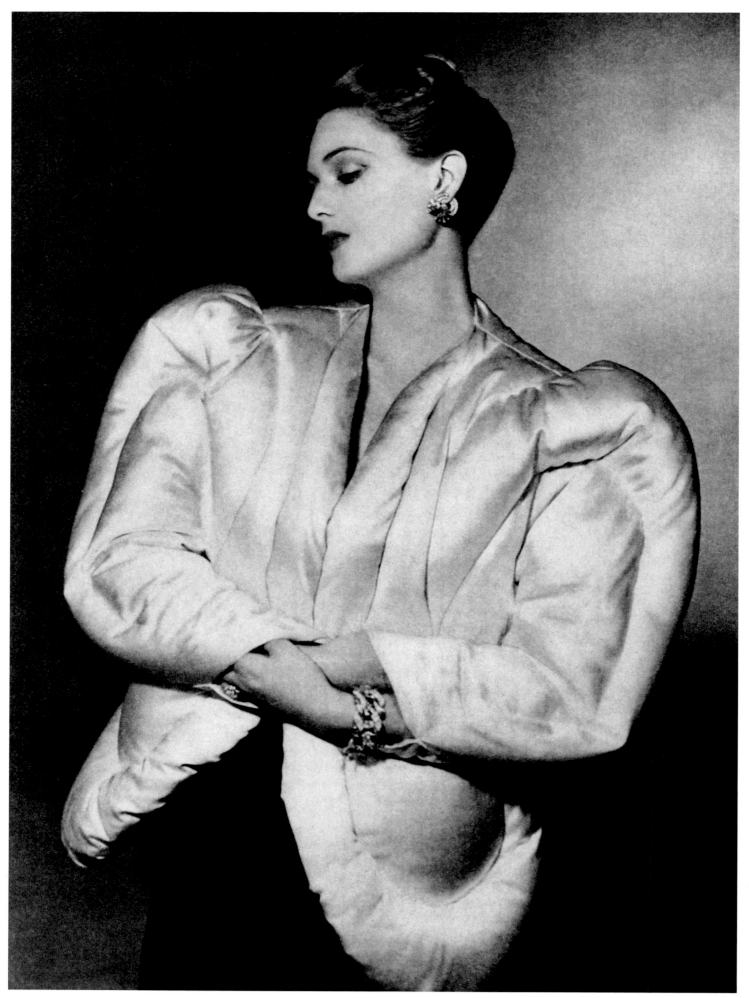

Charles James, **Woman's Jacket**, 1937. Photographed for *Harper's Bazaar*, October 1938

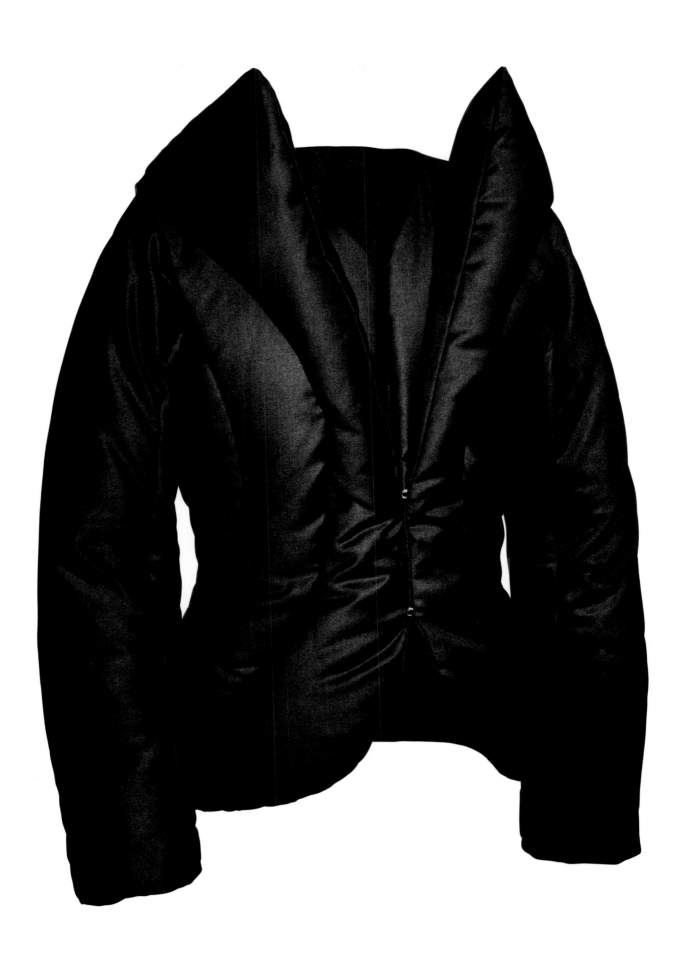

Alexander McQueen, **Woman's Jacket**, from *The Overlook* collection, Fall/Winter 1999–2000

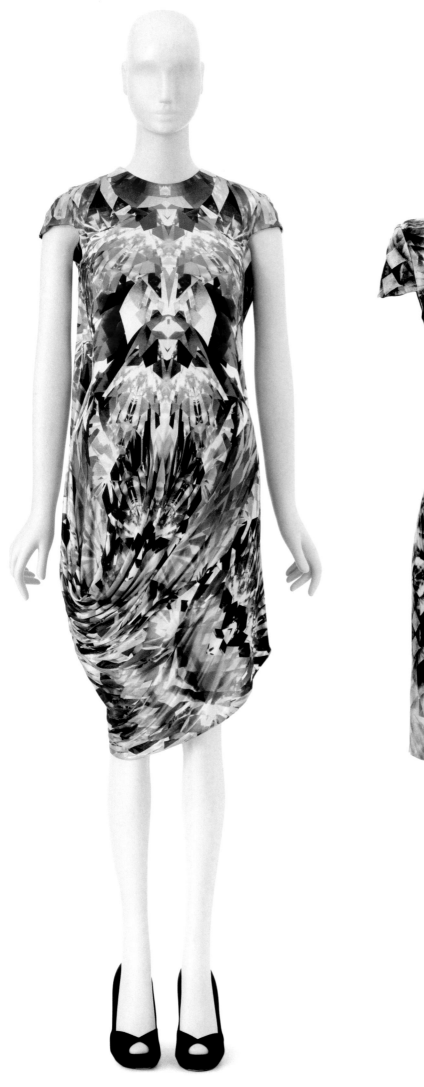

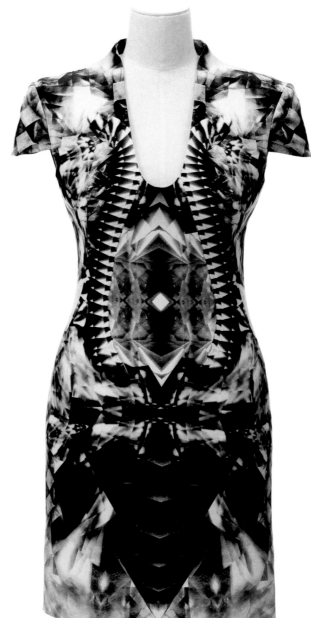

Left: Alexander McQueen, **Woman's Dress and Shoes**, from the *Natural Dis-tinction, Un-natural Selection* collection, Spring/Summer 2009
Right: Alexander McQueen, **Woman's Dress**, from the *Natural Dis-tinction, Un-natural Selection* collection, Spring/Summer 2009

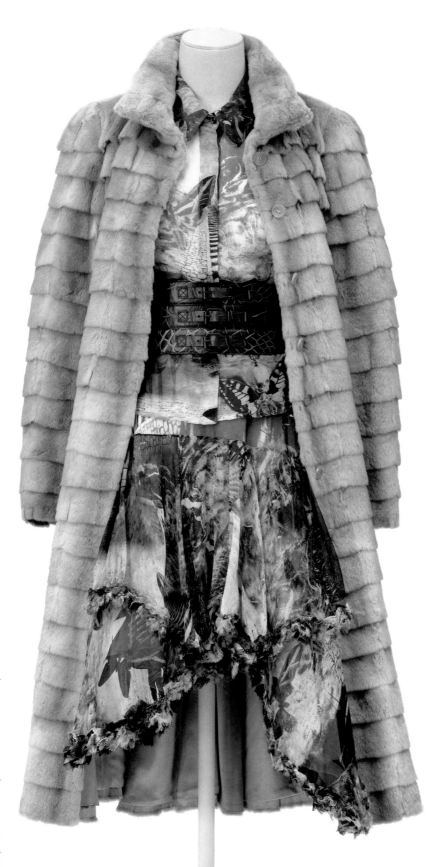

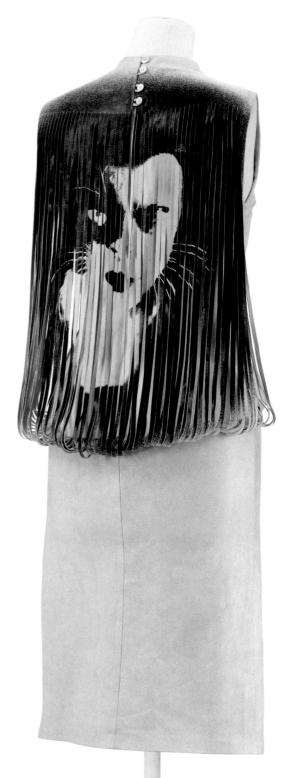

Left: Alexander McQueen, **Woman's Ensemble (Blouse and Skirt), Coat, and Belt,** from *The Widows of Culloden* collection, Fall/Winter 2006–7
Right: Alexander McQueen, **Woman's Dress,** from the *Eshu* collection, Fall/Winter 2000–2001

Alexander McQueen, **Woman's Dress**, from the *La Dame Bleue* collection, Spring/Summer 2008;
Woman's Shoes, attributed to Pre-Collection, Fall/Winter 2003–4; Philip Treacy, **Woman's Hat**, 2005

Alexander McQueen, **Woman's Dress**, from the *La Dame Bleue* collection, Spring/Summer 2008 (detail)

EVOLUTION AND EXISTENCE

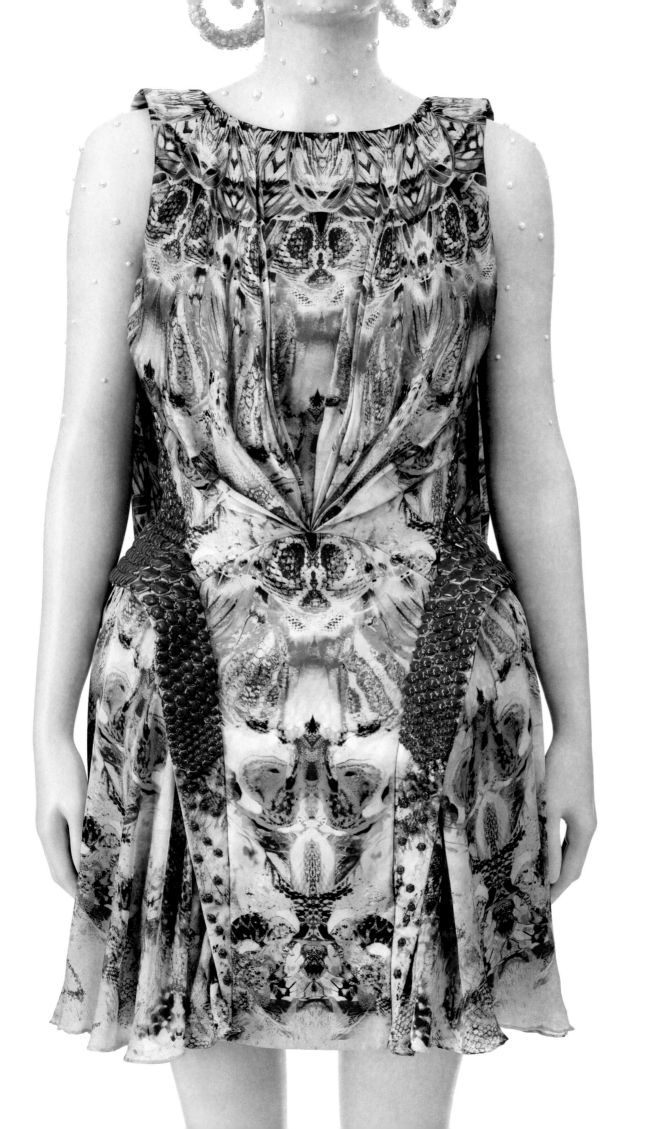

EVOLUTION AND EXISTENCE

EVOLUTION AND EXISTENCE examines McQueen's fascination with life cycles and the human condition. He believed it was important to think deeply about nature, evolution, and death, and his considerations resulted in collections that explored the inherent fragility and regeneration of life. Conceived during the Great Recession, which began in 2007, *The Horn of Plenty* was the designer's critique of consumerism and its role within the worldwide economic collapse. He based the collection on recycling—specifically, recycling famous silhouettes from both himself and haute couturiers before him, but reimagined with references to trash.

1 McQueen, quoted in Harriet Quick, "Killer McQueen," *Vogue* (UK), October 2002.

2 "McQueen: In His Own Words," *Drapers*, February 20, 2010.

"I JUST THINK I'VE SUSSED OUT WHAT IT ALL MEANS.
FROM THE OLD NARRATIVE OF LIFE AND DEATH
I HAVE TO START THINKING ON A WIDER SCOPE.
I MEAN I'VE DONE RELIGION, DONE SEX, DONE POLITICS
AND DEATH IN A BIG WAY. MAYBE I SHOULD START
DOING LIFE—BUT THEN LIFE IS ALL OF THOSE."[1]

In *The Dance of the Twisted Bull*, McQueen looked at the relationship between life and death in a collection inspired by bullfighting. *Deliverance* investigated human desperation amid the Great Depression by showing another sort of "dance to the death." He presented the collection as a 1930s-inspired American dance marathon, strongly informed by the film *They Shoot Horses, Don't They?* (1969). Drawing on Victorian mourning practices, McQueen also cited the work of filmmaker Stanley Kubrick in *Sarabande*. Like seventeenth-century Dutch still life paintings of flowers, the collection examines both beauty and the decay that inevitably follows.

As frequently as McQueen questioned the meaning of life, his work ultimately reinforces his view of death: not as an end, but an opportunity for change. This is clear in his final fully realized collection, *Plato's Atlantis*, which imagines a world consumed by the ocean, the place where life began—and where, McQueen suggested, life would evolve to return. As he asserted, "It is important to look at death because it is a part of life. It is a sad thing, melancholy but romantic at the same time. It is the end of a cycle—everything has to end. The cycle of life is positive because it gives room for new things."[2]

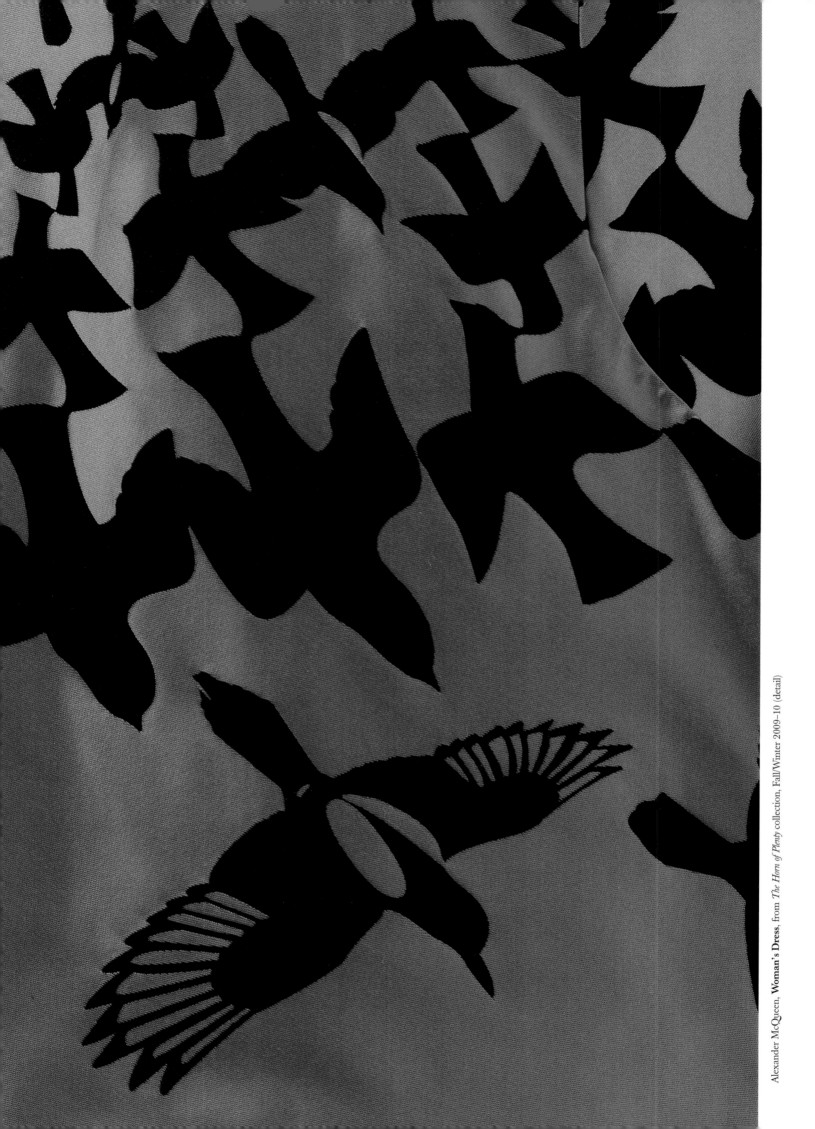

Alexander McQueen, **Woman's Dress**, from *The Horn of Plenty* collection, Fall/Winter 2009–10 (detail)

THE HORN OF PLENTY FALL/WINTER 2009–10

Between 2007 and 2009, economies slumped across the globe. In *The Horn of Plenty*, his Fall/Winter 2009–10 collection, McQueen critiqued the financial and social structures—including the fashion industry and its reliance on over-consumption—that had imperiled the world's economies. "The turnover of fashion is just so quick and so throwaway," he stated, "and I think that is a big part of the problem. There is no longevity."[1]

But he also used the collection as a means of self-reflection: "It's a punked-up McQueen 'It Girl' parody of a certain ideal," he said, "of a woman who never existed in the first place."[2] Parodying famed haute couturiers (including Dior, Chanel, Yves Saint Laurent, and Givenchy) as well as himself, he revised and exaggerated well-known silhouettes of fashion history, mixing these with references to trash and recycling. This includes a black coat dress that resembles a trash bag (p. 137); though made of a woven textile and expertly shaped, its "bin liner" reference is overt.

In the runway show, couture classics were transgressively reimagined as models sported clown-like makeup, a nod to avant-garde subcultural performance artist Leigh Bowery. Artist Rodney McMillian has similarly reflected on the body as a site of artmaking, using post-consumer materials to give insights into class and capitalism. Purchased from a thrift shop, an old bed sheet—an intimate object synonymous with the body and the bed, a place for love, rest, and even death—serves as the canvas for *Untitled (Zip)* (p. 136). The sheet is adorned with latex paint, and a vertical cut down the middle is stitched back together with black thread.

However subversive he intended this collection to be, McQueen also approached *The Horn of Plenty* as a fifteen-year retrospective.[3] The collection's title connotes bounty, but it is also the name of the pub where the final victim of Jack the Ripper (the inspiration behind McQueen's first collection) was last seen. In addition to reusing previous silhouettes in the collection, the runway presentation recycled jewelry, headpieces, and even songs from previous shows. The center of the stage was heaped with previously used stage props, along with additional objects found in landfills.

A textile design imagined by Simon Ungless and first used in McQueen's Spring/Summer 1995 collection, *The Birds*, makes its return in a red dress (opposite and p. 135). Printed with a radiating houndstooth design (a nod to Dior) that transforms into flying birds, the pattern reimagines the graphic work of M. C. Escher. The print also recalls the natural phenomenon of murmuration, where large numbers of starlings fly in formation, morphing between chaos and order—amorphous aerial patterns captured by photographers Richard Barnes and Graciela Iturbide (p. 134). When viewed against the backdrop of the Recession and the culmination of events that caused it, chaos and order depend both on the individual and the group to dictate which direction the flock turns.

1 McQueen, quoted in Judith Watt, *Alexander McQueen: The Life and the Legacy of Alexander McQueen* (New York: HarperCollins, 2012), 258.

2 McQueen, quoted by Susannah Frankel, in Nick Waplington, *Alexander McQueen: Working Process* (Bologna: Damiani, 2013), 2.

3 Tim Lewis, "Why We're All Still Mad about Alexander McQueen," *The Guardian*, February 7, 2015.

134

Top: Richard Barnes, *Murmur 23 (December 6, 2005)*, 2005
Bottom: Graciela Iturbide, *Pájaros en el Poste, Carretera a Guanajuato, México*, 1990, printed c. 2000

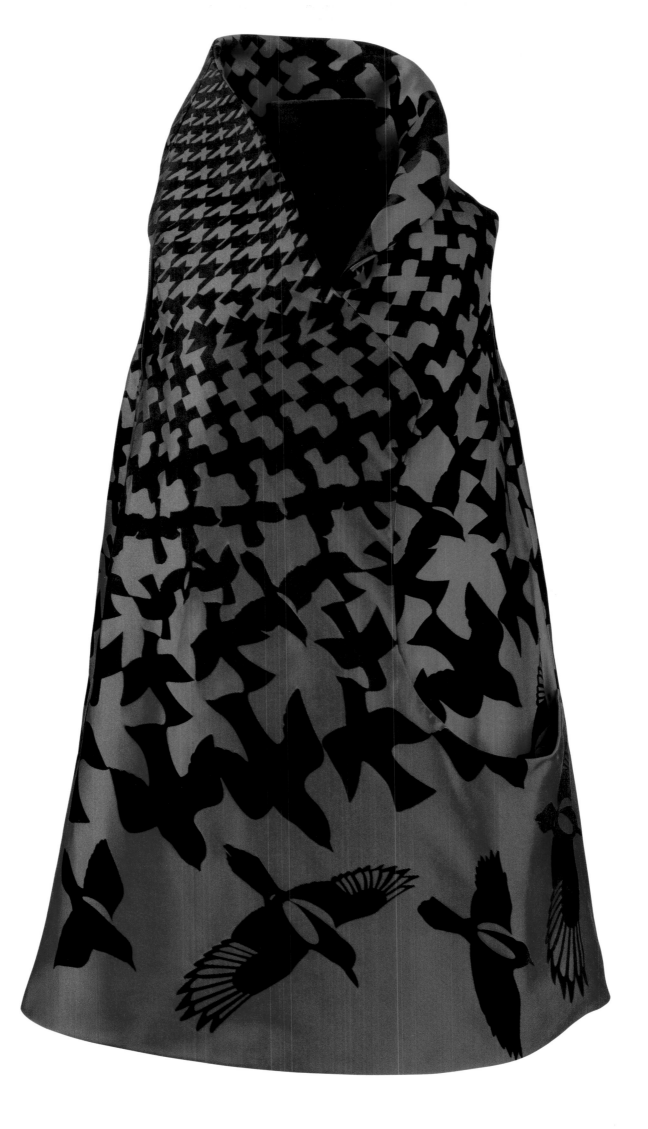

Alexander McQueen, **Woman's Dress**, from *The Horn of Plenty* collection, Fall/Winter 2009–10

Rodney McMillian, *Untitled (Zip)*, 2011

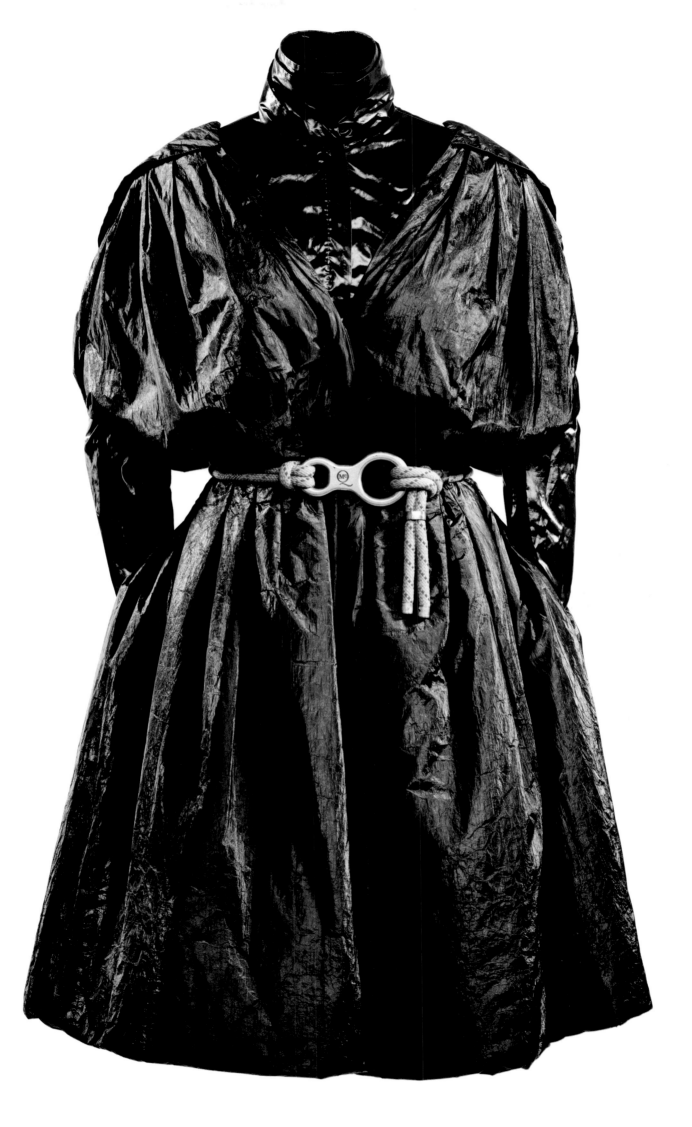

Alexander McQueen, **Woman's Ensemble (Blouse and Dress)**, from *The Horn of Plenty* collection, Fall/Winter 2009–10; McQ by Alexander McQueen, **Woman's Belt**, from the Spring/Summer 2007 collection

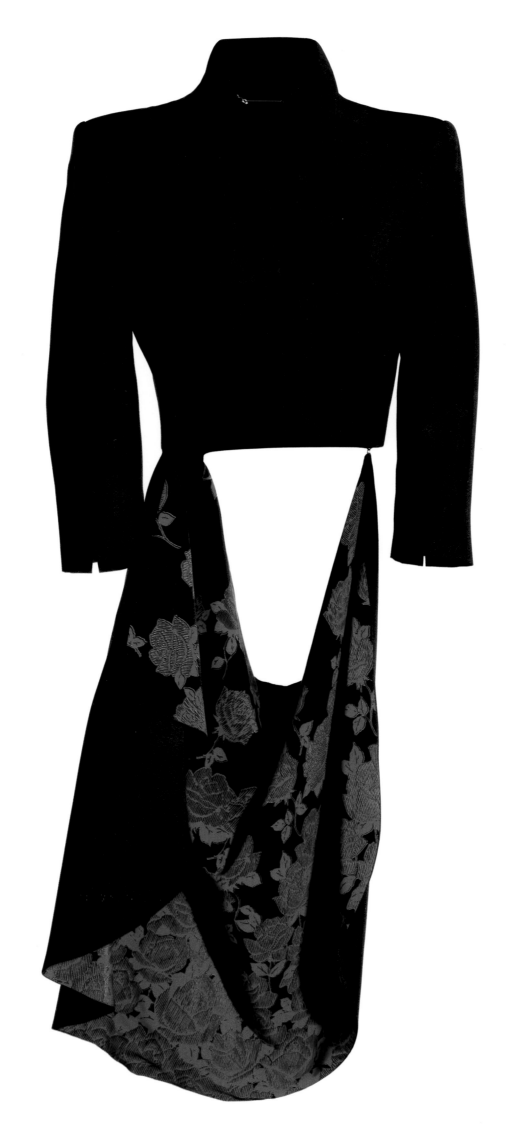

Alexander McQueen, **Woman's Jacket**, from *The Dance of the Twisted Bull* collection, Spring/Summer 2002

THE DANCE OF THE TWISTED BULL

SPRING/SUMMER 2002

The bullfight, or *corrida*, inspired McQueen's Spanish-influenced Spring/Summer 2002 collection, *The Dance of the Twisted Bull*. Interpreted by the designer as both masculine and feminine, the costume of the male matador (known as *traje de luces*, or "suit of lights") informed the collection's silhouettes, with accents drawn from the traditional costume of female flamenco dancers. Tailored angles and draped ruffles blend in a collection that looks at bullfighting's undercurrent of eroticism and death. The runway show featured a video of both a bullfight and a sex scene, clearly reiterating this point.

A black tailored jacket (opposite) with sharp, broad shoulders is cut at the waist, referencing the shortened matador jacket (*chaquetilla*). The jacket's tail is lined in silk printed with red roses, referencing the flowers closely associated with flamenco, but also the color of bloodshed; one side of the tail can be unhooked, giving the effect of the cape used in the matador's dance to entice the bull. A less subtle reimagining of the flamenco dancer's dress is found in a black ensemble (p. 142) that pairs a rigid corset with lacing detail and an asymmetrical ruffled skirt, insinuating the movement of a traditional tiered and ruffled flamenco dress.

A reimagination of the matador's close-fitting breeches (*taleguilla*), worn high on the waist and held in place with braces or suspenders (*tirantes*), is found in two ensembles from McQueen's Spring/Summer 2007 collection, *Sarabande* (p. 143), which was also inspired by Spanish motifs and art. Each look features a ruffled shirt, one in white with open-work embroidery referencing Spanish blackwork, and one of black-embroidered lace recalling a woman's mantilla headcover. Both blouses are constructed similarly to eighteenth-century men's shirts, perhaps due to the influence of the eighteenth-century period film *Barry Lyndon* (pp. 154–55).

The Spanish bullfight has long symbolized dichotomies of brutality and beauty, hard horns or spears and soft flesh.[1] McQueen interpreted the *corrida* from an outsider's perspective, but followed in the footsteps of Spanish artists Francisco de Goya and Pablo Picasso, who both drew upon the bullfight in their own practices. Goya's *Un caballero espanol mata un toro despues de haber perdido el caballo* (A Spanish Knight Kills the Bull after Having Lost His Horse) comes from his series *La Tauromaquia* (Bullfighting), published in 1816. Goya's work, which offers a visual history of bullfighting in Spain, directly inspired Pablo Picasso's 1959 portfolio *La Tauromaquia, o arte de torear* (Tauromachy, or the Art of the Bullfight) (pp. 140–41). Though both artists were devoted to the pastime, they also reflected on the mortal aspects of it.

1 Though bullfighting is legally practiced in Spain, Portugal, southern France, Mexico, Colombia, Ecuador, Venezuela, and Peru, McQueen focused his collection on the *corrida* of Spain.

TAUROMAQUIA

Pablo Picasso

1 Picasso, quoted in Marie-Laure Bernadac, "Le gazpacho de la corrida," in *Picasso: toros y toreros*, exh. cat. (Paris: Réunion des Musées Nationaux, 1993), 48. (My translation.)

2 Jaime Sabartés, *Picasso: Toreros* (New York: George Braziller, 1961), p. 58; quoted in V. P. Curtis, *La Tauromaquia: Goya, Picasso and the Bullfight*, exh. cat. (Milwaukee: Milwaukee Art Museum, 1986), 70.

3 A true obsessive, Picasso designed a bull's head watermark for the custom-made paper. A gilt-lettered spine and yellow cloth-covered slipcase contribute to the overall elegance of the production. The realization of a total edition of 263 is, when considered from the perspective of the many contributors, remarkable.

An innovator in virtually all mediums, Pablo Picasso (1881–1973) frequently turned to print-making as a natural outgrowth of his passion for drawing. He made approximately 2,400 prints in his lifetime, and the theme of the *corrida*, or bullfight in the ring, recurs throughout. His fascination with the bullfight began as a child growing up in Andalucía. Bullfights are traditionally held on Sundays, and Picasso recounted his uncle's persuasive proviso in an attempt to get him to church: "My uncle Salvador told me that if I didn't go to communion, he wouldn't take me to the bullfight. So I went to communion and I would have gone twenty times to be able to go to the corrida."[1] As his lifelong friend Jaime Sabartés once professed, Picasso was an aficionado "by tradition, by blood, and by artistic devotion."[2] Certainly, Picasso took inspiration from his Spanish predecessor, Francisco de Goya, whose thirty-three-print series *Tauromaquia* (1815–16) is one of the landmarks of etching.

Both physical contest and performance art, the corrida allowed Picasso to grapple with themes as elemental as sexual domination and death. In some works he clearly identifies with the bull, capable of overpowering every other creature in the ring; in others, he is the triumphant matador, exerting his will through seductive finesse. By 1927, Picasso's close association with the motif led to an invitation by publisher Gustavo Gili, Sr., to illustrate a special edition of Spanish matador Pepe Illo's *Arte de torear*, a 1796 handbook for *toreros* and aficionados. The Spanish Civil War and World War II contributed to a three-decade pause in the project, until Gili's son brought it back to Picasso's attention in 1956. The artist was by then residing in the south of France, and Gili's prompt was fresh in his mind when he attended Arles' Easter corrida in 1957. In one inspired afternoon shortly thereafter, he took up copper plates and painted directly on them with loose, fluid gestures. In twenty-six scenes, Picasso rendered different moments of combat and ceremony in and around the arena.

Inspiration had struck, but the real work remained to be done. Like couture, printmaking is a collaborative and exacting process, requiring the visionary artist to work in tandem with numerous skilled specialists. In this case, Picasso relied upon the expertise of two master printers over a period of two years: Atelier Lacourière, Paris, for aquatints; and Talleres de Jaume Pla, Barcelona, for drypoints.[3] Ultimately, the *Tauromaquia*'s impact derives from Picasso's devotion to the theme—and from the dedication of many craftspeople, named and unnamed.

BRITT SALVESEN
Curator and Department Head, Wallis Annenberg Photography Department and Department of Prints and Drawings

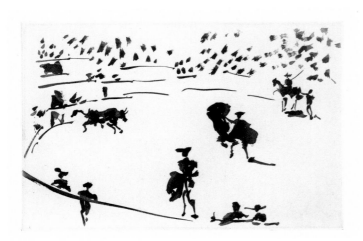
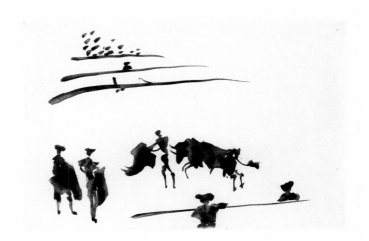
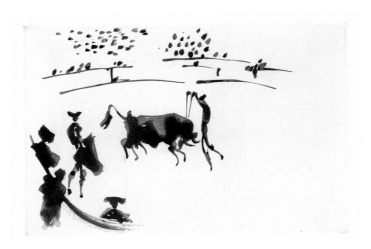
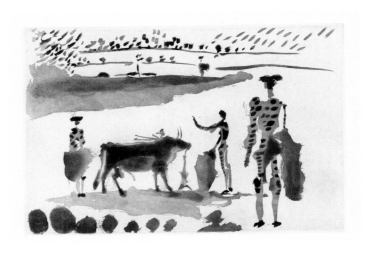
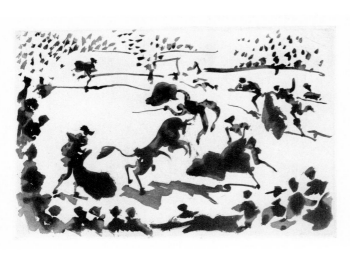
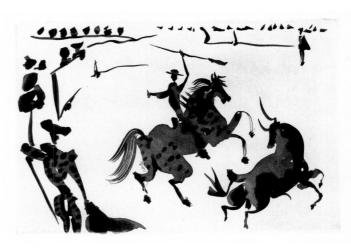

Pablo Picasso, eight scenes from *La Tauromaquia, o arte de torear*, 1959

Alexander McQueen, **Woman's Ensemble (Bustier and Skirt) and Shoes**, from *The Dance of the Twisted Bull* collection, Spring/Summer 2002; Michael Schmidt, **Headpiece** (glass bugle beads, silk, and papier-mâché), 2020

Left: Alexander McQueen, **Woman's Ensemble (Blouse and Skirt) and Shoes,** from the *Sarabande* collection, Spring/Summer 2007

Right: Alexander McQueen, **Woman's Blouse and Trousers,** from the *Sarabande* collection, Spring/Summer 2007; **Woman's Shoes,** Pre-collection, Fall/Winter 2010–11

Alexander McQueen, **Woman's Capelet, Pants, and Shoes,** from the *Deliverance* collection, Spring/Summer 2004; **Woman's Blouse,** from *The Girl Who Lived in the Tree* collection, Fall/Winter 2008–9; Michael Schmidt, **Headpiece** (leather herringbone twill weave), 2021

DELIVERANCE SPRING/SUMMER 2004

Deliverance, the Spring/Summer 2004 collection, was inspired by the 1969 film *They Shoot Horses, Don't They?*, as well as by McQueen's desire to work with dancer Michael Clark. "I've always wanted to incorporate movement into the clothes, some form of emotion through movement of dance," the designer recalled. "I'd watched this film... it had all the feelings of a McQueen show, the sadness, the happiness, the desperation."[1]

The film, directed by Sydney Pollack, portrays contestants in a Great Depression dance marathon risking their health, for the entertainment of paying audiences, in the unlikely hope of winning desperately needed cash. In McQueen's imagination, dance marathons became a metaphor for his experience working in fashion. Capturing the film's sense of foreboding looming amidst the ostensibly jovial dance hall—an atmosphere similarly rendered in Georg Tappert's cabaret scene (pp. 148–49) or Paul Cadmus's satirical portrayal of Coney Island beachgoers (p. 146)—*Deliverance* implicates the fashion industry for profiting from designers subjected to its unrelenting demands.

The collection's silhouettes and runway staging closely approximated the film's set and costume design, as Clark's energetic choreography conveyed the initial anticipation of dance marathon contestants. Crystal-embellished gowns embody the escapism of 1930s Hollywood, while the black-feathered "raven cape" (opposite) introduces an ominous element. Ravens, like some other birds of prey, are traditionally associated with death. McQueen employed such memento mori throughout his career in collections addressing life cycles. This leitmotif even imbued the accessories in *Deliverance*: wristwatch-style sandal straps (p. 147 left and right) were set to six and nine o'clock, a reference to McQueen's 1969 birth year that acknowledged the passage of time.

Both *They Shoot Horses, Don't They?* and *Deliverance* turn their respective settings—dancehalls and runways—into literal racetracks. McQueen translated such scenes into 1930s-style bias-cut dresses that include competitor numbers (p. 147 center) and sporting jersey dresses (p. 147 left and right) worn as models stampeded one another to cross a finish line onstage (p. 151). A notable departure from his signature tailoring, these knit elastic ensembles allow the wearer an athlete's freedom of movement. *Deliverance*'s racetrack was also suggestive of seasonal pressure on designers to deliver new ideas, and the burnout experienced by many in the fashion industry.[2]

McQueen's final looks represented exhaustion—of the Depression, of dance marathons, of designers—with patchworking (pp. 4, 92) and denim workwear looks based on Americana that cautioned of struggles waiting outside glamorous fashion week presentations. The runway show closed on a dancer collapsed lifelessly at center stage, animating *danse macabre* imagery (p. 150) in a provocative critique of the fashion industry.

1 *Paris Modes*, episode featuring Alexander McQueen, produced and presented by Marie-Christiane Marek, aired January 15, 2004, on Paris Première (www.youtube.com/watch?v=hOA-osK6aH0).

2 *They Shoot Horses, Don't They?* culminates with the protagonist, played by Jane Fonda, expressing her desperation with the statement, "I'm gonna get off this merry-go-round." This phrasing raises the possibility that McQueen's Fall/Winter 2001–2 collection, *What a Merry Go Round,* may have also been referencing Pollack's film. Presented on a macabre carousel set, the collection, like *Deliverance,* commented on McQueen's fashion industry experiences and incorporated memento mori, such as a prop skeleton attached to a model's ankle.

Paul Cadmus, *Coney Island*, 1934

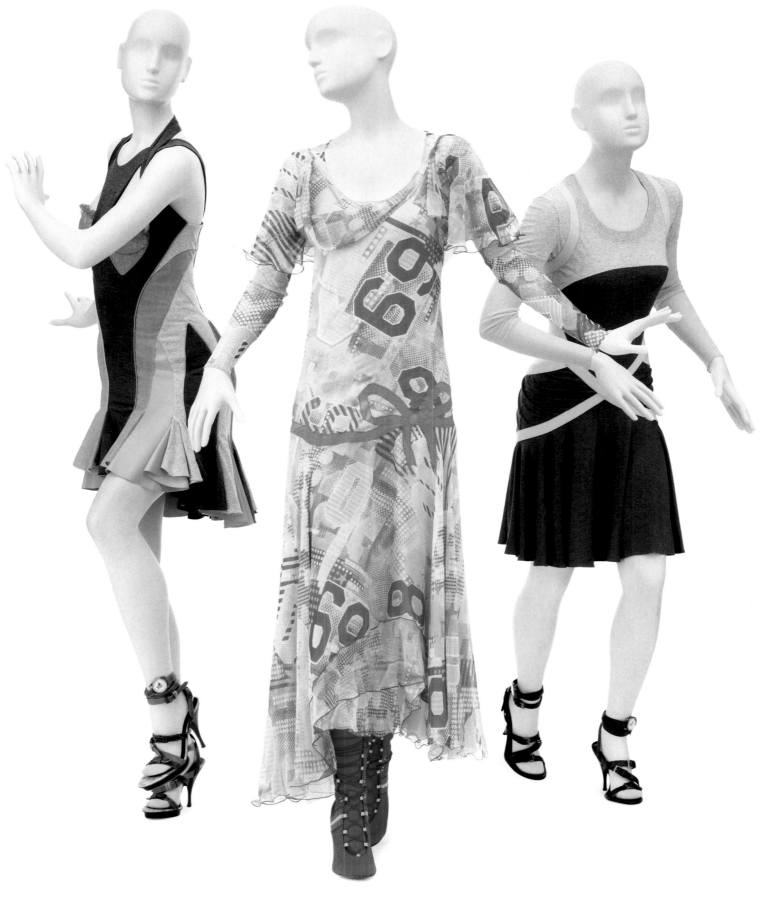

Left: Alexander McQueen, **Woman's Dress and Shoes**, from the *Deliverance* collection, Spring/Summer 2004; Center: Alexander McQueen, **Woman's Ensemble (Dress and Bodysuit) and Boots**, from the *Deliverance* collection, Spring/Summer 2004; Right: Alexander McQueen, **Woman's Dress and Shoes**, from the *Deliverance* collection, Spring/Summer 2004

EVOLUTION AND EXISTENCE

DANCE IN THE CABARET

Georg Tappert

1 *Dance in the Cabaret* is from a portfolio of eight woodcuts by Tappert illustrating Theodor Däubler's poem "Der Nachtwandler" (The Sleepwalker). Both Tappert and Däubler were affiliated with German Expressionism, a movement that included artists, writers, poets, and intellectuals. Däubler's poetry was frequently included in Expressionist periodicals and was issued in luxury editions like this portfolio, which was published by Alfred Flectheim, an important Düsseldorf gallerist.

2 Alice Gerstel, "Jazz Band," in *Die Aktion* 12, nos. 4–5 (February 4, 1922), 90–91, in *The Weimar Republic Sourcebook*, ed. Anton Kaes, Martin Jay, and Edward Dimendberg (Berkeley: University of California Press, 1994), 554.

Georg Tappert's *Dance in the Cabaret* offers a jumble of curvilinear shapes and hatch marks that transform, on closer inspection, into dancing bodies lit by spotlights and encircled by faces.[1] There is no depth, no sense of perspective; Tappert's fractured cubist forms enhance the scene's claustrophobic compression of space and the feeling of frenzied movement.

This compositional arrangement—with dancers at the center and observers on the periphery—mimics the layout of a cabaret, in which the audience views performers from tables surrounding the stage. Cabaret was introduced to Germany from France around 1900 and became especially popular in cosmopolitan Berlin. Featuring singing, dancing, and comic acts, it was distinguished by a satirical perspective that treated sex, politics, and culture with ironic, even cynical detachment. It not only offered distracting thrills and amusements, it also centered the marginal and was a place of subversion and escape.

Tappert's print is characterized by an uncanny mixing of dream and reality, but also typifies the surreality of Germany itself during the early years of the Weimar Republic. The manic energy of the "roaring twenties" was already present, but this carried a more ruthless character in a country that was constantly churning from one upheaval to the next—from disastrous defeat in World War I in 1918, followed by a bloody revolution in 1919 and devastating inflation that would persist through 1923. In this unsettled environment, people pursued temporary pleasures with abandon. One contemporary commentator would write of these joyless hedonists that "Nothing can dissuade them from the secret of which they are certain: how dreadful is the wretchedness of this time, how there remains nothing for them to do but dance."[2]

ERIN SULLIVAN MAYNES
Assistant Curator, Robert Gore Rifkind Center for German Expressionist Studies

53/130

Georg Tappert, *Dance in the Cabaret*, 1918, published 1920

Ernst Barlach, *Dance of Death 2*, 1924

Runway presentation of Alexander McQueen's *Deliverance* collection, Spring/Summer 2004, at La Salle Wagram, Paris, October 10, 2003

EVOLUTION AND EXISTENCE

151

Alexander McQueen, **Woman's Ensemble (Dress and Blouse) and Shoes,** from the *Sarabande* collection, Spring/Summer 2007; Michael Schmidt, **Headpiece** (silk flowers, Swarovski crystals, and silk lace), 2021

SARABANDE SPRING/SUMMER 2007

An ode to the fragility of beauty, the *Sarabande* collection derived its title from a sixteenth-century dance originating in colonial Latin America. The musical style was considered provocative in Europe until its adaptation by Baroque composers such as George Frideric Handel, whose fourth movement of the harpsichord suite in D minor would later be used for the title sequence of Stanley Kubrick's *Barry Lyndon* (1975) (pp. 154–55). The fatalistic romanticism manifested in *Barry Lyndon* and evoked in *Sarabande* underscores the artistic proficiencies shared by Kubrick and McQueen, including craftsmanship, singular vision, and an exceptional capacity for worldmaking.

The collection's suits and dresses in black, white, and muted pink and mauve reference European mourning practices. Delicately ruched black silk net over white (pp. 157, 159) accentuates the curves of the body while mimicking the feel of crape, the textured silks fashionably appropriate for grieving in the nineteenth and early twentieth centuries.

McQueen used flowers, both silk and fresh, throughout the collection in both grand and subtle ways, as seen in muted pink shoes (p. 159) with flowers at the heel accessorizing a softly draped dress. He cited Sam Taylor-Johnson's film of decaying fruit, *Still Life*, as a source of inspiration: "Things rot. It was all about decay. I used flowers because they die."[1] Taylor-Johnson, in turn, cited the work of seventeenth-century Dutch still-life paintings as her inspiration. With its masterful use of light and shadow, Dirck de Bray's *Flowers in a Glass Vase* (p. 158) illustrates colorful wildflowers picked at their height of beauty, with some beginning to wilt. Garden flowers, their blooms inevitably giving way to eventual decay, serve to remind viewers of the passage of time.

A black lace dress with patterns of flowers in vases features wide hips (opposite and pp. 128–29), a silhouette that references the panniers worn in the eighteenth century, as featured throughout *Barry Lyndon*. However, McQueen looked at this shape more architecturally: "I liked the padded hips because they didn't make the [piece] look historical, but... more sensual. Like the statue of Diana with breasts and big hips. It's more maternal, more womanly."[2] He balanced the feminine form with the grandeur of decay by also referencing the work of painter and printmaker Francisco de Goya (p. 156), particularly in the artist's honest approach towards depicting humanity. McQueen does the same in his examination of the inevitability of life and death; in the final walk of the collection's runway show, the color palette transitioned from black, to gray, to mauve—the traditional order of mourning colors—circling the runway like a cycle of life.

1 McQueen, quoted in Susannah Frankel, "The Real McQueen," *Harper's Bazaar*, April 1, 2007.

2 McQueen, quoted in Oliver Zahm, "Alexander McQueen," *Purple Fashion*, no. 7, Spring/Summer 2007.

BARRY LYNDON

Stanley Kubrick

1 *The Luck of Barry Lyndon* was first published as a serial in 1844 and reissued as *The Memoirs of Barry Lyndon, Esq.* in 1852.

2 Willem Hesling, "Kubrick, Thackeray and *The Memoirs of Barry Lyndon, Esq.*," *Literature/Film Quarterly* 29, no. 4 (2001): 276.

3 These compositions were aided by the production design of Ken Adam, the cinematography of John Alcott, and the costume design of Milena Canonero and Ulla-Britt Søderlund.

4 Rodney Hill, "*Barry Lyndon*," in *The Stanley Kubrick Archives*, ed. Alison Castle (Cologne: Taschen, 2005), 435.

5 John Hofsess, "How I Learned to Stop Worrying and Love *Barry Lyndon*," *New York Times*, January 11, 1976.

Adapted from the picaresque novel by William Makepeace Thackeray,[1] Stanley Kubrick's *Barry Lyndon* (1975) chronicles the eighteenth-century exploits of Redmond Barry (played by Ryan O'Neal), an Irish opportunist who ascends to become Lord Barry Lyndon before fate ultimately unravels his self-styled transformation. Structured in two parts, the film propounds a stunning arrangement of symmetries—of love requited and spurned and fortune gained and squandered, punctuated by an epilogue that signals the blossoming of a new century. As a "melancholy lamentation" of time elapsed and vitality lost,[2] *Barry Lyndon* also illuminates the emotionalism that perpetually simmers under—and occasionally punctures—the languidness of powdered gentility.

The film's rhythmic pacing underscores the constrictive absurdities of eighteenth-century classism while also relishing the candlelit lushness of Baroque ornamentation. Kubrick deliberately composed scenes to resemble paintings of the period, drawing particular inspiration from eighteenth-century *tableaux vivants* and the works of Thomas Gainsborough, Joshua Reynolds, William Hogarth, and Jean-Antoine Watteau.[3]

Handel's "Sarabande," reorchestrated by Leonard Rosenman, establishes a "majestic melancholy"[4] that defines the film's tone from its opening credits and beacons the advent of death throughout Barry's rise and fall. Lady Lyndon (played by Marisa Berenson), serenely described by the film's omniscient narrator as "melancholy and maudlin" in temper, is adorned in laces and embroidered silks of soft grays, ivories, and faded pinks, which starkly contrast the sanguine redcoats and emerald baize of gambling tables that determine Barry's own trajectory.

Audacious in its visual strategies and meticulous in its historicism, *Barry Lyndon* brings alive an idea of eighteenth-century Europe unparalleled in its painterly aesthetic and atmospheric immersion. "The most important parts of a film," Kubrick reflected, "are the mysterious parts—beyond the reach of reason and language."[5]

MEGHAN DOHERTY
Supervising Archivist, Graphic Arts, Academy Museum of Motion Pictures

Marisa Berenson as Lady Honoria Lyndon, on the set of *Barry Lyndon* at Wilton House, Wiltshire, England

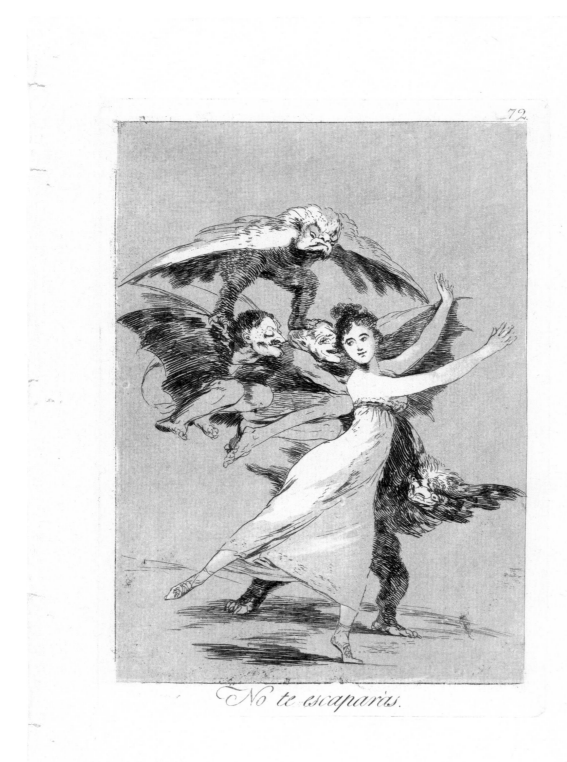

No te escaparás.

Francisco de Goya, *You Will Not Escape*, 1799

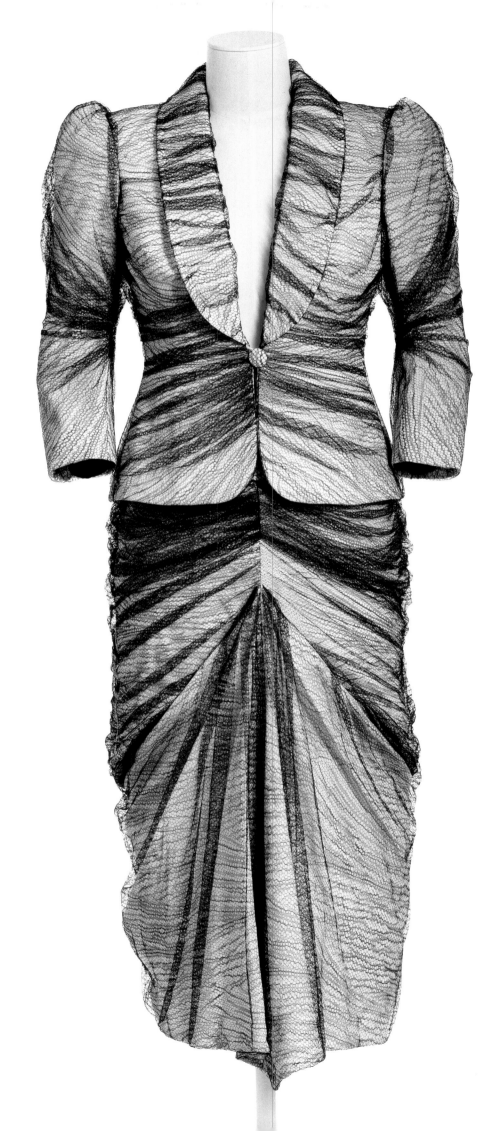

Alexander McQueen, **Woman's Suit (Jacket and Skirt)**, from the *Sarabande* collection, Spring/Summer 2007

Dirck de Bray, *Flowers in a Glass Vase*, 1671

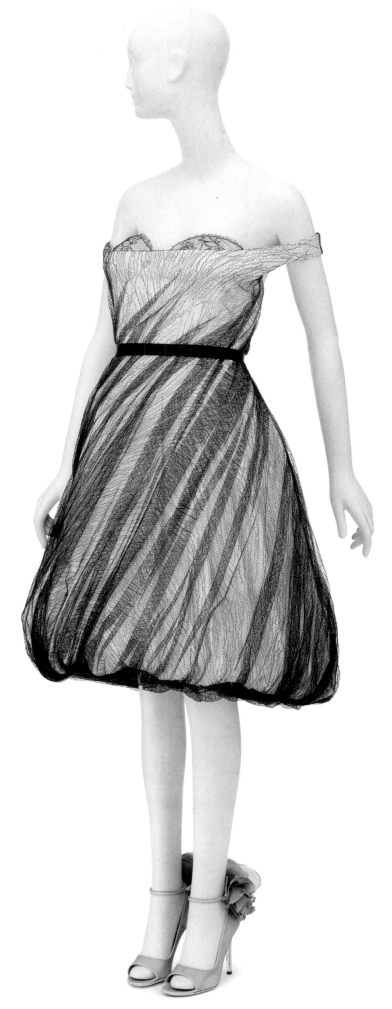

Alexander McQueen, **Woman's Dress and Shoes**, from the *Sarabande* collection, Spring/Summer 2007

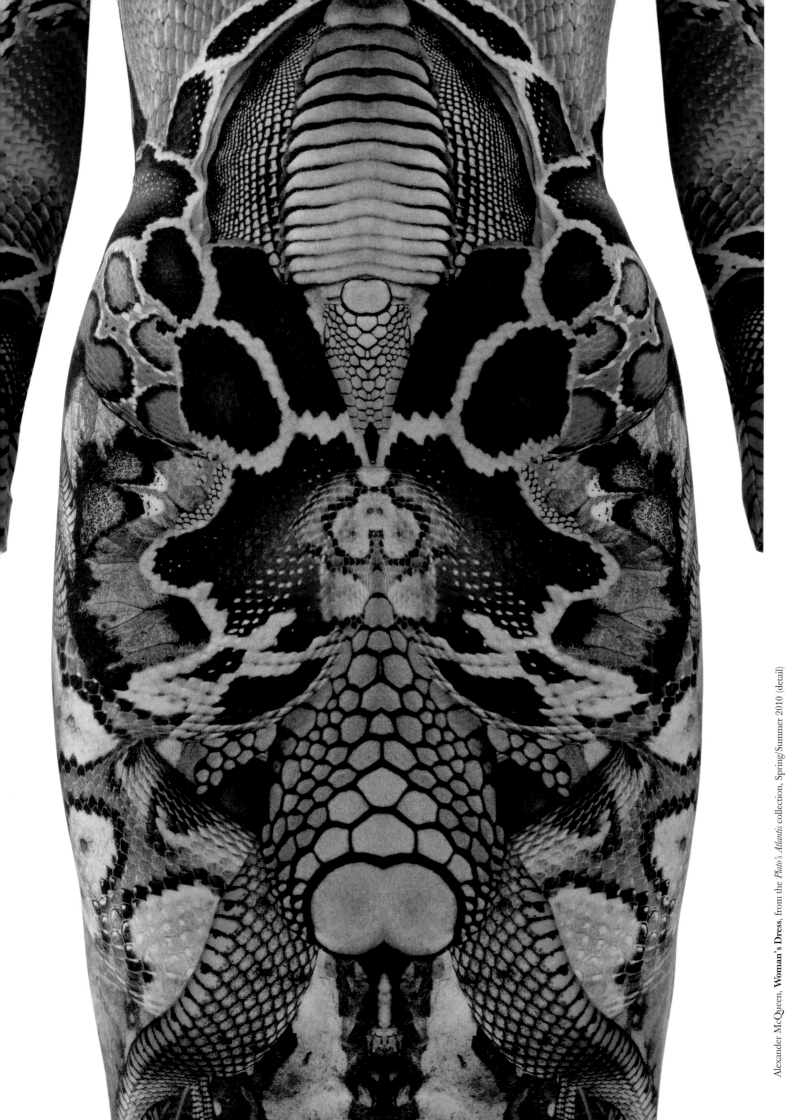

Alexander McQueen, **Woman's Dress**, from the *Plato's Atlantis* collection, Spring/Summer 2010 (detail)

PLATO'S ATLANTIS SPRING/SUMMER 2010

Plato's Atlantis envisions a science-fiction scenario: global warming has reversed evolution, driving humanity to adapt for survival underwater. The stages of this evolution—from human to hybrid, aquatic forms—are arrayed in the collection's innovative, digitally-engineered textiles and silhouettes that radically alter the female form.

Throughout his career, McQueen demonstrated an interest in evolutionary theories, which inspired explorations of humanity's place in the natural world or Darwinism as a metaphor for the cut-throat fashion industry. Here, a moth-print dress (pp. 166, 167 left) is a visual expression of natural selection and protective camouflage. Other designs harness the innate evolutionary defense mechanisms of stingrays and jellyfish (p. 167 right) for the wearer, in studies of the beauty found in strength. Digitally collaged textiles capturing meticulous likenesses of animals from the land, sky, and sea recall life-casting techniques used in lead-glazed earthenware to achieve remarkable animal facsimiles (pp. 162, 164–65). The style's sixteenth-century progenitor, Bernard Palissy, was a polymath whose art practice and observation of nature lead him to reject the prevailing explanation of fossils as remnants of the Great Flood in the Bible. Like McQueen, Palissy's intellectual engagement with ecosystem change was fundamentally visual.

Plato's Atlantis is also a commentary on rising sea levels. The collection demonstrates contemporary concerns about climate change that are echoed by Andreas Gursky's monumental photograph (p. 168) documenting melting ice caps from a series made the same year. The collection's "Titanic" shoe design, shown here in a ballerina style with a "Meccano" heel (p. 169 right),[1] references the famous ocean liner sunk by an iceberg. In McQueen's handling, the cautionary tale of the Titanic warns of impending repercussions for continued human destruction of the environment.

Despite portraying humanity's Atlantean return to the sea, the collection's overall tone was not pessimistic. Rather, *Plato's Atlantis* emphasized the interconnectedness of all existence. A blue mandala-like print design (pp. 8, 169 right) evokes the cosmic ocean and water's life-giving power. This notion of circularity, whether in nature or theology, features in much of McQueen's work, and is embodied in *Plato's Atlantis* by the "Reptilia" print (opposite and p. 163). Across cultures and art history, snakes have represented duality or life cycles, symbolizing evil or mortality, but also good and rebirth. The collection's runway show opened with a yellow hued "Reptilia" print, and, like an ouroboros, concluded with its return in watery shades of blue. Along with details such as scale-like paillettes (pp. 130, 169 left), the collection recalls the serpent's regenerative possibilities. For McQueen, who viewed water as a refuge, and Atlantis as "a metaphor for Neverland,"[2] *Plato's Atlantis* affirmed that from destruction, regrowth inevitably follows.

1 For more on this shoe style, see www.vam.ac.uk/museumofsavagebeauty/mcq/titanic-shoe/.

2 McQueen, interviewed by Nick Knight for SHOWStudio's *In Fashion* series, June 1, 2009 (showstudio.com/projects/in_fashion/alexander_mcqueen).

Manuel Cipriano Gomes Mafra, **Urn**, c. 1865–87

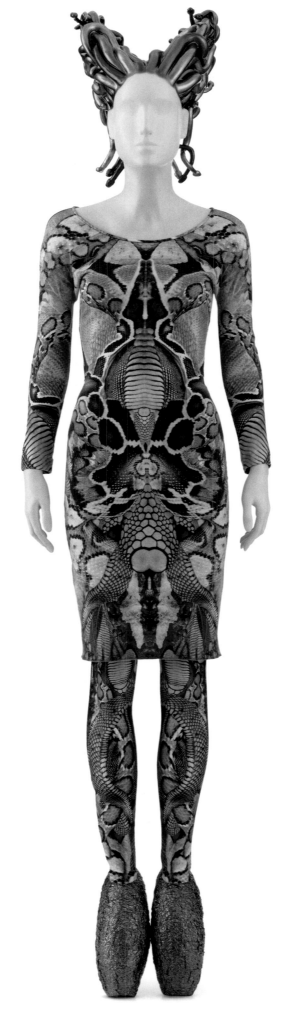

Alexander McQueen, **Woman's Ensemble (Dress and Leggings)**, from the *Plato's Atlantis* collection, Spring/Summer 2010;
Michael Schmidt, **Headpiece and Shoes** (Headpiece: 3D-printed mannequin and clay, painted; Shoes: heat-set candy wrappers, antiqued), 2021

LARGE OVAL RUSTIC DISH

1 See Jean-Claude Plaziat, "L'identification des moulages des coquilles fossiles et des organismes actuels des rustiques figulines: un apport naturaliste à la caractérisation des ateliers successifs de Palissy et de ses émules," *Technè* 47 (2019), journals.openedition.org/techne/1569.

2 For additional examples in LACMA's collection, see a Wedgwood platter with fish and foliage from 1876 (56.30.5), a dish with shells and fish from the Mafra factory in Caldas da Rainha, Portugal, made c. 1865–87 (M.2013.193.4), and a dish with lobsters and shells made in nineteenth-century France (M.2013.193.2).

3 For the identification of the Griffin Master, see Leonard Amico, *Bernard Palissy: In Search of Earthly Paradise* (New York: Flammarion, 1996), 127–29.

Teeming with foliage, fish, amphibians, reptiles, insects, crustaceans, and mollusks, this spectacular display dish, made in the style of Bernard Palissy, presents an ecological fantasy. While nearly all of its elements were moulded from casts of flora and fauna harvested from the wild, their arrangement on the dish is artificial. Resembling a natural history diorama, the specimens are individually spaced for ease of identification in this stylized portrayal of the rich environment of a freshwater pond. Moreover, some of the shells are actually marine fossils dating back fifty million years, a period when the center of the Paris Basin region was covered by the salt waters of the North Sea.[1]

Natural scientist and potter Bernard Palissy (1510–1590), inventor of this distinctive style of ceramics, correctly deduced the true origin and nature of such fossils. Born into a family of artisans in southwest France, Palissy educated himself through his artistic practice as well as by observing nature. He recognized that fossil seashells, like his molds of plants and animals, were impressions of living things—albeit ones that had been created through gradual geological processes. He thereby rejected the prevalent theory that marine fossils found on land were deposited by the great flood described in the Bible. Palissy disseminated his ideas through lectures and publications before dying while incarcerated in the Bastille, persecuted for his Protestant faith.

This dish testifies to the enduring appeal of Palissy's vibrant displays of nature. Since the 1550s, when King Henry II first acquired one of his extraordinary dishes, ceramics decorated with pond life have never been out of fashion, becoming especially popular in nineteenth-century England and Portugal (p. 162) as well as France.[2] The fossils on this particular dish indicate that it was inspired by Palissy rather than a work by his own hand (since Palissy cast only living specimens for his art, despite his deep scientific interest in fossils). Additionally, a maker's mark in the form of a dragon (above) identifies this dish with other works being produced by 1738 by an artisan known as the Griffin Master, recently updated to Master of the Dragon.[3]

ROSIE CHAMBERS MILLS
The Rosalinde and Arthur Gilbert Foundation Associate Curator, Department of Decorative Arts and Design

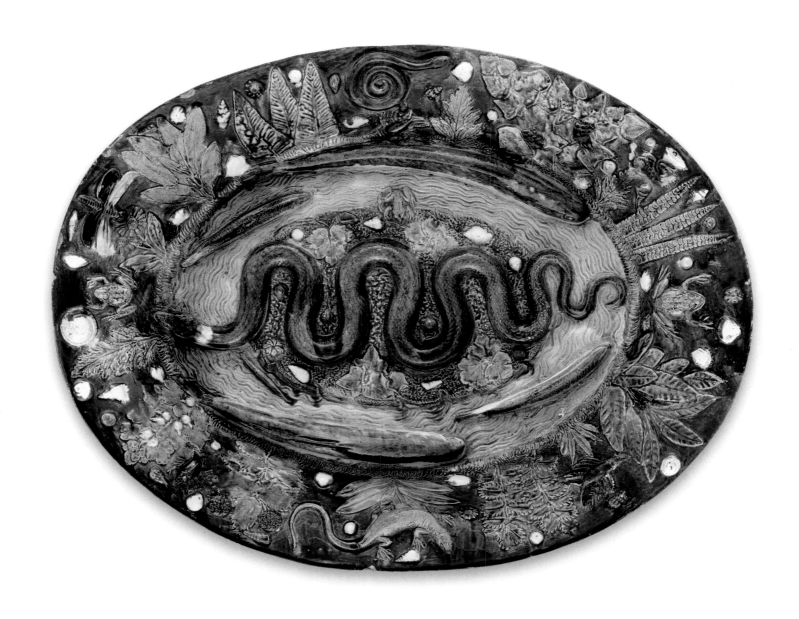

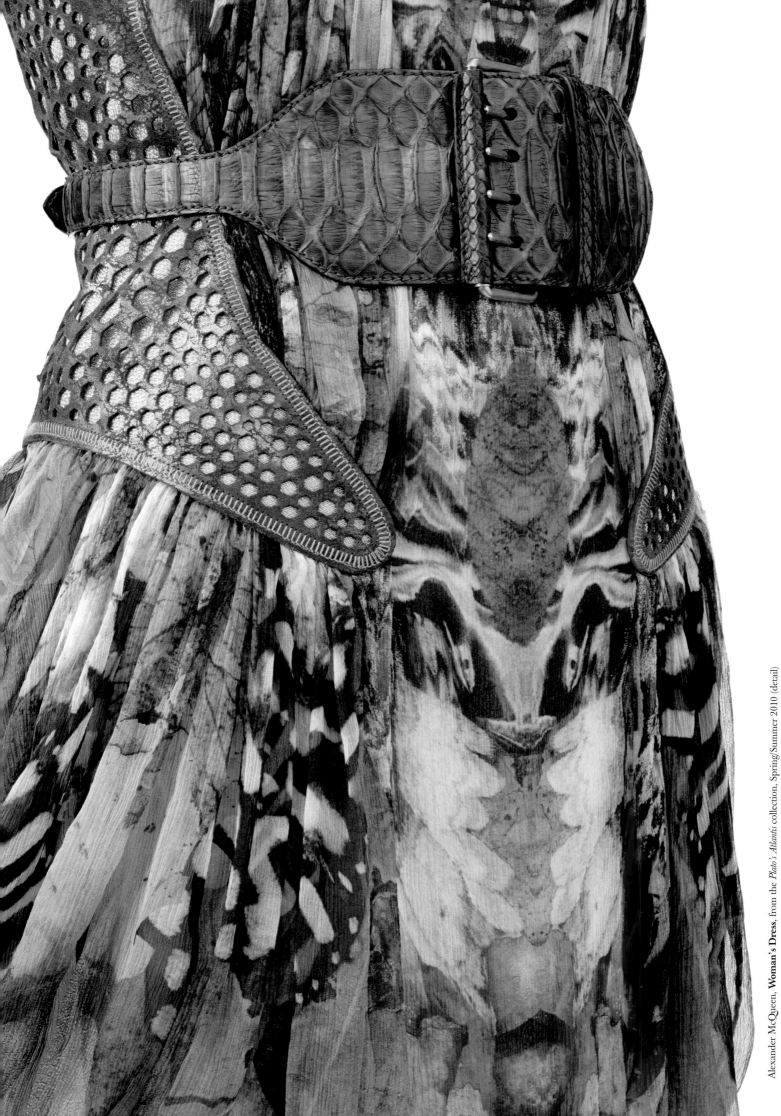

Alexander McQueen, **Woman's Dress**, from the *Plato's Atlantis* collection, Spring/Summer 2010 (detail)

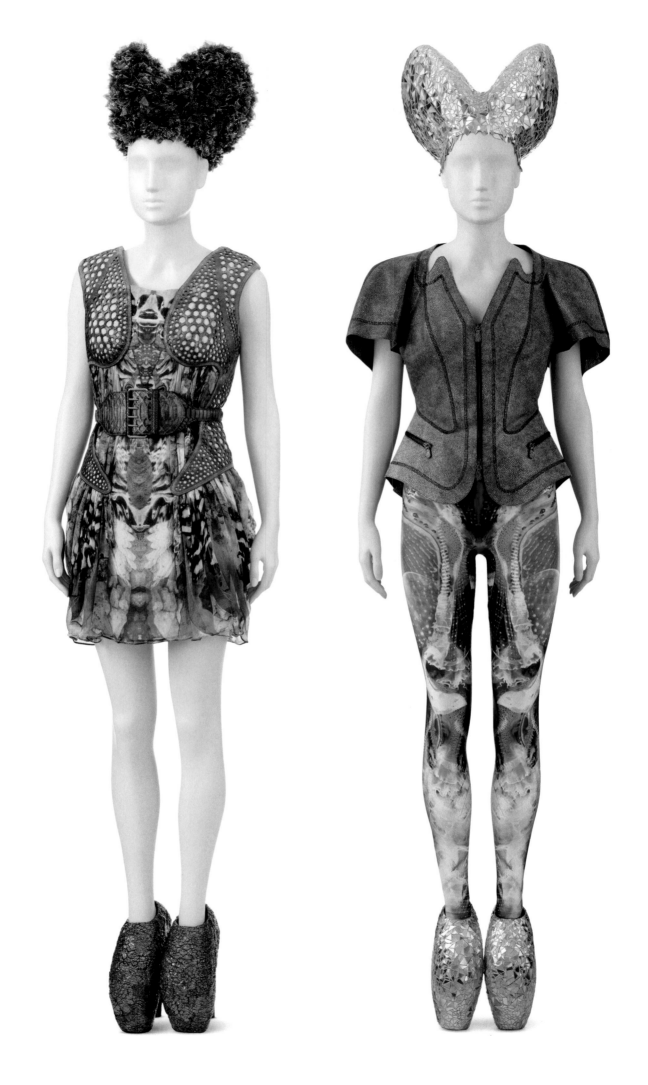

Left: Alexander McQueen, **Woman's Dress**, from the *Plato's Atlantis* collection, Spring/Summer 2010; Michael Schmidt, **Headpiece and Shoes** (Headpiece: candy wrappers; Shoes: candy wrappers, antiqued), 2021
Right: Alexander McQueen, **Woman's Ensemble (Bodice and Leggings)**, from the *Plato's Atlantis* collection, Spring/Summer 2010; Michael Schmidt, **Headpiece and Shoes** (CD-shard mosaic and papier-mâché), 2021

Andreas Gursky, *Ocean IV*, 2010

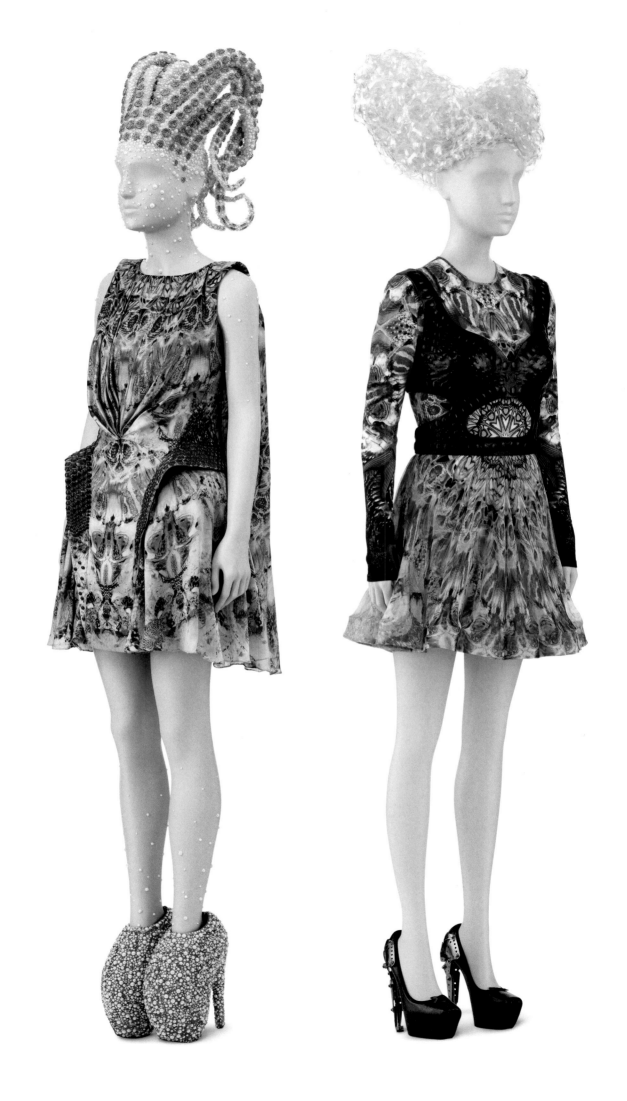

Left: Alexander McQueen, **Woman's Dress**, from the *Plato's Atlantis* collection, Spring/Summer 2010; Michael Schmidt, **Headpiece and Shoes** (Headpiece: 3D-printed mannequin, Swarovski crystals, and faux pearls; Shoes: Swarovski crystals and faux pearls), 2021; Right: Alexander McQueen, **Woman's Dress, Harness, and Shoes**, from the *Plato's Atlantis* collection, Spring/Summer 2010; Michael Schmidt, **Headpiece** (plastic six-pack rings and acrylic plastic), 2021

169

CHECKLIST OF THE EXHIBITION

SECTION 1

All works are by Lee Alexander McQueen (1969–2010) for Alexander McQueen (founded 1992), and are from the collection of the Los Angeles County Museum of Art, Gift from the Collection of Regina J. Drucker, except as noted.

——

Dante, Fall/Winter 1996–97

Woman's Dress
Acetate/nylon/elastane twill weave and nylon/elastane net
M.2019.394.3
p. 95 right

——

Untitled (*Golden Showers*),
Spring/Summer 1998

Woman's Dress
Wool plain weave
M.2019.399.8
p. 95 left

Woman's Dress
Wool plain weave with nylon/elastane net
M.2016.260.26
p. 94

——

Joan, Fall/Winter 1998–99

Woman's Jacket
Polyester/acetate plain weave (crepe) and plastic sequins, printed
M.2018.278.11
pp. 86–87 (detail), 118

——

No. 13, Spring/Summer 1999

Woman's Coat
Cotton/rayon/silk twill weave with mother-of-pearl buttons
M.2020.122.2
p. 112 left

Woman's Coat
Polyester/acetate twill weave
M.2020.122.30
pp. 112 right, 113 (detail)

——

The Overlook,
Fall/Winter 1999–2000

Woman's Jacket
Wool twill weave, quilted
M.2017.280.12
p. 123

——

Eye, Spring/Summer 2000

Woman's Ensemble
(Top and Pants)
Top: silk and rayon twill weave with metal coins; Pants: silk and rayon twill weave
M.2018.278.23a–b
pp. 42, 45 (detail)

Woman's Dress
Polyester jacquard knit, rayon flock printed
M.2019.399.7
p. 49 (detail)

Woman's Ensemble
(Top and Skirt)
Top: wool twill weave; Skirt: silk and rayon twill weave with silk warp-patterning and rayon supplementary-weft patterning
M.2019.399.6a–b
p. 51

——

Eshu, Fall/Winter 2000–2001

Woman's Dress
Leather, screen printed and laser cut, with mother-of-pearl buttons
M.2018.278.12
p. 125 right

——

Voss, Spring/Summer 2001

Woman's Blouse
Silk plain weave
M.2016.260.22
p. 93

——

What a Merry Go Round,
Fall/Winter 2001–2

Woman's Dress
Polyamide net with plastic sequins and silk and metallic-thread lace
M.2018.278.18
p. 100

——

The Dance of the Twisted Bull,
Spring/Summer 2002

Woman's Jacket
Wool plain weave with silk plain weave (crepe), printed
M.2018.278.16
p. 138

Woman's Ensemble
(Bustier and Skirt)
Bustier: wool/rayon/silk twill weave with cotton-braid lacing and mother-of-pearl buttons; Skirt: cotton plain weave
M.2018.278.20a–b
p. 142

Woman's Shoes
Leather and plastic with metal buckles
M.2020.122.15a–b
p. 142

——

Supercalifragilisticexpialidocious,
Fall/Winter 2002–3

Woman's Jacket
Wool plain weave and wool knit, cord quilted, with leather
M.2020.122.25
pp. 98 right, 99 (detail)

Woman's Jeans
Cotton/elastane twill weave (denim) and leather
M.2020.122.24
p. 98 right

Woman's Dress
Silk satin with cotton embroidery (open work)
M.2016.260.21
p. 115

Woman's Boots
Attributed to
Supercalifragilisticexpialidocious
Leather with metal buckles and cotton braid, waxed
M.2020.123.9a–b
p. 71

——

Irere, Spring/Summer 2003

Woman's Dress
Silk/cotton plain weave (crepe chiffon)
M.2020.122.41
p. 96 right

Woman's Vest
Leather, quilted, with glass beads, painted, and metal chains
M.2016.260.14
pp. 10 (detail), 103 right

Woman's Skirt
Silk plain weave (crepe chiffon) with leather and metal buckles
M.2020.122.5
pp. 10 (detail), 103 right

Woman's Purse
Leather (suede) with metal, feathers, and silk twill weave, printed
M.2020.122.32a–c
p. 103 right

Woman's Shoes
Leather, plastic, and metal
M.2020.122.31a–b
p. 103 right

Woman's Ensemble
(Jacket and Jeans)
Cotton twill weave (denim) and leather
M.2020.122.26a–b
p. 103 left

Woman's Jacket
Leather, die cut
M.2019.399.17
p. 105

Woman's Coat
Wool/elastane plain weave with metallic-thread embroidery and metal sequins
M.2020.122.13
p. 111

——

Pre-collection,
Fall/Winter 2003–4

Woman's Shoes
Probably 2003
Leather and crystals
Lent by Regina J. Drucker
p. 126

Scanners, Fall/Winter 2003–4

Woman's Dress
Silk/spandex plain weave (crepe) with leather and metal zippers
M.2020.122.40
p. 98 left

Woman's Ensemble
(Coat and Skirt)
Coat: rabbit and fox fur and silk plain weave (organza) with metal sequins and metallic-thread embroidery; Skirt: wool plain weave with warp- and weft-patterning and wool damask with wool pom poms, leather, and metal buckles
M.2017.280.6a–b
p. 69

Woman's Boots
Leather
M.2020.123.7a–b
p. 69

Woman's Top
Wool/cashmere knit
M.2020.122.3
p. 66

Woman's Top
Polyester/nylon net with metal sequins
M.2020.122.9
p. 66

Woman's Skirt
Cotton twill weave with acetate satin ribbon and leather
M.2020.122.1
p. 66

Woman's Dress
Silk/rayon/polyester jacquard weave with acetate satin ribbon and acetate twill weave ribbon
M.2018.278.15
p. 71

Woman's Jacket
Silk/rayon/polyester jacquard weave
M.2019.394.5
p. 73

Woman's Skirt
Cotton plain weave, quilted, with leather trim
M.2019.394.6
p. 73 (detail)

Woman's Suit (Jacket and Skirt)
Cotton/wool plain-weave double cloth
M.2017.63.4a–b
p. 121

——

Deliverance, Spring/Summer 2004

Woman's Suit (Jacket and Skirt)
Jacket: cotton plain weave; cotton damask; silk plain weave; and cotton plain weave with Lurex supplementary-weft patterning, silk embroidery, and mother-of-pearl buttons; Skirt: cotton plain weave; cotton damask; silk plain weave; and cotton plain weave with Lurex supplementary-weft patterning and silk embroidery
M.2019.399.14a–b
pp. 4 (detail), 92 left

Woman's Dress
Silk/nylon plain weave (crepe),
printed
M.2016.260.17
p. 92 right

Woman's Capelet
Feathers and silk satin
M.2018.278.24
p. 144

Woman's Pants
Polyester twill weave and silk plain
weave with metal screw studs
M.2018.278.25
p. 144

Woman's Shoes
Leather with metal, crystals,
and faux pearls
M.2018.278.10a–b
p. 144

**Woman's Ensemble
(Dress and Bodysuit)**
Dress: silk plain weave (crepe),
printed, and silk plain weave (crepe)
appliqué; Bodysuit: nylon/elastane
net, printed
M.2018.278.17a–b
p. 147 center

Woman's Boots
Cotton plain weave (canvas),
polyester grosgrain ribbon, and
plastic with metal and cotton
braided cord
M.2019.399.20a–b
p. 147 center

Woman's Dress
Cotton knit (jersey), rayon/elastane
knit (jersey), nylon/elastane net,
rubber, silk satin, nylon lace, and
polyurethane plain weave
M.2018.278.28
p. 147 left

Woman's Shoes
Leather with metal, glass, and plastic
M.2020.122.16a–b
p. 147 left

Woman's Dress
Cotton knit (jersey) and
cotton/silk/elastane knit (jersey),
with polyamide/elastane net and
nylon/elastane knit trim
M.2019.399.2
p. 147 right

Woman's Shoes
Leather with metal, glass, and plastic
M.2020.122.17a–b
p. 147 right

———

Pantheon ad Lucem,
Fall/Winter 2004–5

Woman's Dress
Silk/elastane plain weave
(crepe chiffon)
M.2020.122.6
p. 96 left

Woman's Boots
Leather
M.2021.18.3a–b
p. 117 right

———

It's Only a Game,
Spring/Summer 2005

Woman's Suit (Jacket and Skirt)
Jacket: silk plain weave (taffeta) with
silk supplementary-weft patterning
and cotton net, cotton lace, silk plain
weave (faille), silk grosgrain ribbon
and mother-of-pearl buttons; Skirt: silk
plain weave with silk supplementary-
weft patterning, laser cut
M.2019.399.22a–b
p. 117 left

Woman's Shoes
Leather
M.2020.122.38a–b
p. 117 left

Woman's Jacket
Cotton twill weave and silk net
with silk lace, silk plain weave (faille),
and mother-of-pearl buttons
M.2020.122.11
p. 117 right

Woman's Skirt
Leather, laser cut, with silk
plain weave (organza)
M.2020.122.12
p. 117 right

———

The Man Who Knew Too Much,
Fall/Winter 2005–6

Woman's Shoes
Attributed to *The Man Who Knew
Too Much*
Cotton sateen with silk plain-weave
(grosgrain) ribbon, silk velvet ribbon,
and leather
M.2020.123.18a–b
p. 97

Woman's Shoes
Attributed to *The Man Who Knew
Too Much*
Cotton sateen with silk plain-weave
(grosgrain) ribbon, silk-velvet ribbon,
and leather
M.2020.123.22a–b
p. 103 left

———

Neptune, **Spring/Summer 2006**

Woman's Dress
Silk knit and nylon net with beads
M.2019.394.4
p. 33

Woman's Shoes
Leather with metal and stones
M.2020.122.20a–b
p. 33

**Woman's Ensemble
(Blouse, Skirt, and Belt)**
Blouse: cotton/Lurex plain weave
with mother-of-pearl buttons;
Skirt: cashmere/silk plain weave
(crepe) with polyester and Lurex
plain weave; Belt: leather, quilted,
with metal buckle
M.2016.260.27a–c
pp. 30, 35 (detail)

Woman's Shoes
Leather and metal
M.2020.123.1a–b
p. 30

Woman's Dress
Silk plain weave (crepe) with crystals
M.2016.260.11
pp. 20 (detail), 36

Woman's Dress
Acetate and rayon plain weave
(crepe), silk net with glass beads,
and metal chain
M.2016.260.9
pp. 37, 39 (detail)

———

The Widows of Culloden,
Fall/Winter 2006–7

**Woman's Ensemble
(Jacket, Blouse, Jabot, Skirt,
Boots, and Belt)**
Jacket: leather; Blouse: cotton/
elastane plain weave; Jabot: silk plain
weave (taffeta) with silk plain weave
grosgrain ribbon; Skirt: wool twill
weave; Boots: leather; Belt: leather
with metal and crystals
M.2019.399.12a–g
pp. 2 (detail), 81

Woman's Dress
Dress: wool knit (jersey);
Belt: leather with metal buckle
M.2017.280.5a–b
p. 76

Woman's Shoes
Attributed to *The Widows of Culloden*
Leather
M.2020.122.23a–b
p. 76

Woman's Boots
Attributed to *The Widows of Culloden*
Leather
M.2020.122.33a–b
p. 98 right

Woman's Dress
Silk plain weave (chiffon) with
feathers, silk net, glass beads,
crystals, and metallic-thread braid
M.2017.280.2
p. 107

Woman's Coat and Belt
Coat: Rabbit fur;
Belt: crocodile skin and metal
M.2020.122.27a–b
p. 125 left

**Woman's Ensemble
(Blouse and Skirt)**
Silk plain weave (chiffon), printed
M.2020.122.28a–b
p. 125 left

———

Sarabande,
Spring/Summer 2007

**Woman's Ensemble
(Blouse and Skirt)**
Blouse: cotton plain weave
with cotton-cutwork embroidery
(broderie anglaise); Skirt: silk plain
weave (crepe) with silk net, glass
beads, crystals, and metal sequins
M.2018.278.22a–b
p. 143 left

Woman's Shoes
Silk plain weave (faille) with
crystals, plastic, and leather
M.2020.123.8a–b
p. 143 left

Woman's Blouse
Silk net with silk embroidery
M.2020.122.7
p. 143 right

Woman's Trousers
Acetate/rayon crepe-back satin
with leather and metal buckles
M.2020.122.8
p. 143 right

Woman's Suit (Jacket and Skirt)
Jacket: polyamide/rayon plain weave
(faille) with moiré finish and poly-
amide net; Skirt: acetate/rayon plain
weave (crepe) and polyamide net
M.2016.260.28a–b
p. 157

Woman's Dress
Rayon/cotton plain weave (faille)
and polyamide lace
M.2016.260.29
p. 159

Woman's Shoes
Silk net, silk plain weave, and leather
M.2021.18.1a–b
p. 159

**Woman's Ensemble
(Dress and Blouse)**
Dress: cotton net with cotton lace,
glass beads, plastic sequins, and
silk satin; Blouse: cotton plain weave
with mother-of-pearl buttons
M.2016.260.8a–b
pp. 128–29 (detail), 152

Woman's Shoes
Leather and silk net
M.2021.18.2a–b
p. 152

———

Spring/Summer 2007
Lee Alexander McQueen
(1969–2010) for McQ (founded 2006)

Woman's Belt
Cotton braid with metal
M.2020.122.13c
p. 137

———

Pre-collection, Fall/Winter 2007–8

Woman's Dress
Rayon/polyamide lace with metallic-
thread embroidery and silk plain
weave (crepe)
M.2019.399.11
pp. 90 (detail), 97

Woman's Dress
Silk plain weave (taffeta)
M.2019.394.7
p. 109

———

*In Memory of Elizabeth How,
Salem, 1692,* **Fall/Winter 2007–8**

Woman's Dress
Silk velvet with glass beads
M.2016.260.10
p. 85 right

Woman's Shoes
Patent leather
M.2020.123.21a–b
p. 85 right

Woman's Dress
Silk satin with glass beads
M.2019.394.10
pp. 82 (detail), 85 left

Woman's Boots
Leather with cotton embroidery,
elastic knit, and plastic
M.2020.123.25a–b
p. 85 left

Woman's Boots
Patent leather and metal
M.2020.122.22a–b
p. 66

Woman's Shoes
Leather and plastic
M.2019.399.4a–b

La Dame Bleue,
Spring/Summer 2008

Woman's Dress
Silk plain weave (crepe) with
plastic sequins and glass beads
M.2019.394.9
pp. 126, 127 (detail)

The Girl Who Lived in the Tree,
Fall/Winter 2008–9

Woman's Dress
Silk/cotton jacquard weave
with silk plain weave (organza)
M.2020.123.14
pp. 56 (detail), 58

Woman's Boots
Leather and patent leather
with plastic and metal
M.2020.123.4a–b
p. 58

Woman's Dress
Silk plain weave (crepe chiffon),
silk net, and silk-embroidered
appliqué with glass beads
M.2016.260.20
p. 61

Woman's Boots
Leather and patent leather
M.2020.123.10a–b
p. 61

Woman's Dress
Attributed to *The Girl Who Lived
in the Tree*
Silk/polyamide satin and silk tulle
with metallic-thread and metal-sequin
embroidered appliqués
M.2018.278.13
pp. 54–55 (detail), 63

Woman's Shoes
Leather, silk plain weave, and silk
net with crystals and glass beads
M.2019.399.13a–b
p. 63

Woman's Blouse
Cotton/elastane plain weave with
mother-of-pearl buttons
M.2020.123.12
p. 144

*Natural Dis-tinction, Un-natural
Selection,* **Spring/Summer 2009**

Woman's Dress
Wool/silk/nylon twill weave,
digitally printed
M.2020.123.15
pp. 88 (detail), 124 right

Woman's Dress
Rayon knit, digitally printed
M.2018.278.1
p. 124 left

Woman's Shoes
Silk satin, leather, and acrylic
M.2019.394.11a–b
pp. 96 left, 124 left

The Horn of Plenty,
Fall/Winter 2009–10

**Woman's Ensemble
(Blouse and Dress)**
Blouse: polyamide plain weave;
Dress: polyamide/polyurethane plain
weave (crepe)
Gift from the Collection of Regina J.
Drucker in honor of Bruce Drucker
M.2020.123.13a–b
p. 137

Woman's Dress
Silk damask
M.2019.394.2
pp. 132 (detail), 135

Plato's Atlantis,
Spring/Summer 2010

**Woman's Ensemble
(Dress and Leggings)**
Dress: rayon/elastane knit (jersey),
digitally printed; Leggings: nylon/
elastane knit (jersey), digitally printed
M.2016.260.19a–b
pp. 160 (detail), 163

Woman's Dress
Dress: silk plain weave (crepe
chiffon), digitally printed, and lamé
plain weave with leather, painted
and laser cut; Belt: leather and metal
M.2019.394.1a–b
pp. 166 (detail), 167 left

**Woman's Ensemble
(Bodice and Leggings)**
Bodice: faux stingray leather and
metal; Leggings: nylon/polyamide
and elastane knit, digitally printed
Gift from the Collection of Regina
J. Drucker in memory of Vincent
Venegas
M.2019.394.8a–b
p. 167 right

Woman's Dress
Silk satin, digitally printed, and
silk plain weave (chiffon), digitally
printed, with enameled metal beads
M.2020.122.10
pp. 130, 169 left

Woman's Dress
Silk/rayon/elastane knit and silk
plain weave (chiffon), digitally
printed, with nylon braid
Gift from the Collection of
Regina J. Drucker in memory
of Juliana Cairone
M.2017.276.1
pp. 8, 169 right

Woman's Harness
Leather
Gift from the Collection of
Regina J. Drucker in memory
of Juliana Cairone
M.2017.276.2
pp. 8, 169 right

Woman's Shoes
Leather and metal with silk
plain-weave (grosgrain) ribbon
M.2020.123.5a–b
pp. 169 right

Pre-collection, Fall/Winter 2010–11

Woman's Shoes
Silk and cotton lace with nylon
plain weave and patent leather
M.2020.123.6a–b
p. 143 right

Untitled (*Angels and Demons*),
Fall/Winter 2010–11
Lee Alexander McQueen
(1969–2010) and Sarah Burton
(born 1974) for Alexander McQueen
(founded 1992)

Woman's Jacket
Silk, polyester, and metallic thread
jacquard weave
M.2018.278.8
pp. 22, 25 (detail)

Woman's Dress
Silk satin and silk jacquard weave
with metal zipper and metal buckle
M.2018.278.9
pp. 18–19 (detail), 27

Woman's Shoes
Leather with Lurex embroidery
and metal
M.2020.123.17a–b
p. 98 left

SECTION 2

All works are from the collection of
the Los Angeles County Museum of
Art. Works are organized chronolog-
ically within the thematic section in
which they appear in the exhibition.
Dimensions are height × width ×
depth unless otherwise noted.

**Mythos: Untitled
(*Angels and Demons*)**

Circle of Desiderio da Settignano
(Italy, Florence, 1428–1464)
Fragment with Two Seraphim,
c. 1460
Marble
11⅝ × 9 × 7 in.
(29.5 × 22.9 × 17.8 cm)
William Randolph Hearst Collection
51.18.3
p. 24 left

Circle of Desiderio da Settignano
(Italy, Florence, 1428–1464)
Fragment with Two Seraphim,
c. 1460
Marble
16 × 7½ × 5⁹/₁₆ in.
(40.6 × 19 × 14.1 cm)
William Randolph Hearst Collection
51.13.7
p. 24 right

Circle of Desiderio da Settignano
(Italy, Florence, 1428–1464)
**Fragment with Seraph Enframed
by His Wings**, c. 1460
Marble on modern stone base
12⅜ × 8½ × 7⅞ in.
(31.5 × 21.6 × 20.1 cm)
William Randolph Hearst Collection
51.13.8

Jan Mandijn
(Netherlands, 1500–1560)
*Saint Christopher and the
Christ Child*, c. 1550
Oil on wood panel
13½ × 18¼ in. (34.3 × 46.4 cm)
Gift of Mr. and Mrs. Ben Maddow
59.48
p. 26

Pieter van der Heyden
(Flanders, c. 1530–after 1572)
After Pieter Bruegel the Elder
(Flanders, 1525–1569)
Envy (Invidia), 1558
Engraving
From *The Seven Vices*
Image: 8⅞ × 11½ in. (22.5 × 29.2 cm)
Mary Stansbury Ruiz Bequest
M.88.91.438
p. 29

Pieter van der Heyden
(Flanders, c. 1530–after 1572)
After Pieter Bruegel the Elder
(Flanders, 1525–1569)
Christ's Descent into Limbo, c. 1561
Engraving
Image: 8¾ × 11⅝ in. (22.2 × 29.5 cm)
Mary Stansbury Ruiz Bequest
M.88.91.440

Mythos: *Neptune*

Hippocamp
Italy, Sicily, 3rd century BC
Earthenware
6⅞ × 12¼ × 3¼ in.
(17.5 × 31.1 × 8.3 cm)
Gift of Varya and Hans Cohn
AC1992.152.13
p. 34 bottom

Fontana Workshop
(Italy, Urbino, c. 1510–1571)
Wine Cistern, c. 1565–71
Tin glazed earthenware (maiolica)
9 × 19 × 19 in.
(22.9 × 48.3 × 48.3 cm)
Gift of Stanley Mortimer
50.42.1

Seahorse
Germany, c. 1590–1600
Silver gilt, turban shell
(*Turbo marmoratus*)
7 × 7⅞ in. (17.8 × 2 cm)
Gift of Varya and Hans Cohn
AC1992.152.108a–b
p. 34 top

Neptune on a Seahorse
France, c. 1600–50
Lead-glazed earthenware
7¹¹/₁₆ × 6¹³/₁₆ × 3¾ in.
(19.5 × 17.3 × 9.5 cm)
Purchased with funds provided by
Alan Ross Smith, Mr. and Mrs.
Edward Sowter, John Spring, Mrs.
A. Stiassni, Walter Stein, Mr. B.L.
Stilphen, Grenville W. Stratton,
and Anna A. Streckewald
82.9.15

Jacques-Antoine Beaufort
(France, 1721–1784)
The Oath of Brutus, c. 1771
Oil on canvas
25⅞ × 31⅝ in. (65.7 × 80.3 cm)
The Ciechanowiecki Collection,
Gift of The Ahmanson Foundation
M.2000.179.18
p. 32

Textile Length
France, 1820–40
Silk satin and silk plain-weave
double cloth
74½ × 21¾ in. (189.2 × 55.5 cm)
Gift of Mr. and Mrs. John
Jewett Garland
M.61.15
p. 38

Aimé-Jules Dalou
(France, 1838–1902)
Caryatids of the Four Continents,
c. 1867
Patinated plaster
Each: 35 × 8 × 8 in.
(88.9 × 20.3 × 20.3 cm)
Gift of Leona Cantor Palmer
M.82.197.1–.4
p. 41

———

Mythos: *Eye*

Liturgical Veil (Cover for Chalice and Paten Set)
Turkey, 1550–1600; remade in Eastern or Southeastern Europe, after 1600
Silk satin with silk and metallic-thread supplementary-weft patterning bound in twill (lampas or *kemha*) and silk embroidery
21⅛ × 23 in. (53.7 × 58.4 cm)
Gift of Miss Bella Mabury
M.39.2.478
p. 50

Jean-Baptiste Greuze
(France, 1725–1805)
Portrait of a Lady in Turkish Fancy Dress, c. 1790
Oil on canvas
46 × 35¾ in. (116.8 × 90.8 cm)
Gift of Hearst Magazines
47.29.6
p. 53

Banner (Sanjak)
Turkey, probably Istanbul, early 19th century
Silk and metallic-thread plain weave with silk and metallic-thread discontinuous supplementary-weft patterning (brocade) and silk plain weave with metallic-thread supplementary-weft patterning
122¾ × 82⅞ in. (311.8 × 210.5 cm)
The Edwin Binney, 3rd, Collection of Turkish Art at the Los Angeles County Museum of Art
M.85.237.6
p. 48

Woman's Wedding Headdress (Wuqayat al-darahim) or "Money Hat"
Palestine, Hebron, 20th century
Silver and brass coins with metal chain, cotton embroidery, silk embroidery, amber beads, stone beads, coral beads, glass beads, silk tassels, metal ornaments, and cowrie shells
25 × 8 × 8 in. (63.5 × 20.3 × 20.3 cm)
Gift of B. Rich
M.2012.188.36
p. 44

Youssef Nabil
(Egypt, born 1972)
Natacha Atlas, Cairo, 2000
Hand-colored gelatin silver print
Image: 29½ × 45 in.
(74.9 × 114.3 cm)
Purchased with funds provided by Walid and Susie Wahab
M.2014.178
p. 47

Fashioned Narratives:
The Girl Who Lived in the Tree

Man's Waist Sash (Patka)
India, probably Lucknow, early 19th century
Cotton plain weave with metallic-thread embroidery, beetle-wing (elytra) sequins, and silk braid, with metallic-thread fringe
132¼ × 24¾ in. (335.9 × 62.9 cm)
From the Nasli and Alice Heeramaneck Collection, Museum Associates Purchase
M.71.1.38
p. 62 (detail)

Fashion Plate, "A Lady of Hindoostan"
England, early 19th century
Hand-colored engraving on paper
Image: 7¼ × 4⅝ in. (18.4 × 11.8 cm)
Gift of Dr. and Mrs. Gerald Labiner
M.86.266.18
p. 64

Fashion Plate, "Evening Dress"
England, 1819
Hand-colored engraving on paper
For *La Belle Assemblée*, published by John Bell, London
Image: 8¼ × 4¾ in. (21 × 12.1 cm)
Gift of Dr. and Mrs. Gerald Labiner
M.86.266.272

Woman's Dress
England, 1820s
Silk gauze with silk supplementary-weft patterning, silk satin, silk net, and linen lace
Center-back length: 47½ in.
(120.7 cm)
Costume Council Fund
M.59.24.6
p. 60

John Hook
(England, active early 19th century)
Woman's Shoes, c. 1820
Silk satin with silk plain-weave ribbon and leather
Each: 2¼ × 2½ in. × 9½ in.
(5.7 × 6.4 × 24.1 cm)
Purchased with funds provided by Suzanne A. Saperstein and Michael and Ellen Michelson, with additional funding from the Costume Council, the Edgerton Foundation, Gail and Gerald Oppenheimer, Maureen H. Shapiro, Grace Tsao, and Lenore and Richard Wayne
M.2007.211.299a–b
p. 60

Woman's Dress
England, c. 1820
Cotton plain weave with metal-strip embroidery and silk gauze weave with metallic-thread and metal sequin passementerie and metallic-thread tassels
Center-back length: 50½ in.
(128.3 cm)
Purchased with funds provided by Suzanne A. Saperstein and Michael and Ellen Michelson, with additional funding from the Costume Council, the Edgerton Foundation, Gail and Gerald Oppenheimer, Maureen H. Shapiro, Grace Tsao, and Lenore and Richard Wayne
M.2007.211.734
p. 65

Woman's Shoes
England, 1825–50
Silk satin with silk plain weave and leather
Each: 2⅛ × 3 × 10¼ in.
(5.4 × 7.6 × 26 cm)
Purchased with funds provided by Suzanne A. Saperstein and Michael and Ellen Michelson, with additional funding from the Costume Council, the Edgerton Foundation, Gail and Gerald Oppenheimer, Maureen H. Shapiro, Grace Tsao, and Lenore and Richard Wayne
M.2007.211.312a–b
p. 65

———

Fashioned Narratives: *Scanners*

Pair of Brocade Design (Kati Rimo) Temple Hangings
Tibet, 17th century
Silk twill weave with silk supplementary-weft patterning bound in twill (lampas) and silk tassels
Each: 54 × 7 in. (137.2 × 17.8 cm)
Gift of Ruth Sutherlin Hayward and Robert W. Hayward in Honor of the 18th Birthday (April 25, 2007) of the 11th Panchen Lama, Gendun Choekyi Nyima
M.2006.156.3a–b
p. 72

Trunk with Brocade Design (Kati Rimo)
Tibet, 17th–18th century
Wood with mineral pigments; metal fittings
22¼ × 44½ × 17 in.
(56.5 × 113 × 43.2 cm)
Gift of Dr. Robert Hayward in memory of Ruth Sutherlin Hayward
M.2013.183.1
p. 70

Textile Cover
Probably Russia, early 18th century
Silk satin with silk and metallic-thread supplementary-weft patterning bound in twill (lampas) and silk (chenille) and metallic-thread discontinuous supplementary-weft patterning (brocade) with metallic-thread passementerie and metallic-thread fringe
63 × 52½ in. (160 × 133.4 cm)
Gift of Anton Lourie
M.75.68
p. 68

Buddhist Priest's Mantle (Kesa)
Japan, late Edo to early Meiji period, 19th century
Silk twill weave with silk and gilt-paper thread supplementary-weft patterning, with gilt-paper-wrapped silk thread embroidery
44¾ × 79¾ in. (113.7 × 202.6 cm)
Gift of Miss Bella Mabury
M.39.2.32
p. 75 (detail)

Fashioned Narratives:
The Widows of Culloden

John Singleton Copley
(United States, 1738–1815)
Portrait of Hugh Montgomerie, Later Twelfth Earl of Eglinton, 1780
Oil on canvas
94½ × 59¾ in. (240 × 151.8 cm)
Gift of Andrew Norman Foundation and Museum Acquisition Fund
M.68.74
p. 79

Fashioned Narratives:
In Memory of Elizabeth How, Salem, 1692

Ernst Barlach
(Germany, 1870–1938)
Will o' the Wisp, 1922, published 1923
Woodcut on Japan paper
From the portfolio *Goethe: Walpurgisnacht*
Image: 5 × 4½ in.
(12.7 × 11.4 cm)
The Robert Gore Rifkind Center for German Expressionist Studies, purchased with funds provided by Anna Bing Arnold, Museum Associates Acquisition Fund, and deaccession funds
83.1.34.2d

Ernst Barlach
(Germany, 1870–1938)
Witch's Ride, 1922, published 1923
Woodcut on Japan paper
From the portfolio *Goethe: Walpurgisnacht*
Image: 7⅜ × 5¹¹/₁₆ in.
(18.7 × 14.5 cm)
The Robert Gore Rifkind Center for German Expressionist Studies, purchased with funds provided by Anna Bing Arnold, Museum Associates Acquisition Fund, and deaccession funds
83.1.34.2k

Ernst Barlach
(Germany, 1870–1938)
Lilith, Adam's First Wife, 1922, published 1923
Woodcut on Japan paper
From the portfolio *Goethe: Walpurgisnacht*
Image: 7⅜ × 5¾ in. (18.7 × 14.6 cm)
The Robert Gore Rifkind Center for German Expressionist Studies, purchased with funds provided by Anna Bing Arnold, Museum Associates Acquisition Fund, and deaccession funds
83.1.34.2o
p. 84

———

Technique and Innovation:
Costume History

Hendrik Goltzius
(Netherlands, 1558–1617)
Portrait of Lady Françoise van Egmond, 1580
Engraving
Image: 7⅛ × 5⅝ in. (18.1 × 14.3 cm)
Mary Stansbury Ruiz Bequest
M.88.91.394
p. 102

Hendrik Goltzius
(Netherlands, 1558–1617)
A Polish Nobleman Standing: Balthasar Bathory De Somlyo, 1583
Engraving
Image: 9¾ × 6⅝ in. (24.8 × 16.8 cm)
Mary Stansbury Ruiz Bequest
M.88.91.423
p. 104

Frans Pourbus II
(Flanders, 1569–1622)
Portrait of Louis XIII, King of France, as a Boy, c. 1616
Oil on canvas
21½ × 17½ in. (54.6 × 44.5 cm)
Gift of Mr. and Mrs. William May Garland
M.48.1
p. 106

Woman's Dress (*Robe à la française*)
Probably Italy; Textile: 1700–20;
Dress: constructed 1760s
Silk damask with silk supplementary-
weft patterning
Center-back length: 53 in. (134.6 cm)
Costume Council Fund
M.64.83.1a
p. 108

Woman's Stomacher
England, mid-18th century
Linen plain weave with silk and
metallic-thread embroidery and silk
and metallic-thread passementerie
12 × 10¼ in. (30.5 × 26 cm)
Gift of Dr. Alessandro Morandotti
M.59.21.2
p. 108

Woman's Petticoat
England, c. 1760
Silk satin, quilted
Length: 40 in. (101.6 cm)
Gift of Mrs. Henry Salvatori
M.79.19.2
p. 108

Man's Suit (Coat, Waistcoat, and Breeches)
England, c. 1770
Silk plain weave with warp patterning,
metal sequins, and metallic-thread
embroidery
Coat center-back length: 42 in.
(106.7 cm); Waistcoat center-back
length: 25¾ in. (65.4 cm); Breeches
inseam length: 17¼ in. (43.8 cm)
Purchased with funds provided by
Suzanne A. Saperstein and Michael
and Ellen Michelson, with additional
funding from the Costume Council,
the Edgerton Foundation, Gail and
Gerald Oppenheimer, Maureen H.
Shapiro, Grace Tsao, and Lenore and
Richard Wayne
M.2007.211.799a–c
p. 110

Fashion Plate, "Evening or Full Dress"
England, 1810
Hand-colored engraving on paper
For *Ackermann's Repository of Arts*,
published by Rudolph Ackermann,
London
Image: 8⅛ × 5⁹⁄₁₆ in. (20.6 × 14.1 cm)
Gift of Charles LeMaire
M.83.161.148
p. 114

Emma and Marie Weille
(France, Paris, active early
20th century)
Woman's Dress (Bodice and Skirt),
c. 1905
Bodice: silk plain weave (crepe
chiffon) with silk satin, linen lace,
and metal beads; Skirt: silk plain
weave (crepe chiffon)
Bodice center-back length: 19 in.
(48.3 cm); Skirt center-back length:
51½ in. (130.8 cm)
Gift of Miss Jean Grant Dunham
63.8.1a–b
p. 116

Technique and Innovation:
Surface Decoration

Gilbert Adrian
(United States, 1903–1959)
Woman's Suit (Jacket and Skirt),
1943–45
Wool twill weave
Jacket center-back length: 25⅜ in.
(64.5 cm); Skirt center-back length:
27⅛ in. (68.9 cm)
Gift of Mrs. Houston Rehrig
CR.69.55.3a–b
p. 120

Philip Treacy
(Ireland, active England, born 1967)
Woman's Hat, 2005
Twine, metal, horsehair, and crystals
5½ × 9 × 7 in. (14 × 22.9 × 17.8 cm)
Lent by Regina J. Drucker
p. 126

Evolution and Existence:
The Horn of Plenty

Graciela Iturbide
(Mexico, born 1942)
**Pájaros en el Poste, Carretera a
Guanajuato, México**, 1990,
printed c. 2000
Platinum palladium print
Image: 13⅜ × 20⅜ in. (34 × 51.8 cm)
Purchased with funds provided by the
Ralph M. Parsons Fund
M.2003.96
p. 134 bottom

Richard Barnes
(United States, born 1953)
Murmur 23 (December 6, 2005),
2005
Inkjet print (pigment based)
Image: 39½ × 40 in.
(100.3 × 101.6 cm)
Purchased with funds provided
by the Ralph M. Parsons Fund
M.2012.16
p. 134 top

Rodney McMillian
(United States, born 1969)
Untitled (Zip), 2011
Full sheet, latex and thread
97 × 76 in. (246.4 × 193 cm)
Promised gift of Emily and
Teddy Greenspan
PG.2015.32
p. 136

Evolution and Existence:
The Dance of the Twisted Bull

Francisco de Goya y Lucientes
(Spain, 1746–1828)
**A Spanish Knight Kills the Bull
after Having Lost His Horse**, 1816
Etching, burnished aquatint, and burin
From *La Tauromaquia*
Image: 8⅛ × 12⅜ in. (20.6 × 31.4 cm)
Gift of Gail and Stuart Buchalter in
memory of Ethel Buchalter
M.91.131.2

Pablo Picasso
(Spain, 1881–1973, active France)
La Tauromaquia, o arte de torear
(Tauromachy, or the Art of the
Bullfight), 1959
Portfolio of twenty-seven aquatints
Image (each): 7⅞ × 11¾ in.
(20 × 29.9 cm)
Gift of Mr. and Mrs. David Gensburg
M.68.13.1–.27
p. 141

Evolution and Existence:
Deliverance

Albrecht Dürer
(Germany, 1471–1528)
The Coat of Arms with the Skull,
1503
Engraving
Image: 8¾ × 6¼ in. (22.2 × 15.9 cm)
Art Museum Council Fund
M.62.3.2

Jean-Baptiste Auguste Clésinger
(France, 1814–1883)
Owl and Skull, c. 1871
Earthenware
11½ × 10⁵⁄₁₆ × 11¹³⁄₁₆ in.
(29.2 × 26 × 29.9 cm)
Purchased with funds provided
by J. B. Koepfli by exchange
M.73.61

Georg Tappert
(Germany, 1880–1957)
Dance in the Cabaret, 1918,
published 1920
Woodcut
From the portfolio *Der Nachtwandler*
Image: 11⅞ × 8⅛ in. (30.2 × 20.6 cm)
The Robert Gore Rifkind Center
for German Expressionist Studies,
purchased with funds provided
by Anna Bing Arnold, Museum
Associates Acquisition Fund, and
deaccession funds
83.1.17d
p. 149

Ernst Barlach
(Germany, 1870–1938)
Dance of Death 2, 1924
Lithograph
From the portfolio *Goethe:
Ausgewählte Gedichte*
Image: 10⅜ × 8⅛ in. (26.4 × 20.6 cm)
The Robert Gore Rifkind Center
for German Expressionist Studies,
purchased with funds provided
by Anna Bing Arnold, Museum
Associates Acquisition Fund, and
deaccession funds
83.1.33.1d
p. 150

Paul Cadmus
(United States, 1904–1999)
Coney Island, 1934
Oil on canvas
32⁷⁄₁₆ × 36⁵⁄₁₆ in. (82.4 × 92.2 cm)
Gift of Peter A. Paanakker
59.72
p. 146

Aaron Siskind
(United States, 1903–1991)
Harlem Street Scene, 1935,
printed 1980
Gelatin silver print
Image: 8½ × 11⅞ in. (21.6 × 30.2 cm)
The Marjorie and Leonard Vernon
Collection, gift of The Annenberg
Foundation, acquired from Carol
Vernon and Robert Turbin
M.2008.40.1831

Dorothea Lange
(United States, 1895–1965)
**Migrant Mother, Nipomo,
California**, 1936
Gelatin silver print
Image: 7⁹⁄₁₆ × 9½ in. (19.2 × 24.1 cm)
The Marjorie and Leonard Vernon
Collection, gift of The Annenberg
Foundation and Carol Vernon and
Robert Turbin
M.2008.40.1221

Arthur Rothstein
(United States, 1915–1985)
**Dust Storm, Cimarron County,
Oklahoma**, 1936, printed later
Gelatin silver print
Image: 19⅛ × 19 in. (48.6 × 48.3 cm)
Anonymous gift, Los Angeles, in
honor of Robert Sobieszek
M.2005.150.118

Evolution and Existence:
Sarabande

Dirck de Bray
(Netherlands, c. 1635–c. 1694)
Flowers in a Glass Vase, 1671
Oil on wood panel
19 × 14⅜ in. (48.3 × 36.5 cm)
Gift of Mr. and Mrs. Edward
William Carter
M.2009.106.4
p. 158

Francisco de Goya y Lucientes
(Spain, 1746–1828)
You Will Not Escape, 1799
Etching and aquatint, with burnishing
From *Los Caprichos*
Image: 8¼ × 5⅜ in. (20.1 × 13.7 cm)
Paul Rodman Mabury Trust Fund
63.11.72
p. 156

Evolution and Existence:
Plato's Atlantis

Large Oval Rustic Dish
France, c. 1600–50
Lead glazed earthenware
3⅞ × 20½ × 16⅛ in.
(9.8 × 52.1 × 41 cm)
Gift of the Hearst Foundation
49.26.2
pp. 164 (detail), 165

Manuel Cipriano Gomes Mafra
(Portugal, 1830–1905)
Urn, c. 1865–87
Glazed earthenware
17½ × 11 × 10 in.
(44.5 × 27.9 × 25.4 cm)
Gift of Barbara Barbara and
Marty Frenkel
M.2013.193.5
p. 162

Robert Mapplethorpe
(United States, 1946–1989)
Snakeman, 1981
Gelatin silver print
Image: 17¹⁵⁄₁₆ × 14 in. (45.5 × 35.5 cm)
Gift of The Robert Mapplethorpe
Foundation to the Los Angeles
County Museum of Art and to
The J. Paul Getty Trust
M.2016.152.579

Andreas Gursky
(Germany, born 1955)
Ocean IV, 2010
Dye coupler print
Frame: 134 × 98¼ in.
(340.5 × 249.6 cm)
Anonymous gift
M.2011.23.2
p. 168

Image Credits

Unless otherwise indicated below, all photographs are Photo © Museum Associates/LACMA.

47: © Youssef Nabil; 80: Royal Collection Trust/© Her Majesty Queen Elizabeth II 2021; 122: © George Hoyningen-Huene Estate Archives; 134 top: © Richard Barnes; 134 bottom: © Graciela Iturbide; 136: © Rodney McMillian, photo credit: Robert Wedemeyer, courtesy of the artist and Vielmetter Los Angeles; 141: © 2021 Estate of Pablo Picasso/Artists Rights Society (ARS), New York; 146: © 2021 Estate of Paul Cadmus/Artists Rights Society (ARS), NY; 149: © 2021 Artists Rights Society (ARS), New York/ VG Bild-Kunst, Bonn; 151: Photo © Robert Fairer; 155: © 2021 Artists Rights Society (ARS), New York/ DACS, London; 168: © Andreas Gursky/ARS, New York, 2021, photo courtesy of Sprüth Magers

Front cover: Frans Pourbus II, **Portrait of Louis XIII, King of France, as a Boy**, c. 1616 (detail); Alexander McQueen, **Woman's Dress**, from *The Widows of Culloden* collection, Fall/Winter 2006–7

Published in conjunction with

LEE ALEXANDER McQUEEN: MIND, MYTHOS, MUSE

This exhibition was organized by the Los Angeles County Museum of Art. Support for *Lee Alexander McQueen: Mind, Mythos, Muse* was provided by the 2021 Collectors Committee and The Jacqueline and Hoyt B. Leisure Costume and Textiles Fund.

Exhibition Itinerary:
Los Angeles County Museum of Art
April 24–October 9, 2022

Musée national des beaux-arts du Québec
Summer 2023

Published by Los Angeles County Museum of Art and DelMonico Books • D.A.P.
Copyright © 2022 Museum Associates/Los Angeles County Museum of Art

Los Angeles County Museum of Art
5905 Wilshire Boulevard
Los Angeles, CA 90036
www.lacma.org

DelMonico Books • D.A.P.
75 Broad Street, Suite 630
New York, NY 10024
www.delmonicobooks.com

Publisher: Lisa Gabrielle Mark
Editor: Sara Cody
Designer: James Gamboa
Photographers: Peter Brenner and Jonathan Urban
Photo Editor: Piper Severance
Production Manager: Karen Farquhar for DelMonico Books • D.A.P.

Printed and bound in Singapore

Library of Congress Control Number: 2021947478

ISBN: 978-1-63681-018-8